Dedalus Euro
General Edito.

Modern Art
(*L'Art moderne*)

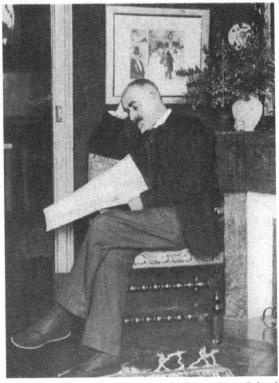

J.-K. Huysmans at home, 11 Rue de Sèvres, Paris. Behind him on the wall is a picture by Jean-Louis Forain. See p.116.

J.-K. Huysmans

Modern Art
(*L'Art moderne*)

Translated with an introduction and notes by
Brendan King

Dedalus

This book is supported by the Arts Council England and by the Institut français (Royaume Uni) as part of the Burgess programme (www.frenchbooknews.com)

Published in the UK by Dedalus Limited
24-26, St Judith's Lane, Sawtry, Cambs, PE28 5XE
email: info@dedalusbooks.com
www.dedalusbooks.com

ISBN printed book 978 1 910213 99 5
ISBN ebook 978 1 912868 07 0

Dedalus is distributed in the USA & Canada by SCB Distributors
15608 South New Century Drive, Gardena, CA 90248
email: info@scbdistributors.com www.scbdistributors.com

Dedalus is distributed in Australia by Peribo Pty Ltd
58, Beaumont Road, Mount Kuring-gai, N.S.W 2080
email: info@peribo.com.au

First published in France in 1883
First published by Dedalus in 2019, reprinted 2020

Printed & bound in the UK by Clays Ltd, Elcograf S.p.A.
Typeset by Brendan King

Contents

INTRODUCTION

First established in 1667 by Louis XIV, over the course of the 18th century the biannual Salon des Beaux Arts became the most important institution in the French art world, the means by which artists acquired their reputations and sold their work – and also the means by which a powerful establishment controlled the representation of the world to its citizens.

By the 19th century, the institution had become an annual event. The Salon ran from May to July, and attracted tens of thousands of visitors who would flock to see the thousands of works of art on display, especially on Sundays when entrance was free. During the 1880s, the number of exhibits averaged around 5,000, including sculpture, engraving, watercolour, and fine art painting. The Salon was surrounded by a whole superstructure of cultural production, of illustrated books and newspapers in which journalists and writers reviewed and promoted the work being shown, and explained its significance to the public. For a writer, writing about the Salon became a way to attract attention, to become known and to influence the public debate. During the 19th century it was practically a literary rite of passage: Stendhal, Baudelaire, Gautier, Goncourt, Zola, all turned their hand to reviewing the Salon at important stages in their careers.

Although better known today as a novelist than as an art critic, J.-K. Huysmans (1848-1907) was no exception. In the 1870s and early 1880s, when he was still trying to make a name for himself in the literary world and to reach a wider readership, he too assumed the mantle of art critic and began to write reviews of the Salon.

In the past, writers often tried to justify their decision to write about the Salon through their own personal connection

to art: Gautier made much of the fact that he was a former art student, the Goncourts were known to be passionate art collectors (and Edmond's younger brother, Jules, was himself an accomplished watercolourist), and when Zola came to publish his 'Salon of 1866', he dedicated it to his childhood friend, Cézanne, reminding him that they'd "been talking about art and literature for the past ten years."

Again, Huysmans was no exception. In interviews and profiles during the early 1880s he would play on his artistic ancestry, claiming that he was descended from the Flemish painter Cornelis Huysmans (1648-1727), and that he was the "last descendant" of a long line of painters, running from father to son down through the generations. In an autobiographical profile written for the press in 1885 he described himself, only half tongue-in-cheek, as "an inexplicable amalgam of a refined Parisien and a Dutch painter".

Indeed, art played a significant role in the construction of Huysmans' public image, and his early career both as a writer and a journalist revolved around art and art criticism. His first published piece of writing was a review of a landscape exhibition in 1867, and throughout the early 1870s he would write a string of reviews of art exhibitions, profiles of painters and analyses of paintings – mostly for Brussels-based journals.

Huysmans' fiction was equally art-centred, either making specific references to painters or works of art, or practising what Théophile Gautier termed *transpositions d'art* – literary passages that described or invoked through the written word, real or imaginary works of art. The prefatory poem to *Le Drageoir à épices* (*The Dish of Spices*), Huysmans' first collection of prose poems published in 1874, described the "principal subjects" treated in the book – which included fictionalised stories from the lives of painters such as Adrian Brauwer and Cornelius Bega – as "old sculpted medals, enamels, faded pastels, etchings and prints". In 1880, when Huysmans published his first collection of stories,

he aptly entitled it *Croquis parisiens* (*Parisian Sketches*), and with its descriptive scenes of café-concerts and circuses, its evocations of suburban Parisian landscapes, and its sketches of working-class characters such as the baker, the chestnut-seller and the streetwalker, Huysmans seemed to be doing with the pen what Edgar Degas and the Impressionists were doing with the brush. Even his novels didn't escape this imaginative fascination with the artistic image, and some of the most striking scenes in his fiction revolve around iconic *transpositions d'art*, such as that of Gustave Moreau's painting of Salomé in *À rebours* (*Against Nature*) of 1884, Matthias Grünewald's *Crucifixion* in *Là-bas* (*Là-bas: A Journey into the Self*) of 1891, and Fra Angelico's *Coronation of the Virgin* in *La Cathédrale* (*The Cathedral*) of 1898.

All of which, if it didn't exactly constitute a comprehensive, academic training in art history, put Huysmans in a better position than most when it came to discussing works of art. To his sense of a personal connection with art he added two vital qualities: a unique, not to say idiosyncratic, writing style, and an acute perception of the visual world, which seemed to fix itself indelibly on his retina: "Huysmans is an eye", as Rémy de Gourmont succinctly put it in *The Book of Masks* (1896). He not only knew what he liked – and more vehemently what he didn't like – he had the power to convey his emotional and aesthetic feelings through his writing: "Huysmans describes in the same way others paint", noted the French critic Brigitte Cabirol.

In many ways Huysmans couldn't have chosen a better time to launch himself into art criticism, or indeed a better method than the one he used in *L'Art moderne,* the first collection of his art criticism published in 1883. In the second half of the 19th century the art world began to change. It was no longer the case that the Salon represented the sole means of access to – and the all-powerful arbiter of – the artistic output of the nation. Instead, the Salon was increasingly being seen for what it had become, part

of a State apparatus that defined and limited what art could be, and narrowly determined how people could see it. Unsurprisingly, an increasing number of artists were becoming more and more dissatisfied with the situation.

The first major crack in the edifice came in 1863, when so many paintings were refused by the Salon jury that to quell the subsequent outcry, Napoleon III established a Salon des Refusés. If anything, this exacerbated the situation. One of the paintings exhibited at the Refusés was a provocative and incendiary work by Édouard Manet, *Le Dejeuner sur l'herbe*, a contemporary scene of a naked woman who stares unabashedly out at the viewer and who is sitting and talking with two clothed men, while another naked woman bathes in the river behind them. The subsequent newspaper outcry against it helped turn the work into an attraction that rivalled anything on display at the official Salon. But Manet's controversial painting also showed that a new style and movement in art was taking place, one that didn't conform to the conventions, rules and traditions of the École des Beaux Arts, the training ground of so many artists, and of the small cabal of men who formed the Salon's selection juries and ran it as an institution.

By the early 1870s, a group of artists who saw themselves as outside the Salon tradition, the 'Independents' as they called themselves, began to come to the fore, eventually organising their own exhibition in April 1874. It was in the wake of this watershed event, after a dismissive journalist referred to the "mere impressions" which, in his opinion, was all their pictures amounted to, that the group acquired the name that stuck with the public: the Impressionists.

Given how universally popular Impressionism is today – indeed, it has almost become a byword for art that is 'nice' and 'pretty' – it might be difficult for some people to conceive just how radical, how unpopular, and how controversial the paintings of the Impressionists were at the time. To many critics – as well as to

a conservative, politically reactionary public – the pictures seemed garish, unfinished and morally suspect, the products of artists who were untalented, if not even a bit sick in the head. (Indeed, it was suggested that the Impressionist style was a result of poor eyesight or some form of neurological disease afflicting the painter's sense of colour, something that Huysmans, swayed by contemporary researches in physiology and psychology, gave a certain credence to. See Note 8 on page 278 for a fuller explanation.)

An article that appeared in *Le Figaro* just after the opening of the first 'Impressionist' exhibition, gives a flavour of the abuse that was heaped on the movement and its practitioners:

> The Rue le Peletier is certainly unlucky. After the fire at the Opera, here is a new disaster afflicting the neighbourhood. An exhibition at Durand-Ruel has just opened which is described as being 'painting'. But if an innocent passerby, drawn in by the flags decorating the façade, should enter, an appalling spectacle presents itself before his fearful eyes. Five or six lunatics, one of them a woman, misfortunates suffering from the madness of ambition, have come together to exhibit their art works.

> Some people burst out laughing in front of these things; as for me, I'm aghast. These so-called artists call themselves 'the Intransigents', 'the Impressionists'; they take a canvas, paint and brushes, throw a few colours together at random and imagine the result is a masterpiece. In the same way that lost souls in the Ville-Évrard insane asylum pick up a pebble in the road and imagine they've found a diamond. A frightful spectacle of human vanity straying into dementia. It should be made clear to M. Pissarro that trees are not purple, that the sky is not the colour of fresh butter, that in no country can we see the things he paints and that no intelligent person should give themselves up to such aberrations...

> And just think of the fatal consequences that exposing the public to such a heap of philistinism can lead. Yesterday, a young

man stopped at the Rue le Peletier, and on leaving bit a passerby.

(*Le Figaro*, 3 April 1874)

However, as with many artistic movements that are derided at their inception, the Impressionists, encouraged by a few critics who took up their cause, gradually began to attract a wider public. Huysmans was fortunate enough, or perceptive enough, to throw himself in with the new art movement at the right time, and as the Impressionists grew in popularity and in reputation, his name was increasingly associated with theirs. So much so, in fact, that one critic, the journalist Félix Fénéon, referred to Huysmans as "the inventor of Impressionism".

Whether it was a result of deliberate choice or whether it was simply a reflection of the widening fracture running through the art world at the time, Huysmans' decision to divide *L'Art moderne* into successive reviews of the Salon and the exhibitions of the Independents was inspired. It is the binary nature of the articles that gives the collection its *animus*, with Huysmans being alternately stimulated to paroxysms of derision at the tired, cliché-ridden works displayed in the Salon, and to outbursts of enthusiasm for the work of the Independents – or some of them at least. This is one of the reasons why Huysmans' art criticism – and *L'Art moderne* in particular – remains so fascinating, bringing to life as it does a significant moment in art history, a shift in power that marked the decline of the establishment system and the rise of a group of independent artists who formed what would become the first great movement of modern art: Impressionism.

The writing and preparation of *L'Art moderne*.

Although it wouldn't be published until May 1883, Huysmans originally conceived the idea of a book about art in the spring of 1881. He was almost certainly influenced in this by Émile Zola, the de facto head of the Naturalist movement whose own collection of writings on art, *Mes Haines. Causeries litteraires et artistiques*

INTRODUCTION

(literally 'My hates: discussions on literature and art'), which included a review of the 1866 Salon and an essay on Édouard Manet, had been published in a new edition just a year previously.

Huysmans outlined his initial plan for the book in a letter to his Belgian friend, the poet Théodore Hannon:

My dear Hannon,

I am busy on an art book, which will be interesting I think, though it's giving me some difficulty. I've reworked my Salons of 1879 and 1880 from top to bottom, I'm now dipping into an enormous study of the Independents. In oil paint up to my neck! I'm going to add to it a piece on modern architecture, the architecture of iron and steel. I'll then add the Salon of 1881 and try to serve it up hot.

(Huysmans to Théodore Hannon, 29 March 1881)

The intention was to offer it to his new publisher, Georges Charpentier, to whom he'd been introduced by Zola and who was himself an avid art collector. Huysmans may have had the idea of compiling a collection of previously published reviews, but as it turned out this was more problematic than it first appeared, and the material ultimately included in *L'Art moderne* shows the somewhat unsettled, itinerant nature of his work as an art critic up to that point. It's true that Huysmans had written numerous reviews and articles about art for newspapers, but they tended to be small, Brussels-based publications, rather than the larger, more prestigious Paris-based journals that would have signalled to his literary peers that he should be taken more seriously as an art critic.

Huysmans' problem is perhaps best exemplified by the opening review, 'The Salon of 1879', originally published in twelve parts by *La Voltaire*, a Republican journal popularly referred to as '*le Figaro républicain*' that also included Zola and Goncourt as contributors. If Huysmans had hoped his review of the Salon would become a regular feature he was to be disappointed – the paper unceremoniously ditched him after his first attempt.

Reading the piece, which is not so much a review of official art as a demolition of it, it is clear why. Huysmans' promotion of the then-unfashionable Impressionists, his diatribes against academic painters and the Salon system, and his intemperate language, were practically designed to rub the newspaper's readers up the wrong way. Complaints were not long in coming – along with threats to withdraw subscriptions. Huysmans' position became untenable and he later learned that the editor had chosen a more compliant, less controversial critic for the following year's review of the Salon.

In truth, Huysmans wasn't exactly surprised by this turn of events. Even before his articles were published he had told Hannon that he and Henry Céard – another ally in the Naturalist movement who had been hired by the newspaper at the same time – "were going to try their hand at great Parisian journalism and turn *Le Voltaire* into an organ of Naturalism". Two weeks later, after sending Hannon the first two instalments of his Salon, Huysmans' described the effect it was having on the paper's readership:

> It's rattled a few cages here!! The anger and hatred I'm harvesting are unspeakable – *Le Voltaire* was furious, Zola had to use his influence to make them back down, and they were obliged to put up with my attacks, even the most ferocious – what fun!
>
> (Huysmans to Théodore Hannon, 24 May 1879).

Huysmans had little more luck the next year, when he published his review of the 1880 Salon in *La Réforme politique et littéraire*, a Naturalist-friendly journal with close ties to Zola. Although Huysmans' review didn't spark the same controversy as the year before, he was again out of luck: by 1881 the journal had ceased publication, or at least had changed its focus in order to concentrate on theatre criticism. Huysmans' review of 1880, was the last 'Salon' the paper ever published.

The following year, Huysmans' attempts to get his Salon review placed satisfactorily in a suitable journal reached an impasse. Aside from some short reviews of individual paintings by James Tissot,

Introduction

Félix Ziem and Léon Belly at the Musée du Luxembourg, the only substantial piece of art criticism he published in 1881 was an essay on the English illustrators Randolph Caldecott, Walter Crane and Kate Greenaway, which had no connection at all with the Salon.

Frustratingly for Huysmans, he was unable to place his review of the Salon that year, and it would remain unpublished until it appeared in *L'Art moderne*, some two years later. However, not one to waste material he'd already written, when it came to compiling the book, he shoehorned his essay on English illustrators into the 1881 Salon review anyway.

The rest of 1881 was taken up with other writing projects. Huysmans spent several months struggling to write his novel about Paris during the 1870-71 seige, *La Faim* (*Hunger*) – which he would abandon shortly afterwards and which remained incomplete – and during the autumn and winter he composed his novella, *À vau-l'eau* (*Drifting*).

In the spring of 1882, with the approach of the Salon season, Huysmans returned to his art book idea again, and he updated Hannon on its progress:

My dear friend,

For the moment I am busy preparing a big volume on modern art, comprising the Impressionist aesthetic, the exhibitions of the Official Salons and the Independents for the past three years, the English annuals, iron and steel architecture in modern Paris, and the printing of illustrated books etc. I hope it'll appear in May...

(Huysmans to Théodore Hannon, 25 March 1882)

But once again, Huysmans' plans were delayed, initally by a long bout of illness, as he explained to Zola:

I was affected by a methodical cough, beginning at 3 o'clock in the morning precisely, and which continued mechanically until 7 o'clock...This was a cause of stupefaction to the men newspapers call the 'Princes of Science'. They tapped me on

the back, declared in chorus that the chest was good, the bronchi intact and finally, not having found my case related in the medical books, they gave up. Then one of them discovered I must be suffering from a disease of the nerves. At this I was given valerian, asafoetida, bromide – all the antispasmodics. Result: nothing. Finally, they resorted to icy showers, with water at o° centigrade. This was more successful – thanks to this regime, the mechanical cough has stopped. So I spend my time at the public baths, exhibiting my shivering skeleton to the gaze of a fireman, who pulverises my spine under columns of freezing water. My disgust for this ridiculous and painful treatment exceeds the limits of the possible…I still have persistent insomnia…I read in bed, alternately swallowing laurel-cherry water and laudanum…

(Huysmans to Émile Zola, 19 June 1882)

Despite this, Huysmans managed to finish his manuscript and handed it to Charpentier in June. This wasn't, as he might have hoped, the end of his problems with the book – indeed, the process of preparing the book for the press turned out to be a contentious, ill-tempered and time-consuming one. As had been the case at *Le Voltaire*, Huysmans found that speaking his mind so freely in public had its drawbacks. Charpentier, as an art collector and a publisher who frequently used artists and engravers to illustrate his books, was put in a difficult position by the manuscript of *L'Art moderne*, which ferociously criticised many of the artists he had personal and business relationships with. The result was a conflict over what should or shouldn't be included – or more specifically which artists could or couldn't be attacked – as Huysmans complained to Zola:

Saw the good Charpentier…I gave him my volume on art. Now he begs me to carry out deep cuts, since I attack painters who give him free drawings for *La Vie Moderne* [a weekly art journal that Charpentier edited]. We finally came to an

agreement with mutual concessions...

<p style="text-align:right">(Huysmans to Émile Zola, 19 June 1882)</p>

Huysmans may have been trying to strike a more conciliatory tone with Zola, who had long been friends with Charpentier. Later, he would express himself more forthrightly on the matter to the art critic Gustave Geffroy, complaining that the cuts were hardly mutally agreed and that they'd had a detrimental effect on his text:

> It's full of gaps, of things unexplained, things unconnected, rough bits...but there you go. Emasculated by order of the publisher, this book had whole pages struck out at the proof stage. You can imagine the impossibility of joining it together. Things that should be completed by examples have been completely suppressed. Everything concerning Henner and Cot was mercilessly slashed, and given the impossibility of finding in the streets of the capital two publishers willing to print this piece of wreckage that passes for an art book, I had to submit and, what is more, sprinkle some ash on my sentences here and there.

<p style="text-align:right">(Huysmans to Gustave Geffroy, 9 August 1883)</p>

But as with many of Huysmans' vituperative complaints, his statements need to be taken with a pinch of salt. The two first pieces in the collection were published substantially unchanged from their periodical appearances, so whatever cuts he made were to previously unpublished pieces. It is true that the name of Jean-Jacques Henner (1829-1905) – a painter who relied too heavily on chiaroscuro for Huysmans' tastes – doesn't appear in the book, nor does that of Pierre Auguste Cot (1837-1883), a pupil of Alexandre Cabanel and William Bouguereau whose nauseatingly saccharine pictures would have received pretty short shrift at Huysmans' hands, but while it is a pity not to be able to read what would probably have been entertaining demolitions of the two artists, the existing book still includes plenty in the way of Huysmans' trademark invective.

By the autumn of 1882, Huysmans was thoroughly fed up with

the whole business, as he told Hannon:

> There are times when things are so unspeakably mad one can't
> even joke about them. I spent an abominable winter with bad,
> incurable nerves, which incapacitated me for any work and
> which required cold showers and suffusions of valerian. Try
> and write an amusing letter in the midde of such a shambles,
> aggravated by annoyances at the Ministry and with my family!
> Beginning last winter, continuing through summer, right up
> to this accursed autumn.
>
> There, my dear friend, are the reasons for my silence – I'm
> hunkered down in the shitstorm of my own existence, feeling
> disgust to the highest degree at everything that happens.
>
> (Huysmans to Théodore Hannon, 13 September 1882)

This process would drag on for almost another six months.
In the end, the book wasn't ready to go to press until April of the
following year, and was finally published in May. But even then
Huysmans' problems weren't over. Unsurprisingly, Charpentier
wasn't wholly committed to the book, and Huysmans learned from
his friend Léon Hennique that the publisher had been deliberately
dragging his heels as regards marketing and distributing it. Again,
he wrote to Hannon to give him the full story:

> I am shaking off my fearful idleness a little in order to write
> to you; you ask me for information about the effect produced
> by the art book. That is quite a story. Charpentier, terrified,
> despite the cuts he'd imposed on me regarding Henner etc.
> didn't put it on sale! It was like this: scared in advance of
> complaints by those who were attacked and by the reproaches
> of his friends Gervex and Bastien-Lepage etc, he didn't even
> announce its publication, and he finally admitted to Hennique
> that he would prefer to lose money on it rather than put it on
> sale; in short, he did his best to kill it. Unfortunately for him,
> the book nevertheless found its way into the hands of some
> painters; thereupon there was a general uproar in the studios.

The booksellers, who they requested the book from, had to go out and get copies; in short, in spite of everything, the said book has exploded like a bomb in an oil depot – which has also brought me a series of letters, quite badly expressed, but above all stupid and badly spelled!

Whatever happens, the sales will be almost nothing under these circumstances; deep down, I don't care – it's a collection of articles; I wanted, in the face of the cowardice and stupidity of French criticism, to state my opinion, to express what I believe to be the truth – in short, to be the first to write how great Degas' personality is; it's done, so all is for the best.

(Huysmans to Théodore Hannon, 28 May 1883)

Contemporary responses to *L'Art moderne*

Charpentier's reluctance to distribute *L'Art moderne* seems to have had an impact on the book's initial coverage in the press, something reflected by the fact the scrapbooks Huysmans filled with newspaper reviews contain fewer clippings devoted to *L'Art moderne* than to his other books.

Given Huysmans' partisan stance in favour of the Impressionists and his intemperate attacks on established Salon painters, it was inevitable that press reaction, such as it was, would be divided. Conservative papers predictably dismissed the book. Some, like *L'Illustration,* were content to puzzle over Huysmans' contradictory tastes, finding it difficult to see how a supporter of Manet could also be an admirer of Dutch masters like Van Ostade, and complaining that he seemed to denigrate artists who were held in high esteem by everyone else. Others, such as *Le Soir* and *La Paix*, were more pointed in their criticisms:

In no fashion, absolutely no fashion, can we accept the artistic theories of J.-K. Huysmans. As a piece of paradox and as a challenge to good taste, to all that is beautiful, to all that is admired and admirable, the book may seem amusing to some

minds. But as a study and as a piece of artistic criticism, we advise the author of *L'Art moderne* to go back to school and study the real masters in these matters. His book has nothing to recommend it, moreover he disparages anyone who has acquired a reputation, and his aphorisms are far too Naturalistic.

(*Le Soir*, 21 May 1883)

For Huysmans, the only true artists are the Impressionists, the Naturalists, and the Independents, with their cult of *splotches* and their skill in reproducing the ugly in its modern form. This new conception of art leaves us absolutely cold, and we mention M. Huysmans' book simply as a curiosity.

(*La Paix*, 26 June 1883)

But despite these "howls of protest", as Huysmans referred to them, the book received support in journals that were more open to the new developments in literature and art represented by Naturalism and Impressionism. Huysmans' personal connections with the Belgian literary and artistic milieu also helped ensure positive notices in periodicals there:

Feline criticism is not J.-K. Huysmans' style...on the contrary, his idea is to go straight to the point, unhesitatingly, without mincing his words...I understand that the history painters and the purveyors of illustrations for chocolate boxes have squealed a little. As one would. By God! what verve, what a grip he has! The exact, cutting epithet abounds, the turns of phrase are incisive and picturesque...I noted some of his transcriptions of landscapes, by Pissarro and Raffaëlli among others, which are the work of a subtle and compendious mind. And this avant-garde work, which has a whiff of gunpowder about it, is also full of fine and sensible reflections about Impressionism and the leading painters of that school, among which one could certainly point out a masterful criticism of Édouard Manet's paintings.

(*La Jeune Belgique*, c.1883)

INTRODUCTION

Huysmans' literary connections in Paris also guaranteed him at least some favourable reviews, such as that by Paul Alexis in *Le Reveil* (13 May 1883), who like Huysmans had contributed to Zola's anti-war collection of short stories, *Les Soirées de Médan* in 1880. Predictably, perhaps, Alexis praised the book's author for his "courageous combat on behalf of truth and audacity in art against received prejudice, easy success and overblown reputations".

But there were other, more independent reviews, notably a dense, in-depth evaluation by the young Paul Bourget in *Le Parlement* (31 May 1883), who perceptively noted the aesthetic gulf that separated Huysmans from other writers in the Naturalist school such as Zola and Maupassant, and another by the critic Gustave Geffroy:

> [*L'Art moderne*] is a sincere work by a philosophic and literate man. I don't think the writer compromises a single time about any of those he meets on his way, whatever their name or whatever their reputation. He is always mercilessly honest; and it's genuinely in the name of modern art that he makes his enquiry, searching out those who have a passion for their times and praising them when he finds them, and shoving to one side all those who look for easy success, gained at the expense of truth.
>
> (Gustave Geffroy, *La Justice*, 9 August 1883)

What is perhaps more significant, however, than the notices the book received in the press, whether good or bad, was the response of Huysmans' peers. Tellingly, he received no messages of support from the two writers he might have expected positive reactions from: Zola and Edmond de Goncourt. While Zola actively criticised Huysmans' opinions, dismissing his praise of Degas and arguing that Courbet was still the master of the Realist school, Goncourt went one further – he ignored the book entirely.

By contrast, Stéphane Mallarmé, the Symbolist poet with whom Huysmans had recently become friends, wrote enthusiastically:

> You are the only commentator on art [*causeur d'art*] whose

Salons of previous years one can read from beginning to end
and find them more interesting than those of today...What a
fine passion for truth you display, with a penetrating eye and
a persuasive voice to serve it.

(Stephane Mallarmé to Huysmans, 12 May 1883)

These shifts in literary allegiance are indicators of the aesthetic
direction Huysmans was travelling in, though their significance
would only really become apparent in the light of his subsequent
book, the iconoclastic *À rebours* of 1884, which effectively marked
his parting of ways with Zola and the Naturalists.

Huysmans as art critic

Huysmans' criticism had a considerable impact on a number of
artists at the time, helping to give a wider exposure to those whose
names were barely known to the general public. Paul Gauguin
was a relative unknown when Huysmans first wrote about him
in *L'Art moderne*, and Pissarro had yet to gain the widespread
reputation he later acquired when Huysmans described him as
a master landscape painter. It is hard to imagine what Gustave
Moreau's reputation would be today if it were not for Huysmans'
radical reimagining of his work (and the same could be said of
Matthais Grünewald, whose name had been almost forgotten
when Huysmans wrote about him in the 1890s). Likewise, Odilon
Redon's early career as an artist was given an important boost
by Huysmans' promotion of his work. Although it's true the
artist would later come to feel that Huysmans' highly personal
interpretation of his work amounted to an 'appropriation' of it, he
was initially grateful for the exposure: "I'm singularly happy – and
proud, too – of the section Huysmans has devoted to me," he told
the critic Émile Hennequin.

Perhaps the most unequivocal critical judgement Huysmans
makes in *L'Art moderne* is his recognition of Degas as France's
greatest living painter. Like Baudelaire and Zola before him,

Huysmans saw it as part of his job as a critic to find the 'painter of modern life'. Whereas Baudelaire posited Constantine Guys as a possible contender, and Zola looked to Manet, Huysmans boldly staked his claim on Degas. At the time this was neither a universal nor a popular view, even among those in the literary and artistic world. Zola, for example, far from sharing Huysmans' high opinion of Degas, dismissed him as "nothing more than a constipated artist with a talent for the pretty".

It would be unrealistic to expect all of Huysmans' critical opinions to stand the test of time, but it is nevertheless remarkable how many of the painters he singled out for praise are still considered major figures in the canon. Although it might be objected that the tone Huysmans' adopts in his scathing attacks on academic painters and established Salon artists hardly belongs to the language of traditional art criticsm, he could also be sensitive and acute in his critical judgements when he chose. His distinction between the painters he saw as truly modern – such as Caillebotte, Manet, and Raffaëlli – as opposed to those who painted in what he considered to be a 'faux-modern' style that was acceptable to conventional bourgeois tastes – such as Bastien-Lepage, Gervex, and Carolus-Duran – still holds true today, as does his instinctive recognition that a painter like Fantin-Latour belonged with the former rather than the latter.

Huysmans also deserves credit for being one of the first critics to treat what were previously considered 'lesser' genres as seriously as the 'fine arts'. Huysmans saw Jules Chéret, who made his name with his distinctive lithographic posters advertising circuses and café-concerts, as a genuine artist whose work he considered finer than many of the 'serious' artists exhibiting in the Salon, and he would compare the skill of the illustrators of certain children's books, such as Walter Crane and Kate Greenaway, with that of the Japanese woodblock masters of the late 18th and early 19th centuries.

INTRODUCTION

But if Huysmans was a partisan critic, he was also a contradictory and idiosyncratic one. This often makes it harder to evaluate his criticism than that of other writers of the same period. Consistency was not one of Huysmans' strong points – as his life and career trajectory would prove – and the writer who could praise Degas and Forain for presenting life as it really was, could also laud Gustave Moreau and Odilon Redon, whose work seemed to represent its complete antithesis.

Arthur Symons, who was instrumental in promoting Huysmans' work to readers in Britain during the 1890s, was one of the first writers to also recognise his achievements as a critic:

> [Huysmans] the most modern of artists in literature, has applied himself to the criticism – the revelation, rather – of modernity in art…No literary artist since Baudelaire has made so valuable a contribution to art criticism, and [Baudelaire's] *Curiosites Esthetiques* are, after all, less exact in their actual study, less revolutionary, and less really significant in their critical judgements, than *L'Art moderne*.
>
> (Arthur Symons, *Symbolist Movement in Literature*, 1898)

But perhaps the final word should be left to Anita Brookner, who, like Huysmans, was as accomplished as an art critic as she was a novelist. Her critical study on influential literary figures in 19th century art singles out *L'Art moderne* for praise:

> Certainly the reviews in *L'Art moderne* are a remarkable achievement, not only because in them…Huysmans manages a consistent fidelity to the painted image…but because this collection of essays marks the culmination of the century's campaigns in search of a new form for a new situation. The essays have written in as their central theme the search for, and, triumphantly, the discovery of, the painter of modern life…It is impossible to close this volume without feeling that Huysmans is for once writing in the best French tradition.
>
> (Anita Brookner, *The Genius of the Future*, 1970.)

Translator's note

Huysmans was not always very rigorous when transcribing a painting's title, sometimes referring to it by a shorter title than that given in the Salon catalogue, and sometimes even calling it something else altogether, based on his recollection of the painting's subject matter. In these instances I have tried to give the full title of the painting as it appeared in the Salon catalogue, both to make Huysmans' description and analysis clearer, and also to make the picture easier to find if anyone wants to look it up. To this end, in the Notes and the Glossary I have given the full title of paintings in French rather than English. As Huysmans refers to so many painters and artists in the course of his reviews, some of whom are now little known, the Glossary at the end of the book gives some basic information about those mentioned, as well as the titles of works the artist exhibited at the Salon in the year Huysmans wrote about them. Although *L'Art moderne* wasn't illustrated, I have included small black and white illustrations for a number of the paintings referred to, some of which are taken from the original Salon exhibition catalogues.

Modern Art
(*L'Art moderne*)

Contrary to popular opinion, I believe that it is good to tell the whole truth. That is why I am bringing together these articles, which appeared, for the most part, in *Le Voltaire*, in *La Réforme*, and in the *Revue littéraire et artistique*.

J.-K. H.[1]

THE SALON OF 1879

I

If, first of all, I exclude a Herkomer, a Fantin-Latour, two Manets, some landscapes by Guillemet and Yon, a seascape by Mesdag, and several canvases signed by Raffaëlli, Bartholomé and a few others, I don't see much that, from the point of view of modern art, one can find truly interesting or truly new in the offcuts of canvas unfurled over every wall of the 1879 Salon.

Aside from the few artists I've just mentioned, the rest are quietly continuing their humdrum routine. It's absolutely the same as the exhibitions of previous years, neither better nor worse. The mediocrity of those raised in the State-run farms of the Academy of Fine Arts[1] remains unchanged.

One could – and this present Salon proves it once again – divide these painters into two camps: those who are still competing for a medal, and those who, no longer eligible to obtain one,[2] are simply seeking to sell their products as best they can.

The former knock out those deplorably hackneyed scenes you know so well. They choose by preference subjects drawn from religious or classical history, and they constantly talk about

making it distinguished, as if distinction came from the subject itself, and had no connection to the manner in which one treats it.

Admittedly, most of them didn't receive any education, they've seen nothing and read nothing, and for them *making it distinguished* means quite simply making it so it doesn't seem alive or making it so it doesn't seem true. Ah, what an expression! and what about that other one, *great art*, which is constantly on these wretches' lips. Tell them that the modern world would furnish the subject of a great work just as well as the classical, and they're astounded and get indignant. So these painted window-blinds they've nailed up in their golden frames, that's *great art* is it? *Great art*, these *Ecce homos* and *Assumptions* of Virgins wrapped up in pink and blue like sweet wrappers? *Great art*, these Heavenly Fathers with their white beards, these Brutuses painted to order, these made-to-measure Venuses, these Oriental scenes painted like Batignolles embroideries[3] on a cold winter day? Is that *great art*? Let's move on, then, to *industrial art*,[4] and as quickly as possible! Because at the rate it's going *industrial art* will soon be the only one we should study if we're in search of truth and life.

Such are the painters who follow, and apply themselves to, the tradition of the Academy of Fine Arts. Let us now pass to the others. These painters no longer listen to the tenets of their maternal school, they've abandoned antiquity as it doesn't sell any more, and, in order to earn money, they try to flatter, through prettiness and mimicry, the unsophisticated tastes of the public. They sugarcoat their babies, they dress their mannequins in silk as stiff as tinplate, they give a bereaved mother who's lost her newborn a log wrapped in swaddling to cradle, they put a rifle into the hands of a callow youth, and then they embellish the whole lot with titles of this kind: *First Sign of Trouble; Sadness; The One-Year Volunteer;*[5] *Can I Come in?*, and *Daydream* – needless to say these latter artists are no more refined than the former, and even if they've begun to ridicule *great art*, they too have similar

pretentions to work only in the *distinguished*.

So one can, without any fear of being mistaken, propose this axiom: the less education a painter has received, the more he wants to make *great art* or sentimental paintings. A painter from a working-class family will never paint workmen, but rather gentlemen in black suits, about whom he knows nothing. Assuredly, idealism is a very wonderful thing!

And so here we are in the year of grace 1879, when Naturalism has tried to overthrow all the old conventions and all the old formulas. But even though Romanticism is dying, the paintings accepted into the Stock Exchange for oils on the Champs-Élysées[6] continue to take it easy, to shut their eyes to everything that's happening in the streets, to remain indifferent or hostile to the attempts at modernisation being made against it. In painting, as in poetry, we are still on the slopes of Parnassus. It's all finicky detail and cheap tricks, nothing more.

Much more interesting are those troublemakers, so reviled and decried, the Independents.[7] I don't deny that among them there are some who aren't familiar enough with their trade, but take a man of great talent like M. Degas, take even his pupil, Mlle. Mary Cassatt, and see if the works of these artists aren't more interesting, more curious, more *distinguished* than all those jingling contrivances that hang, from picture rail to parquet, in the interminable rooms of the Salon.

It's because in their work I find a genuine concern with contemporary life, and M. Degas – on whom I must expatiate a little, because his work will serve me many times as a point of comparison when I arrive at the Salon's 'modern' paintings – is definitely, of all those who followed in the wake of the Naturalist movement, established in painting by the Impressionists and by Manet, the one who has remained the boldest and the most original. He was one of the first to tackle the feminine charms of the common woman; one of the first who dared grapple with

artificial lighting, the brilliance of raked stages on which singers with plunging necklines bawled their bawdy songs, or on which dancers dressed in gauze frolicked and pirouetted. Here there's no smooth creamy flesh, no silky gossamer skin, but real powdered flesh, the painted flesh of the theatre and the bedchamber, just as it is, like flannelette, with its veiny granularity when seen up close, and its unhealthy sheen when seen from a distance. M. Degas is a past master in the art of capturing woman, in representing her with her pretty movements and her graceful bearing, in whatever class of society she belongs.

That people unaccustomed to this style of painting are terrified of it matters little. Their familiar slippers have been changed, but they'll fit well enough when they're put on. They'll end up realising that the excellent methods of painting employed by the old Flemish school to render those quiet interiors, in which maternal women plumply smile, are impotent to render today's upholstered interiors and those exquisite Parisiennes with their pale complexions, rouged lips and suggestive hips that sway in a skintight armour of silk and satin. Obviously, for my own part,[8] I admire Jan Steen and Ostade, Terburg and Metsu, and my passion for certain Rembrandts is great; but that doesn't prevent me from declaring that today one has to find something else. These masters painted the people of their time with the techniques of their time – that's now done and dusted, so onto something different! While waiting for a man of genius, uniting all the fascinating elements of Impressionist painting, to rise up and take the battle by storm, I can only applaud the attempts of the Independents, who bring us a new method, an artistic fragrance that is unique and truthful, which distils the essence of their time in the same way that the Dutch Naturalists captured the aroma of theirs; for new times, new techniques. It's a simple matter of common sense.

Is it necessary to add now that the official Salon exhibition distils less of the bitter juice of contemporary life than that of the

Independents? The first glance is dispiriting. So much canvas and wood used to so little purpose! This whole pretentious motley of decorative wall-hangings[9] strikes a false note. Of the 3,040 paintings listed in the catalogue, there's not a hundred that are worth looking at. The rest are certainly inferior to the advertising posters on the walls of our streets and on the pissoirs of our boulevards, those tableaux that represent little slices of Parisian life: ballet gymnastics, clown acts, English mimes, racetracks and circus arenas.

For me, I'd like it better if all the rooms of the exhibition were papered with Chéret's chromolithographs, or those marvellous sheets of Japanese paper[10] you can buy for a franc a piece, rather than to see them stained by such a sad heap of stuff. Art which lives and breathes for God's sake, and into the bin with all these cardboard cut-out goddesses and all this devotional trash of the past! Into the bin with all this lick-polished[11] rubbish by the likes of Cabanel and Gérôme!

Ah, God be thanked, we're beginning to unlearn our respect for the conventional glories of the past. We no longer bow down before reputations sanctified by special interests or by stupidity; and rather than all the Thomas Coutures and Émile Signols of this world, we prefer the debutant who understands the marvellous spectacle

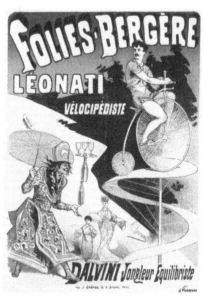

Jules Chéret's poster advertising the Folies-Bergère c.1880.

offered by the drawing room and the street, and endeavours to paint them. Even his hesitant first steps are interesting to me because they are the prelude to a new art; but, alas, it's not a question of a new art at present, since the canvases piled up here in the Palais d'Industrie are the same as those that appeared here ten years ago. It's like old clothes being passed down from father to son, shortening them or lengthening them, according to their size.

And so, without further discussion, we come to the works themselves; first of all let's look at the metres of painted canvas destined to cover the yellowing whitewashed walls of churches, to adorn provincial galleries, council meeting rooms and town halls in large boroughs; in other words, let's start by visiting what my peers have taken to calling 'history painting'.

II

The brothers Mélingue have drawn from that lamentable 'hand-me-down' box of old clothes in order to filch the uniforms and bits of braid that have served to adorn their kind of painting over the years. One of them depicts Edward Jenner, about to inoculate a young boy with a virus gathered from milk infected by smallpox. Alas, the whole seems to have been cut down from a larger sheet of canvas, and one searches in vain for its focal point. His brother's painting, *Provost Etienne Marcel and the Dauphin Charles*, testifies to a greater effort, but here it is suffocating and lacks air. I admit the Dauphin might well blanch when confronted by this invasion of men about to cut the throats of two marshals right in front of him; but never, and I mean never, even if he wasn't overwhelmed with fear, could a drop of blood ever flow beneath that pallid face, beneath that piece of taffeta that serves him as skin. Added to which these fabrics envelop no human frame that ever lived.

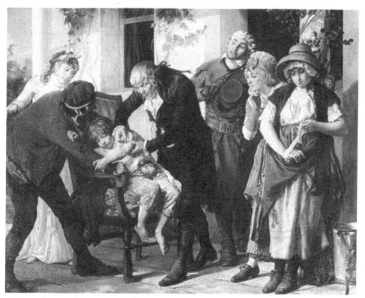

Edward Jenner by Gaston Mélingue.

Provost Étienne Marcel and the Dauphin Charles by Lucien Mélingue.

An Ecstatic of the XVIII Century by Georges Moreau de Tours.

Blanche of Castille, Queen of France by Georges Moreau de Tours.

Death of Commodus by Fernand Pelez.

THE SALON OF 1879

If a breath of air were to penetrate the room in which this scene occurs, you'd see the wafting robes open and close on a void, only the stick-like armature that supports them would be visible.

You can see the same thing, except lying down this time, in *An Ecstatic of the XVIII Century* by M. Moreau de Tours. The woman's flesh is too flabby, and her torturers, instead of occupying themselves with their patient, seem to be saying: 'Hmmm, are we dressed elegantly enough?' M. Moreau would do well to go to Haarlem, he would then see how Hals and Jan de Bray group their figures, and the simple and realistic attitude each of them preserves in the work as a whole. I prefer Moreau de Tour's other canvas, bought by the State, *Blanche of Castille, Queen of France, called 'Beloved of the Poor'*. It is honestly drawn, and in any case as a piece of painting it's less shaky than those by the brothers Mélingue.

I now come to the dry and glassy *Roll Call of the Girondins in the Conciergerie Prison*, by François Flameng, and I wonder why this painter who is so young should have wasted his time going down this well-trodden path. He has, at least, shaken off a little of the disastrous influence of his pitiful master; come on, one more effort Monsieur, leave all this behind and test your mettle, see if you don't have a bit more passion when it comes to the modern!

After the *Girondins* we now find ourselves here in front of the astonishing *Death of Emperor Commodus* by M. Pelez. I initially misunderstood the subject of this painting. I thought the gentleman in the green bathing trunks leaning over the other gentleman in white bathing trunks was a masseur, and the woman lifting the curtain was simply saying: 'The bath is ready.' It appears that the bathroom attendant is a thug, an expert strangler who is in no way kneading the neck of Commodus in order to help his blood circulation; it is even, if I'm to believe the title in the catalogue, completely the opposite. Either way, it matters little to me. As for the other canvas by the same painter, it is quite frankly a carbon copy of the one by Amaury Duval in the Musée de Luxembourg.

If I were to go through two whole rooms crammed with paintings like these I would end up, God forgive me, experiencing an unreasonable admiration for the work of M. Puvis de Chavannes! Certainly, compared to those tedious pastiches, his *Prodigal Son* and *Young Girls at the Seaside* are true marvels. It's still the same pale colour, the same fresco-like air, it's still angular and hard, which, as usual, aggravates with its pretensions

The Prodigal Son by Pierre Puvis de Chavannes.

to naïvety and its affectation of simplicity; and yet, however incomplete he might be, this painter has talent – his frescos in the Pantheon prove it.[12] Buried up to his neck in a sort of fake genre, he dabbles courageously and even achieves, in this unwinnable struggle, a certain grandeur. One admires his efforts, one would like to applaud him; but then one rebels, one wonders what country these anaemics who comb their hair in front of a sea of flint are from? Where, in what suburb, in what province of the country, do these pallid faces, which don't even have the rosy pink cheeks of the consumptive, exist? In the end, one just feels surprise before this peculiar assemblage of young girls' heads and of bodies that should be imprisoned in the black dresses of devout spinsters in the depths of some province depicted by Balzac.

What would be curious would be the marriage of these poor ladies to the rustic strongmen that M. Lehoux unites around a pond of broken marble, a veritable cracked skating rink. I

Young Girls at the Seaside by Pierre Puvis de Chavannes.

point this antithesis out to those in the Romantic school. It could furnish some witticisms, as their master will find. To return to M. Lehoux, one learns that these licorice-complexioned colossi are converts who are about to have their necks wetted. Saint John the Baptist holds his shell full of water like an athlete holds his dumbbells. Ye Gods, what an effort for nothing! I consider it a pity there aren't any blue tattoos on the arms of these wrestlers: 'To you, Adele, for life!' or some such melancholy inscription of a similar kind. The carbonado of holy flesh the painter exhibited two years ago under the title *The Martyrdom of Saint Etienne* had little resemblance to a masterpiece, but his painting this year, with its religious strongmen[13] and its small Christ, who one can make out in the distance with what looks like a fried egg on his head, is worth still less.

All this is very mediocre, and yet there's worse to come. It's astonishing, but it's a fact – M. Lecomte du Nouy has managed to achieve this *tour de force*. Amiably enough, I'd always imagined that M. du Nouy was suited to other work than that of painting. Could he have made an error in his vocation? His *Saint Vincent de Paul*, which has turned as brown as the old panels of the French school painted under Louis XIII, would certainly seem to prove it, if the artist hadn't already furnished the evidence a long time before this. The only merit of this canvas is that none of its defects

are more pronounced than any other. Composition, drawing, colour – they are all in keeping. It's like Gérôme only worse, criminal painting.

Should one be indignant? The picture hardly merits it, at least not as much as the appalling composition by M. Doré. His *Orpheus Torn Apart by the Women of Thrace*[14] is a masquerade of nudities dashed off on a piece of fairground tarpaulin. So is M. Doré going to continue to paint these unrealistic tableaux, and, with his slack colour and design, aggravate still further the tediousness of subjects that have been repeated again and again over the centuries? He has done some fantastical illustrations, amusing in their time, so why the devil does he get himself mixed up in daubing canvases? One could almost pose the same question of M. Garnier. His praying monk would have to be very desperate and on a lengthy fast to be tempted by the horribly ugly girls who torment him. Ah, the sad logic of a sad painting! How much I prefer, despite the haunting memory of Delacroix, particularly in the naked woman's breasts, the work by M. Morot: the *Battle of Aix-en-Province*. He is making progress. There's some blood and bluster in his canvas, it teems with life, and it's much superior to

Temptation by J. A. Garnier.

Battle of Aix-en-Province (detail) by Georges Morot.

his *Médéa* in the 1877 Salon.

I now recommend, as a piece of farcical light relief, M. Lesrel's *France Recovering the Corpse of Henri Regnault*,[15] and a triptych entitled *The Origin of Power: Force, Universal Suffrage, Divine Right* by M. Sergent, though at present 'the time for laughing is over', as the refrain of that jolly little ballad by Théodore de Banville[16] has it. But no, before coming to the landscapes in the exhibition, we still have to visit those manufacturers churning out naïads and nymphs. M. Jean Gigoux has joined their company this year. He has therefore come back from the dead. But why?

The Origin of Power: Force, Universal Suffrage, Divine Right by Lucien Sergent.

III

Painters always amaze me. The way in which they include the nude in the open air perplexes me. They stand or lie a woman under some trees, or in the sun, and they colour her skin as if she were stretched out on a white cloth in a curtained room, or standing in front of a hanging or against some wallpaper. But what about the play of light filtering through the branches? You see, posed there as most of their nudes are, their flesh should be speckled with dots and diamonds, formed by the shadows of the leaves; and what about the ambient air, the reflection of everything that surrounds them and the environment they're in, does all that not exist then?

I know perfectly well that you rarely see naked women under trees. It's an edifying spectacle that police regulations prohibit, but at the end of the day, it *could* happen. If it's never happened to a painter – and I suspect it hasn't – how do they have the audacity to represent it? That seems to me as monstrous as if a painter who has never set foot outside his studio were to compose, just like that, on a whim, a landscape.

I would even go further. The nude, such as painters conceive it, doesn't exist. One is naked only at certain times, under certain conditions, in certain professions; being naked is a provisional state and that's all.

I defy anyone to show me a naked woman by Rembrandt – to take an example from the ancients – who isn't simply an undressed woman, one who will put her clothes back on once the reason which made her strip comes to an end. It's true that if one is happy enough to paint only chimerical beings, such as centaurs, fauns and nereides, it's quite pointless to observe anything real whatsoever. One might as well put, or rather one should put, a wallpaper landscape or a river of spun glass behind them; that would clash less. What meaning can a real backdrop have if the subject itself is a mere convention? Let's be logical about it – at

least Boucher was, with his theatre-backdrop landscapes and his dolled-up actresses dressed as Venus or Diana. Or if you're going to say that the nude exists in a normal state, then at least give me – in a real landscape – nymphs such as they could have been, farm girls, tanned and weather-beaten by the sun and the rain. When you walk around in clearings and in woods without so much as a veil on, you don't have a soft, pale rose complexion, you don't have a massaged, pink and white body.

Now given that for painters of mythology nature and truth don't exist, let's take a look – accepting for a moment their theories – at the way these gentlemen have acquitted themselves of the task they've undertaken.

I have to start, alas, with the work of M. Bouguereau. M. Gérôme has already brought back the glacial ivory skin tones of Willem van Mieris; M. Bouguereau has done worse. In concert with M. Cabanel, he's invented a kind of gaseous painting, a puffed-up art. It's not even porcelain anymore, it's flaccid and over-polished, it's…I don't know even what it is, something like soft octopus flesh. His *Birth of Venus*, sprawling over the picture rail in one of the exhibition rooms, is of a paucity that does not have a name. The composition is the same as everyone else's. A naked woman in the

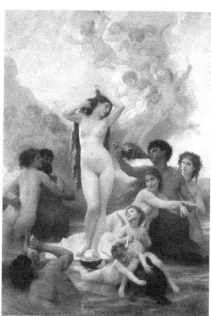

The Birth of Venus by William Bouguereau.

centre of a shell. All around, other women are frolicking about in the usual poses. The heads are banal, they are those of 'Sidonie', the mannekin you see revolving in hairdressers' windows; but what is still more distressing are their busts and their legs. Take Venus – from head to foot she's like a badly inflated balloon. No muscles, no nerves, no blood. Knees sagging, joints failing; it's a miracle of balance that this unfortunate creature can hold herself upright. A pin-prick in the chest and the whole thing would collapse. The colour is vile and the drawing is vile. It's executed like a chromolithograph advertising a box of sugared almonds; the hand of the artist has simply moved, drawing the body's undulations in a machine-like fashion. It's enough to make you howl with rage to think that this painter, who in the hierarchy of mediocrity is the master, is the head of a school, and that this school, if we don't keep a look out, will quite simply become the complete negation of art.

But there, that's enough; these miserable canvases don't deserve one's attention; so let's refresh our eyes with a little fresh flesh.

M. Roll offers it to us in abundance. I feel sympathetic to this painter. He has talent, an effortless and honest one. He is still looking to find his way, but when he discovers it, we will count him, I hope, as one more good painter. M. Roll exhibited, in 1877 I believe, a depiction of a flood which won him a medal.[17] It was a work inspired by Géricault. Since then, Jordaens appears to

The Feast of Silenus by Alfred Roll.

44

have obsessed the artist. His group of women dancing around the satyr Silenus astride a mule, is, as a calling card, reminiscent of the superb group by Carpeaux, *The Dance*.[18] It is less balanced, however, and that jars. His use of colour is not always fortunate. This is not the great lava flow of Jordaens' vermillion paint, rather it's a trickle of wine dregs. Nevertheless, even as it is, this painting reveals serious qualities. Here, there's none of that hideous smoothness and creamy flesh I spoke about earlier. It's boldly drawn with firm strokes. There's exuberance and fervour here, and it's all the better for it. Here, then, is a young painter who stirs things up and makes a noise at least. Good luck, M. Roll.

It now only remains for me to speak about *Diana Surprised* by M. Lefebvre and I'll have finished my critique of the nude. But what good does it do after all to cite these worthless things, these diluted copies of the master scumblers,[19] the various Dianas,[20] nymphs and goddesses that have been conjured up from the verses of libretto writers? It would be time wasted. Let's disencumber ourselves, then, as fast as possible, of M. Lefebvre's huge contrivance.[21] His Diana and her huntresses would make an honourable appearance

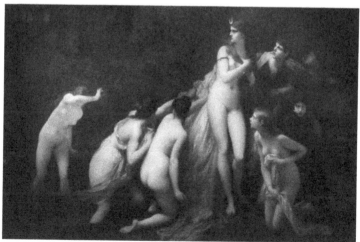

Diana Surprised by Jules Lefebvre.

on a dressing-room screen, if it were possible to reduce the disproportionate size of these monsters. Like all hollow and empty painting of this sort it's not inferior to a Bouguereau.

After 'Sidonie', we now pass on to 'Thérèse',[22] another convenient hatstand that serves to show off the various types of old headgear. Which is better? Which is worse? I don't know. Between the two, my heart can't decide. It's better to throw them both in the same sack.

Religious painting has been floundering in a rut for centuries. If we leave aside the murals done by Delacroix in Saint-Sulpice,[23] we find that a precise formula is scrupulously respected by all these workers in holy chrism. Religious painting of the present day is equal in banality to that of Byzantine painting. Having been presented with a conventional template they proceed to fill it in according to the manner of Manuel Panselinos – the Raphaël of the Byzantine period – or according to that of Paul Delaroche, Ingres, Flandrin and their ilk. They come out more or less well, with more or less the same defects, but that's it. Nor am I going to enlarge on the canvases of Messrs Merle, Matout, Papin and others; I will just point out a Virgin and the infant Jesus sleeping between the paws of a Sphinx,[24] painted in egg tempura

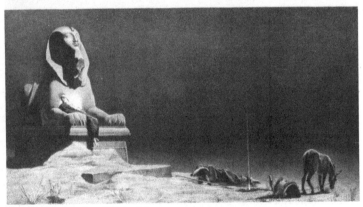

Rest in Egypt by Luc-Olivier Merson.

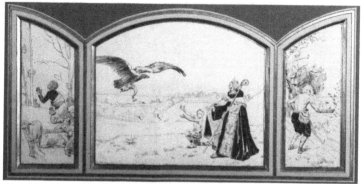

Saint Cuthbert: Triptych by Ernest Duez.

by M. Merson, as well as another tedious contrivance by the same painter, a picture by M. Debat-Ponsan of Saint Louis performing a tango dip with a corpse in an advanced stage of decomposition, and then I will simply stop in front of the triptych by M. Duez, entitled *Saint Cuthbert*.

M. Duez, who up to the present day has painted only modern scenes, has tested himself in the religious genre. He has travelled through Ghent and Bruges to do this. Wouldn't it have been better to try something new rather than just follow in the footsteps of Van Eyck and Memling? I think so, but when all's said and done, I really want to excuse M. Duez because at least he attempted something in his canvas: to the stiff and smooth painting of the Primitives he wanted to add a more expansive, more modern execution. And what's more his triptych seems to be solidly painted: the landscape is attractive; the child who holds out his arms is quite firmly grounded, as is the mitred and stoled saint. So let's pass over that particular anachronism, no doubt motivated by the desire to win a medal or gain a commission, but for pity's sake let's hope that M. Duez quickly returns to the pretty Parisiennes whose elegance he sometimes managed to capture.

By contrast, there's nothing more to be said about M. Jan van Beers, who seems to be making fun of everyone rather too extravagantly;

he formerly exhibited, in a Salon in Antwerp, an enviable canvas, a labourer on a railway track, announcing with a blast of his horn a train surging through the snow in the distance. The desolate landscape had a great impact; but ever since then it's been a case of demented colours, absurdly mad designs, a jumble of the antique and the

The Flemish Poet Jacob van Maerlandt predicts, in death, the deliverance of his homeland to Jan Breydel and Pieter de Coninck by Jan van Beers.

modern mixed up on the same canvas. His triple portrait this year is beyond a joke. Instead of heads, his gentlemen have those outrageous masks that serve as accessories at carnival balls. It's Van Eyck gone mad, it's archaism run riot.

It's necessary now to flee this courtyard of the insane and go and breathe the fresh air of the countryside. God have mercy, the landscapes are numerous – and many of them are almost good – so we should be easily able to satisfy our desires.

IV

This year, Belgium will be able to dispense with its usual fulsome praise of landscapes by Mme. Marie Collart. Her *Evening* is perfectly insignificant. Mottled and laboured, no sense of air circulating in the trees, and the cows, intended to dot some lighter colours over the whole boring canvas, seem to be cut out

of pinewood and newly varnished. *Black Gate* by M. de Knyff is hardly any better. It's a hackneyed painting, though done by a man who is not maladroit with his hands. I prefer by far *Winter's Day in Campine*,[25] by M. Coosemans. The livid sky, marbled with melancholy red, grows dark as the shadows thicken. It is painted quite vigorously and is honest. Another quite amusing painting, with its faux air of a Japanese landscape, is one by M. Den Duyts, a sulphur moon rising over a white landscape, and trees that look like those huge silver flowers with which frost galvanises windowpanes. It's a pretty piece of palette knife work with the fineness of curiously wrought lace. Still with the foreign schools one could point out a fine snow scene, *Return of the Fishermen*, by the Norwegian Frithjof Smith-Hald; a *Corner of Paris in Winter* by Wilhelm von Gegerfelt; a North-European landscape signed by the Norwegian, Frits Thaulow[26] – a sinister landscape with its clusters of ice from which black telegraph poles stick out lugubriously – and finally, *An Old Mill on the Upper Rhine* by the German painter, Hoerter. This painting is a sort of copy of Hobbéma. A contemporary painter who sees nature through the temperament of old Hobbéma? It's more than a bit strange.

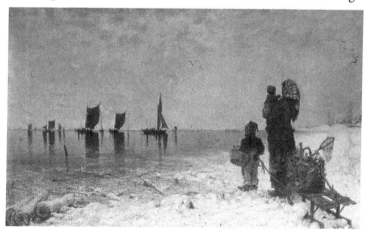

Return of the Fishermen (Norway) by Frithjof Smith-Hald.

You might as well put on a pair of buttoned knee-breeches and a peruke with a ponytail; the time difference would be less, but it would be just as ridiculous.

M. Bernier certainly isn't that bad, but his *Abandoned Path* is nothing more than the work of a good craftsman, an honest canvas but one that reveals no individuality. M. Germain Bonheur is even less original, if that's possible. He produces genre scenes like picture postcards; he's a pupil of his sister, Mlle. Rosa Bonheur, and of Gérôme – now there's something that doesn't surprise me.

M. Karl Daubigny is the pupil of his father; that's surely better. This daddy's boy is not unskilful all the same; he almost seems to brush his canvases too much, only nothing comes of it. They're pasty and heavy. They're the cut down platitudes of the father, whose talent was already very overrated. These are truths that it's good to state whenever one can. They may offend people, but it's a relief to write them down.

I pass in front of the Mesgrignys; what metallic skies, firmaments as shiny as tin-plate, pure Ommeganck! But it would be better to turn napkin rings than to polish a canvas like this until you can see your reflection in it. I'd almost be tempted to say as much to M. Michel, if his landscape didn't evoke in me, by a similarity of setting, the marvellous *Chill October* by Millais, which was resplendent in the English section of the 1878 Exposition Universelle.[27] Except that with M. Millais, the infinite distress of a dying autumn, and the great shudder of nature at the approach of storms and snow, were expressed with a sincerity and a force that was truly admirable. As for M. Michel, he expresses nothing at all, any more than does M. Rapin, whose riverbanks are heavy and lack atmosphere.

I hardly know any great landscape painters who can make you feel cheerful and carefree in front of their canvases. Théodore Rousseau, Jean-François Millet, Constable and, taking one from the old school, Ruisdael, painted landscapes from which a

melancholy grandeur emerged. One could say that the beauty of a landscape is above all made of melancholy. After the masters I've just cited and among the contemporary painters, M. Guillemet is undoubtedly one of those who have best understood the penetrating sadness that falls from overcast and cloudy skies. A pang of anguish even seizes you in front of *Chaos in Villers*, exhibited high up on the picture rail this year. As in his *Environs of Artemare*, which attracted attention at the Salon in 1877, a tempestuous sky roils, swollen with rain, while, whipped by the gusts, a woman walks with difficulty, carrying her load of wood.

Nevertheless, I prefer this year's painting, which seems to me even more assured. The cluster of bushes, twisted by a blast of wind above a very pale green sea breaking beneath the grassy hillocks, has a great impact. Added to which the clouds, a little too massive in *Environs of Artemare*, and especially in *Cliffs of Dieppe*, which was exhibited in the same year, are this time lighter. They envelop an edgy landscape buffeted by great blasts. This simple and robust work, brushed with a surety of hand that at certain moments recalls that of Courbet and Vollon, is

Chill October by John Everett Millais.

astonishing in a period of finicky painting.

M. Léon Flahaut has also exhibited some consistent painting this year. Under a sky streaked with crimson gleams and reflected in a blood-red pond, some sheep wander back to a thatched cottage. It is poignant and done with a sure touch.

I can't say as much for the paintings of Messrs Harpignies and Herpin. Their views of Paris are mediocre. Indeed, what's most remarkable about *The Flore Pavillion, View from the Pont Neuf* signed by the first of these artists, is the two white bow-wows dolled up in their pink and blue ribbons, which are standing on their hind legs as if to attention. It's enough to make sensitive souls swoon. And how badly the soldiers who figure in this canvas are drawn. This is what good-for-nothing children scribble on their schoolbooks! And if M. Harpignies took a little effort to observe the nature he paints, he would see that the trees growing in Paris are not the same as those growing in the countryside. M. Harpignies paints the trees that border the Seine as he would the trees in the forests of Sénart or Fontainebleau. It's wrong! Parisian vegetation is weaker, it doesn't have powerful country sap, it's scrawny and sickly; it's fortunate for us that M. Harpignies isn't a portraitist, because he'd probably paint rustic women and Parisiennes in the same stiff, academic manner. M. Harpignies certainly is an amazing painter.

What to say now about *The Old Port of Marseilles in December* by M. Mols? To think that the author of this painting is the same man who previously pulled off, in a nice range of pale greys, a great view of the port of Antwerp. Another fine piece of mediocrity is a landscape by M. Hanoteau, entitled *The Victim of Christmas Eve*. The pig, gutted and hung, which should have thrown a red note into the painter's dull green palette, doesn't sound any note at all; it's boring and banal. I prefer *The Old Well* by M. Pelouse, with its leaves of copper and rust, and its bit of sky padded with small clouds of lilac and gold. The woman pouring

water into a pot is solidly posed, and the sunlight illuminating the feathers of the chickens flames merrily. It's one of those last fine days of autumn that precede bleak mornings soaked by drizzle. It is rather seductive and handsomely painted.

Bercy during the floods tempted M. Luigi Loir, and he has happily seized on its anxious and distressing aspect. Why the devil, then, did M. Loir think it necessary to draw the attention of the public to it by adding portraits of well known people – too well known – who all happen to be going for a walk at the same time in the same area?[28] It's really unnecessary, and the faces of these cartoonists and ham actors are irritating, like something added as an afterthought – it clumsily spoils the general impression. However that may be, this interesting canvas has a hint of modernism. Here then, finally, is a painter who sees and who loves Paris!

At least M. Yon hasn't had to travel far from the city in order to bring us a good landscape. He's simply installed himself on the banks of the Marne at Montigny, and there, beneath an unsettled sky, he's painted the river growing darker as it reflects the expanse of clouds. His picture is painted in broad strokes, without affectation or hesitation.

Bercy During the Floods by Luigi Loir.

It now only remains for us to review some painters of seascapes. It'll be quickly done. M. Clays continues to dilute his talent more and more; his usual lapping sea gets more solid each year. M. Lansyer seems to be currently working in paints made from china clay, and, next to M. Le Sénéshal, whose cliffs appear to be covered with shagreen, M. Masure gives us a horizon tattooed by smudges of rogue colour playing over an agitated sea. After having cast a quick glance at two panels by M. Lepic, who has packed away his usual tones of lead grey and ash, and at a canvas by M. Ulysse Butin, which is straightforwardly arranged, we will stop in front of some returning fishing boats by M. Mesdag.

The sea, seen from a similar height as in Manet's *The Battle of the Kearsarge and the Alabama*, seems to wet the gilt frame with its bluey-green waves. In the centre, a boat dances, while others are seen in profile in the distance. It's very confidently executed. His *Fish Market at Groningen in the Winter* – with its houses with their roofs stepped like the teeth of a saw and their tiny, leek-green shutters – is amusing, but it's a little thin and a little dry.

All in all this poor, sad Salon contains, like those of previous years, a mass of adequately painted landscapes. Due to lack of space, I can frame only a feeble part of them in these odds and ends of sentences. I will add, however, before closing this section, that some foolhardy painters have exhibited curious specimens of historical landscapes.[29] These are, obviously, pathological cases, diseases of the eye and cerebellum. Eye lotions and cold showers is all that a benevolent critic can wish them.

Return of the Fishermen by Hendrick Willem Mesdag.

V

We have finally arrived at the painters of modernity. First of all let me quote an unpublished document about contemporary life. After that, we can just walk around.

A few years ago, a foreign artist, strolling with M. de Neuville through the rooms of an official exhibition of paintings, met Eugène Fromentin. M. de Neuville left and a conversation began between the two friends on the subject of 'Modernism'.

A listener took down in shorthand the very curious words that now follow:

'You annoy me with your modernity,' exclaimed Fromentin. 'Obviously you must paint your own time, I know that, but you must render the material aspects, its decor, its personalities, and above all, you must render its habits and its emotions – not just its costumes and accessories. Those things play only a secondary role. You'll never persuade me that a young woman in a blue dress reading a letter, or a lady in a pink dress looking at her fan, or a girl in a white dress raising her hand to the sky to see if it's raining, constitute genuinely interesting facets of modern life. Ten photographs from an album would give me the same amount of modernity as that, insofar as the young woman, the lady and the girl are not *captured in the act*, but have been lured into the artist's studio by a fee of a hundred sous per session in order to dress up in the aforementioned dresses and represent modern life. It's as if I were to take a seller of dates from the Rue de Rivoli, put a chibouk in his hands and then paint an Algerian scene using this Tunisian Jew. It's as stupid as that. Where is the modern life in all these paintings which a couturier like Charles Worth[30] could have painted, if he'd had the temperament of a painter?

'Ah, life…life! There's a whole world out there, it laughs, shouts, suffers, has fun, and they don't capture it! Me, I was a contemplative man and I travelled to the East, to those great,

tranquil countries where life is primitive. *If I had to live my life over again, perhaps I would do it differently*; but ultimately I managed to render its appearances and its passions, the final grandeur of a disappearing race which was still of my time; I didn't spend my life painting inert matter.'

Then, after a few minutes silence, Fromentin continued: 'I'm not trying to say that you need to have a lot of spirit, but to be able to see the *spirit of things*, which is immense and flows from all of nature like water flows from a fountain; but look how stupid these so-called painters of modernity are! I was with one of them a week ago. Enter, with a snotty-nosed kid conceived backstage at La Reine Blanche,[31] a little girl of twenty, a knowing look about her and as pretty as anything with a penny's worth of black powder under her eyes. Enough to make a mystic fall into a trance. The painter has her cleaned up, takes the kid into a corner, throws a beautiful velvet dress on this tart, puts a trinket in her paws, and this harlot, so pretty to paint as a harlot, becomes a fine lady looking at some curio! Modernity, my young friend, modernity! If you want to paint a lady, you have to go to a real lady!'

I have almost nothing to add to the preceding observations. No, the modern painter is not simply an excellent 'couturier', as are, unfortunately, the majority of those who wrap their mannekins in a variety of silks under the pretext of modernity; no, it doesn't make it contemporary by renting a model who is indiscriminately used to personify the finest lady and the lowest whore – and it's from this point of view especially that the talented Impressionists are, in my opinion, superior to the painters who exhibit at the official Salon. They go further into the individual they are representing, and if they express outward appearances marvellously, they also know how to make their subjects exude the aroma of the environment to which they belong. The whore smells like a whore and the society woman smells like a society woman; so when it comes to it, there's no need to represent the

chaste Penelope and the courtesan Phryne, as the late Charles Marchal did, with one sewing in a modest grey dress, and the other displaying the bulge of her breasts in a brutally low-cut, black velvet evening dress.[32] A man of talent could have had them both dressed by a designer of renown, and we would still have recognised the two different women under the same apparel.

Take a painting by M. Degas, for example, and see if he's limited to being an excellent 'modiste', see if – aside from his great skill in rendering fabrics – he can't set on her feet a living creature whose face, expression and gestures speak and say what she is. He paints dancers. All are real dancers and all differ in their way of practising a similar exercise. The characteristic of each one stands out, the nervousness of the girl who is gifted with instinctive pirouettes and who will become a star, can be seen even in the midst of this troupe of female athletes who are supposed to be able to earn their living by the force of their legs alone. Such as it is – and particularly such as it will be – Impressionist art reveals a very curious gift for observation, a very particular and very profound analysis of temperament in action. Add to this an astonishingly just vision of colour, a contempt for centuries old conventions in order to render such and such an effect of light, a study – conducted in the open air – of real tones, of life in movement, a technique of broad strokes, of shadows obtained through complementary colours, the pursuit of a general effect simply achieved, and you have the features of this art of which M. Manet (who now actually exhibits in the annual Salons) has been one of the most ardent promoters.

This year, M. Manet has had both his canvases accepted. The first, entitled *In the Conservatory*, represents a woman sitting on a green bench, listening to a man leaning on the backrest of this bench. On all sides, huge plants, and on the left, pink flowers. The woman, a little stiff and daydreamy, is wearing a dress that seems to have been done with large brush strokes and at speed – yes,

indeed, go and look at it – and the execution of which is superb; the man, hatless, with rays of light playing on his forehead with its sparse curls, and falling on his hand, boldly sketched in a few strokes, holding a cigar. Posed like this, lost in talk, the figure of the girl is truly beautiful: she flirts and is alive. The air circulates, the figures stand out marvellously from the green envelope that surrounds them. Here is a very attractive modern work, a struggle undertaken and won against all the conventional things that are taught about sunlight but which are never observed in nature.

His other canvas, *On the Boat*, is also curious. Its very blue water continues to exasperate a number of people. Water doesn't have this hue, they say. But pardon me, it does at certain times, just as it has tones of green and grey, or tints of scabious, chamois and slate at certain others. One just has to take the decision to look around. And this is one of the great mistakes of contemporary landscape artists who, arriving in front of a river with their method decided in advance, fail to establish the necessary relationship that nature always establishes between the river, the sky that's reflected in

In the Conservatory by Édouard Manet.

it, the setting of the banks that border it, and the hour and the season that exist at the moment the artist is painting. M. Manet has never, thank God, known these prejudices, which are stupidly maintained in art schools. To summarise, he paints nature such as it is and such as he sees it. His woman, dressed in blue, seated in a boat cut off by the picture frame, as in certain Japanese illustrations, is well posed, in full sunlight, and she stands out forcefully, in the same way that the rower dressed in white, stands out against the stark blue of the water. These are paintings the like of which, alas, we rarely find in this tiresome Salon.

Let us pass now to the work of M. Gervex. He has escaped from the sweatshop of that all-too-famous patissier of the fine arts, M. Cabanel. Usually, the sous-chefs trained by this gentleman bring to market confections that are identical to those their head chef cooks up. But M. Gervex handed back his apron as soon as he could and began to mix up his dough following his own recipe.

Among the young, M. Gervex was undoubtedly the one who inspired the most hope. His paintings revealed an undeniable talent. I have only to mention his *Autopsy at the Hôtel-Dieu*, so finely observed, his *Communion at the Church of the Trinity* and his *Rolla*. However, I like much less his *Return from the Ball* of this year, though it's still one of the least bad canvases hung on the hooks of this Temple of offcuts. The scene is posed as follows: a gentleman in a black suit is sitting and leaning forward. He has just uttered, to the woman crying with her nose in her arm, all those furious platitudes that have been trotted out by men for centuries and that have only ever served to confirm the power she has over him and the certain abuse she's going to make of it. The gentleman removes his glove with a nervous gesture. His anger is completely captured in this gesture.[33] The idea was ingenious, but the overly emphatic attitude of the woman spoils it all; added to which, the lamplight on the fabrics and the faces is inaccurate. How much more original, more true, was the canvas dealing with

Return from the Ball by Henri Gervex.

an almost identical subject exhibited in 1878 by Edward Gregory, in the English section of the Exposition Universelle.

We find ourselves back with M. Gervex for an open air portrait of a woman. But we have to leave, because time is short and we must now give an account as quickly as possible of *October: Gathering Potatoes* by M. Bastien-Lepage, *Under the Olive Trees* by M. Lahaye, two canvases by M. Raffaëlli, and paintings by Herkomer, de La Hoese, Béraud, Goeneutte and de Jonghe.

VI

M. Bastien-Lepage is a painter of prodigious skill who knows his trade down to his fingertips. *October: Gathering Potatoes* is a good repetition of *Hay Making*, his painting from last year. M. Lepage has taken his peasant woman, but instead of sitting her face on he has her in profile, filling a sack of potatoes. As always, its beautiful qualities make one marvel; it's just that even though I recognise the artist's very real ability, I don't find in his work any sign of

that authority that makes a master. It's skilfully composed, it has the air of being almost deftly painted, it's boastfulness is too mild to accuse it of bravura, but despite everything, I detect in it the preciosity of a meretricious style, its progressive march has been interrupted and astutely halted in order not to displease the public. M. Lepage is a prudent rebel; the platonic Pole[34] of the fine arts.

In *October: Gathering Potatoes* as in *Making Hay*, M. Lepage had the obvious ambition to be simple and to be noble. This is a painter haunted by Jean-François Millet. I'm certainly not going to censure him for it because Millet was a robust artist. It's just that the magnificently true aspect this master captured in his country peasants isn't found here.

To be honest, M. Lepage's frankness and naïvety seem to me to be too obviously feigned; I doubt that he feels a very sincere emotion in front of the poor people he's painting; in any event, he doesn't communicate any to us. Millet was an honest artist;

October: Gathering Potatoes by Jules Bastien-Lepage.

View of the Market by Jean Beraud.

after his death M. Jules Breton began to play the role of 'the worthy peasant of painting'. M. Lepage has gone one further, he is currently playing it with full orchestral accompaniment.

Moreover, it has to be admitted his painting this year testifies to some strange failings. The model is lethargic and the air rarefied. The hands of his peasant aren't the hands of a woman who delves in mud, they're the hands of my maid who dusts as little as possible and who barely even does the washing up. The public will undoubtedly be grateful to M. Lepage to have thus concealed the truth and to have put a little makeup on her skin. But for me, it's an overly polite and well-bred painting, got up by a sly fellow-traveller of modernism.

M. Lepage has been followed in this path by a pupil of Léon Bonnat's, M. Béraud. This artist, who began like everyone else by confecting a little classical study, *Léda*,[35] quickly refreshed his sights and confined himself to painting what he'd experienced, in *Returning from a Funeral*, in *Leaving Mass at Saint-Philippe-du-Roule*, and in *A Fashionable Party*. This last canvas, exhibited in 1878, was interesting. The difficulty of rendering the appearance of

a drawing room, with the flood of light on dresses, on black suits and on female flesh, was formidable.

M. Béraud didn't quite pull it off, but even so, given the technique he was using it was astonishing, especially under the gaslight of the window display in which the painting was exhibited in the evening. There were parts that were very well done, in spite of the poses adopted by the men and the mechanical stiffness of the majority of his women. This year, too, we find some good qualities in his *Condolences*. The effect of light filtered by black draperies, and the street which stretches into the distance in a flood of daylight, are almost perfect. The men, who line up and come to shake hands with the relatives, are well observed and briskly sketched; on the other hand, I have little appreciation – oh, very little – for his *View of the Market*. Under a glare of oxyhydric light, blobs of bright colour spread out. It's garish and arid; these are figurines turned out by machine; these are violently illuminated images of fashion; beware, beware, the ditch in which M. Firmin-Girard is floundering isn't far away!

I really hope that M. Béraud won't fall in. I would be sorry, for my part, because in this period when they only award medals to the disgustingly old-fashioned, Naturalists have so few painters to support. I make the same wish for M. Goeneutte. His *Call for Sweepers in Front of the Opera*, exhibited in 1877, was vaguely daring; but this year, he is stark and dry; his *The Last Salute* contains nice bits – there are some well observed tones, those of a ray of

The Last Salute by Norbert Goeneutte.

light on a white wall, among others – but the ensemble is crude and the details blurred. His passersby hardly move, any more than M. Béraud's market purchasers haggle. Rather than this canvas I prefer one entitled *The Dressmaker*, which was exhibited in the boulevard, even though his women, too uniformly large, were somewhat crammed into the modiste's salon.

Another painter, really modern this time and one who, moreover, is a powerful artist, is M. Raffaëlli. His two canvases this year are absolutely excellent. The first represents the return of some ragpickers. It is twilight. In one of those melancholy landscapes that stretch out around poor Paris, factory chimneys spit puffs of soot into a livid sky. Three ragmen are returning to their lodgings, accompanied by their dogs. Two dawdle laboriously, willow baskets on their backs and their hooks in their hands; the third precedes them, bent under the weight of a sack.

I've seen few paintings in the Salon that have so painfully and also delightfully moved me. M. Raffaëlli evoked in me the sad charm of ramshackle huts, of frail poplars sticking up along those interminable roads that lose themselves in the horizon after leaving the ramparts of the city. Standing in front of these unfortunates, who make their exhausted way amid this marvellous and terrible landscape, all the distress of the old suburbs rose up before me. Here, then, finally, is a work that is truly beautiful and truly great.

Return of the Ragpickers by Jean-François Raffaëlli.

The other painting represents two old men, their hands numbed, cracked and blackened by their crushing jobs. They hold each other by the arm, and they slowly advance towards us, dressed in rags, capped in rabbit-skin hats, revealing honest swarthy faces and bushy grey eyebrows, beneath which dart the fine spark of still alert eyes. Look at them; they move and they live. It requires a certain amount of courage to represent, just as they are without embellishment or cleaning, these two good men worn down by poverty, whose desires are now limited to a cheap glass of wine.

As examples of very powerful and very confident painting, done by a man of incontestable talent, I recommend these two canvases. Naturally, they are placed high up in the gods, whereas dreadful daubs, abominable butcher-shop signs and scenes of hunts passing beneath castle keeps, encumber the first circle and the stalls.[36] M. Raffaëlli has won neither medal nor mention – well, so much the better, it revives our hatred of juries and of the Academy of Fine Art. There are too many injustices like this; too many medals awarded to the producers of ludicrous old saints, of Jeromes done at a hundred sous a pose, of wooden Christs beseeched by leaden soldiers of the guard, of mediocre history paintings like the Girondins, and too many newspapers that consent to promote them; one day we'll end up demolishing these official dispensaries, where every year they hand out certificates and assistance only to those craftsmen who best fulfil the great aim of French art: Don't make it live and don't make it true!

VII

M. Bastien-Lepage, with his *Making Hay* of last year, has evidently inspired the idea of M. Lahaye's painting *Under the Olive Trees*; though M. Lahaye has arranged it in such a fashion that, despite everything, his work remains very personal.

Under some olive trees, a woman dressed in pearl-grey, with a blue scarf wrapped around her neck and seductive blue stockings in shoes matching the dress, laughs openly at the idle stories told by a gentleman stretched out behind her, smoking a cigarette. A little further away, a painter in a pointy straw hat sketches the scene with his back towards us, the whole thing is painted in deliciously fine tones – a range of pale silvers, milky greens, discreet blues and greys. The face of the man lying down is alive and unaffected; one feels that this fellow is at his ease, that he's 'made his place in the grass', as they say. The woman is charming with her pretty laugh and her sensitive, fresh skin, and the painter, seated on his folding stool, has a surprisingly realistic posture.

M. Lahaye has obtained neither medal, nor mention. There, that'll teach him to have talent. Let's hope it's a lesson that won't be useful to him!

I could say as much about the Belgian, M. de La Hoese. His painting has certainly provoked many criticisms, but in the end it's amusing and interesting. He, too, has dispensed with the notion of gathering together within a gilt frame those clowns of ancient Olympus, Juno, Minerva and all the other ham actors out of old Homer; instead, he presents us quite simply with a dressmaker's workshop. And my God these dressmakers interest us more, with their keen faces and their short dresses erotically tight at the hips, than all those Greek murderesses wrapped in fabrics that turn their long legs into boring tubes.

M. de La Hoese's workers are sitting around a table and they thread needles and sew. One of them has collapsed on the floor and bruised her arm, which she rubs piteously, while the broken chair lies, its legs splayed, in the middle of the rags and offcuts. The whole workshop is laughing and making fun of the clumsy girl. It's here that I really have some criticisms to make. If, among these girls, two or three are laughing genuinely and good-naturedly, such as the plump one with the turned-up nose and the girl who

is giggling with her face in her handkerchief, the others grimace and hold their sides unnaturally, descending into caricature. The apprentice in the foreground, to mention just one, looks as if she's been petrified alive. She's a mechanical doll that bows and whose jaw only opens when you pull the string that makes it move. The mistress, who's turning round at the noise and looking at the scene under her glasses, is equally conventional; nevertheless, such as it is, this workshop, dimly lit by daylight, is amusing.

The observation is often just, the poses are sometimes felicitous: that of the redhead gathering up her scissors and her thimble, for example, or that of the woman seated next to the fat pug-nosed girl who is holding her sides. The depiction of Belgian types is precise: the blonde hair turning to straw yellow is right, that's really the fair colour of most young girls in Antwerp. All in all, there is in this canvas a mixture of truth and invention, a certainty of gesture and a tendency to push delight or mockery too far. Its style is generally too sentimental, but with a rousing coquettery of colours here and there.

To sum up, M. de La Hoese's attempt deserves to be encouraged. He is advancing; we wish him good success.

No further encouragement needs to be offered to M. Herkomer, nor success to be wished for him. He has made it, thank God, and is now well known. His *The Last Muster: Chelsea Pensioners in Church*, exhibited in the English section of the Champ de Mars,[37] made him famous overnight in France. His canvas this year, *Old Age: A Study in Westminster Union*, crushes everything around it. The left part of the painting – comprising the corner of the room lit by the window, two old women supporting each other as they walk, and some thin silhouettes of women that can just be made out, hunched in front of a fire like Villon's old women nostalgic for the old days – is quite simply admirable. On the other hand, I like less the whole of the right side, in which, sitting around a table, more women drink their

Old Age: A Study in Westminster Union by Hubert von Herkomer.

coffee and sew. Admittedly, the unfortunate who is sleeping, a book on her knees, is superb, but amid this workhouse of poor, wizened women, their skin wrinkled like reinette apples and their cheeks glowing from the charitable warmth of coffee and ale, the woman who scratches at the table and the one straining to thread her needle, spoil the beautiful whole of the work for me, with their grimaces and their hint of comicality.

A curious fact to note is that the impression given by this workhouse scene is neither as painful, nor as sinister, as that which would emanate from the dens housing the misery of female old age in France. The English asylum, as M. Herkomer represents it, has a sort of resigned, smiling sadness. There's even a certain joyfulness scattered about this place of suffering. The poor women sip gently, and appear willing to accept the work that a young under-mistress distributes to them. Just to highlight the difference: represent in a realistic painting one of the rooms of the Salpêtrière in Paris, it would be poignant and mournful. Here, one would feel more of humanity howling in its poor bones, amid spasms of laughter prompted by the cruel jokes of other inmates. From this point of view, I might even suspect M. Herkomer's

veracity a bit if M. Taine, in his *Notes on England*, hadn't affirmed that in the workhouse 'all the old women seemed to be alright, and don't appear sad'.[38]

In any event, whether embellished or strictly exact, this canvas is marvellously painted and one detects in it the hand of a proud artist.

As for M. Dagnan-Bouveret, he limits himself to being facetious. Last year the jury awarded a medal for his undistinguished *Manon Lescaut*. They thus encouraged him, they duly showed him – and by a generally irresistible argument – that he was following the right path, the only one that brings in commissions and honours – and yet here he is now laughing in the face of the people who'd patted him on the back; he has suddenly broken his tether and is exhibiting a modern canvas: *A Wedding at the Photographer's*.

Because of the pleasure it gives me to see M. Dagnan cock a snook to his academic professors, I wouldn't like to mislead people who really want to follow me in this quick race through the Salon about the real value of this canvas. I acknowledge first of all that it is poorly painted, and what's more I still slightly distrust M. Dagnan's conversion. A couple of years ago he exhibited a small picture of Orpheus, inspired by some astonishingly mediocre verses, which convicts this painter of an unpardonable bad taste in painting, as well as in poetry.

Fortunately, M. Dagnan stopped himself on this slippery slope,

Manon Lescaut by Pascal Dagnan-Bouveret.

and we must be grateful to him at least for that. His painting this year, whose subject does not appear to me to have been provided by any poet, contains a

A Wedding at the Photographer's by Pascal Dagnan-Bouveret.

few bits that are cheerfully executed. The man blowing his pipe smoke into the face of a child is rather funny; the wedding couple are not bad, the husband especially with his braggart air and his curly hair like a cauliflower; it's just that the comic line is overstepped almost everywhere. Not that it's gross farce or bawdy, rather it's artist studio in-jokes and the spirit of vaudeville. The diminutive soldier, who reveals himself only by a glimpse of his spread fingers in white gloves, is a tired cliché;[39] and finally, if the married couple are posing in front of the photographer's lens, the other people at the wedding are also posing – but for the public. They are gathered in a group that is too artificially arranged for us to believe in it as a real life scene, hastily captured by an artist.

The painting thus has a banal flavour. I like it better – this goes without saying – than all the Lobrichons and all the Compte-Calixs of this world, but then anything is preferable to the expanses of canvas daubed by those two gentlemen; it's just that between the work of M. Dagnan and that of M. Herkomer, which I spoke about above, there's a terrible difference, the

difference that exists between a work of art and a topical sketch in an illustrated newspaper. My admiration for *A Wedding at the Photographer's* stops there.

VIII

I've arrived now at the painters of contemporary fabrics, at the tailors and dyers, so to speak. If Fromentin's theory, which I quoted in an earlier section, can apply to a single painter, it is undoubtedly to M. de Jonghe. Ah, to be a couturier and nothing but a couturier, one who clothes his working-class models in robes of a distinguished cut and nuance in order to represent in this garb the elegance and refinement of a society lady – such a one is M. de Jonghe, and, moreover, one of the most persevering and most stubborn!

Indiscretion is almost a masterpiece of the genre. In a drawing room hung with one of those gold Japanese fabrics M. Stevens has so often painted, a society woman, very high society I think, is about to rifle through a drawer in a piece of Japanese furniture, on top of which is a monstrous green and red dragon. The wallpaper and the dragon are dextrously posed, but the woman

Indiscretion by Gustave de Jonghe.

is needlessly silly; she has that expression and gesture that represent guilty uncertainty and a barely contained sense of shame, as demanded by the invariable tradition of the academy. She is an uninteresting puppet who plays only an accessory role in this canvas. The principal subject is the decoration of the furniture and the black dress with its white point lace.

M. de Jonghe's other painting didn't put me in a good mood either. A young girl, blonde and dressed in mauve, languidly massacres Chopin's *Lullaby* on a piano, to the stupefied satisfaction of a mother in a blue dress who is seated on a red velvet armchair and adorned with another child. The style is identical. Here, the Japanese decor is relieved by the medieval point lace of the baby's shawl. All the curios, all the fabrics, are carefully copied. M. de Jonghe is a skilful painter of still life, but he is perfectly incapable of rendering living nature. His modernism is limited to the reproduction of inanimate objects; his elegance goes no deeper than a decorative blue flowerpot – the flower that stands in it is artificial, cropped out of paper by a machine. It's better than a Toulmouche, but it's neither more modern, nor more alive.

M. Frans Verhas[40] forms part of the same school. He hasn't the power, any more than M. de Jonghe has, to knead the flesh of girl or woman into life. His little paintings are hollow, overrun by a mass of little objects that have a value equal to that of his characters; they are, moreover, overworked and prissy, even, to be honest, a bit childish.

M. Ballavoine, who is also a 'couturier', at least has a pretty decorative aspect and an agreeable assortment of fresh colours. His *The Shoot* of this year is painted, as always, with redcurrant juice and whey. His women are frigid, but their violet, dead-leaf brown and pearl-grey dresses make for entertaining splotches in the bright, luminous landscapes he excels at. It's a pleasant sort of painting, diverting to contemplate on days of rain and snow.

M. Boldini is more interesting. He has the microscopic

The Dispatch by Giovanni Boldini.

focus of a Meissonier, and the agile brush of a Fortuny. His municipal horse guard giving a sealed dispatch to a concierge is a little shimmery, with its dabbed brush strokes, but there is in this little painting[41] a devilish edginess, a rapidity of movement that is astonishing. In the street, seen slightly askew, the gentleman speaking to a lady was no doubt rapidly captured in a sketchbook and then transferred straight to the canvas. M. Boldini is truly more than a 'couturier'.

We have now arrived in front of the artists who have pretensions to wit, the vaudevillistes, the imitators of the Dusseldorf school.[42] Let's leave. It goes without saying that in every corner of these interminable rooms we will inevitably find pretentious and pathetic daubs, among them a ragpicker by M. Forcade, who puts spectacles on the man's nose and reflects him in a mirror. What a charming conceit, what wit! Knaus, whose work I hate, is a painter of genius compared to all these men.

But I could have turned cartwheels for joy in front of those miserable canvases after contemplating Mlle. Elisa Koch's *Little Caprice*, a child sulking because she only has one sock. It's a piece of female wit this time. It only has to be endured one day a year, the day of the private view, and it's still too much.

Equally, what can one say about topical painting, like *The Peacemakers of San Stefano*, signed by the American artist, Francis Davis Millet?[43] A Russian offering a match to his enemy who wants to light a cigarette. It's all very nice, it's new as an idea and it goes beyond our human experience. So on that score why not include something by Antoine Wiertz, the mad Belgian, while they're at it![44] But it's really time to occupy ourselves

Little Caprice by Elisa Koch.

with more serious work; and so, as quickly as possible, we will arrive in front of *A Box at the Theatre des Italiens* by Mme. Eva Gonzalès.

This artist presents us with a gentleman and a lady in the red cage of a theatre box. It's a little muddy and the colour is sombre, but there are excellent parts. The pose of the figures is natural, and what's more it's boldly painted. This canvas, derived from Manet, has a certain rough and bitter flavour we find consoling after the nauseatingly sugary confections we've just tasted. It is, in short, a work that possesses attractive qualities, despite its unpleasant hue.

I will leave aside now *The Burial of the Mayor*, by M. Denneulin. His pompous gentlemen and his rustic peasants are caricatures. They belong to that low level of art that M. Léonce Petit professes in the illustrated newspapers.

Amid this disaster of canvases, *Sermon*, by M. La Boulaye, seems to be painted in a manly fashion; his peasant women telling their rosaries are a bit weak, posed at so much per sitting in attitudes of ecstasy and prayer, but the peasant reading his prayerbook prays plainly and simply. Thanks to this canvas M. La Boulaye obtained a medal of the third class. It is certain that,

out of those that have been awarded this year, his at least has a semblance of justification.

An Arrest in Picardie by M. Hugo Salmson is also an honest painting: one contemplates it without joy, but also without disgust or hatred.

Among those who have a reputation for supposedly being modern we have reviewed the 'couturiers' and the 'vaudevillians', but it still remains for us to give an account of the 'weepies'. Let us enter, then, the café-concert of art – in any case, we won't be staying there long.

M. Haquette is one of the foremost of these sentimental tearjerkers.[45] He has gone one further than Henri Murger,[46] by showing us his Francine sweating buckets in one of her fevers. This is a quite astonishing work. Francine whimpers very dolefully, two hands inserted in her muff, in a pose that doesn't at all resemble – that goes without saying! – that of a well-known painting signed 'Jacquet',[47] and unfortunately popularised through photography and engraving.

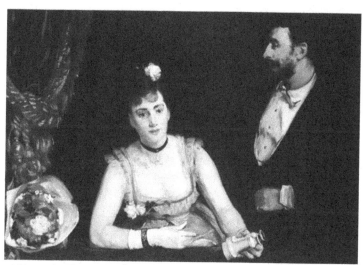

A Box at the Theatre des Italiens by Eva Gonzalès.

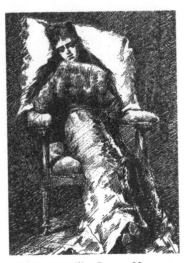

The Sermon by Paul de La Boulaye. *Francine's Muff* by Georges Haquette.

I don't know if, on Sundays, tenderhearted families will dab their eyes in front of this consumptive mannequin, but what is quite certain is that among the people who frittered their time away at the exhibition during weekdays, any emotion was translated only into a simple shrug of the shoulders. I've cited *Francine's Muff* as one of the most characteristic products of this sentimental art that plagues us, but I could also cite *Abandoned*, by M. Geoffroy. This woman, dressed in mourning, cries into the darkness, seated in an upholstered armchair. It's simple and in good taste, and like the canvas by M. Haquette, painted in a weak and woolly fashion. It is only just to add that happy scenes, no less than weepy ones, are also retailed on this stage where the so-called 'principal singers' of art are piled high.

Among them, I will point out M. Amable Pinta (for his cage of monkeys), M. Jules Saintin, and M. Simon Durand (for his *Fire Alarm*), all of whom paint in a manner that is both flabby and sour at the same time; and M. Innocenti, who found this spiritual title, *The White Note* for the following scene: a young

girl, dressed as I don't know what, plays a harpsichord. She taps on a white key while a young man, kissing her on the lips, points to the note!!

There are truly limits to a man's courage. I admit to being at the end of my tether. This heap of crack-brained nonsense, which I've nevertheless got to give an account of, would wear out the tolerance of the most resolute, and the patience of the most robust. Fortunately, the portraits will compensate us a little.

As a simulacrum of the 'grand manner', Bonnat's portrait of Victor Hugo is a masterpiece. It is laboriously and clumsily painted, with an aggravating affectation of profundity. It's the most incredible faking and counterfeiting of true talent one could wish to see. The lighting is, as usual, mad. It's neither daylight, nor twilight, nor arc-light,[48] it's a bit vinous and grimy, like light passing through misty windowpanes that are full of dust. M. Bonnat achieves his trompe-l'oeil effect by highlighting livid flesh against blackness. The pose itself is banal, the elbow leaning on a volume of Homer gives some idea of the painter's wit. This painting might not represent Hugo, but it does represent

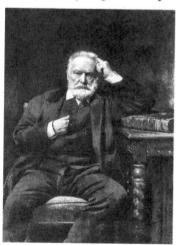

Victor Hugo by Léon Bonnat.

someone, more particularly someone who has just got up after having eaten a copious meal the night before.

As for his *Portrait of Miss Mary S.*, in blue on a brown background, it is a trite and frigid painting.

Such are the new works exhibited by M. Bonnat, and yet, in comparison to the other portraits that spread out shamelessly over the walls of the rooms, I end up thinking

Jeanne Samary by Louise Abbema.　*Jeanne Samary* by Auguste Renoir.

that M. Bonnat's success is almost deserved; M. Bonnat is a genius and a god next to Messrs Cabanel and Dubufe. Ah, it has to be admitted, portrait painters put the critic in an odd situation.

I make an exception of M. Bartholomé. He is a forthright artist, an energetic painter, enamoured with reality and reproducing it with a very particular emphasis. His old smiling lady, a book in one hand and glasses in the other, is a decent woman vividly captured. The banal yellow curtain she's pushing back doesn't particularly please me, but on the other hand the sincerity of the pose, the bravura of the execution, and the powerful sense of truthfulness the canvas exudes have absolutely won me over. I could say as much for his portrait of an old man sitting on a bench. It's taken from life, it's Naturalist art in every respect.

Mlle. Abbéma is less enamoured of understated tones and simple phrases; she is more turbulent, she's mad about strokes of colour and dumps them down with astonishing vigour for a woman who has spent time, like almost all her peers, in M. Chaplin's studio. Her two portraits this year are good. That of *Madame ****, emerging in black from a caulk and tobacco

brown background, has rather nervous brushwork. The black of the dress, the yellow of the rose, the white of the suede gloves on which a bracelet in the form of a golden snake is curled, point her out as a pupil of that 'couturier' who goes by the name of Carolus-Duran. I even prefer this portrait to her one of Jeanne Samary[49] standing in a grey dress and violet scarf against a dark green background. Nevertheless, the frizzy blonde hair, curly as a poodle's and falling like rain over the forehead, and the painted lips, highlighted by the pretty white gleam of the teeth, are neatly done. The eternal, unbearable laughter of the actress is well captured; we find her again, still laughing but dressed in pink this time, in a canvas by M. Renoir that is unaccountably placed so high on the upper rail (which serves as one of the Salon's dumping grounds) that it's absolutely impossible to give an account of the effect the painter wanted to achieve. They might as well line the ceilings with canvases while they're at it.

Madame Georges Charpentier and her Children by Auguste Renoir.

His other painting, on the other hand, is placed really low down. M. Renoir thought it more worthwhile to represent Madame Charpentier[50] at home, with her children, in the middle of her normal occupations, rather than have her standing in a conventional pose against a purple or red curtain. He was perfectly right in my opinion. It's an interesting experiment and it deserves to be praised. There are in this portrait some exquisite flesh tones and the grouping is ingenious. The brushstrokes are a little thin and hurried, blurry in the accessories, but it's skilfully executed, and moreover it's daring. In short, it's the work of an artist who has talent and who – despite appearing in the official Salon – is actually an Independent; it's astonishing, but also very pleasing, to find painters who have long since abandoned the old formulas that are so preciously conserved in aspic by their peers.

As for M. Delaunay, he's got all of them stored away. His portrait of Charles Gounod, staring at the sky and clutching the score of *Don Juan* to his breast, is the height of the ridiculous and the grotesque. M. Delaunay is, be it understood, an exempted artist[51] and one of the most esteemed painters in France!

Unfortunately, I could now cite with a quick flick of the pen, a good gross of portraits that barely deserve anything more. It's true that all these images are suitable for decorating those red velvet-lined drawing rooms, with their fake Boule[52] consoles on which two gilt-bronze lamps stand, their shades topped by little blue tassels. These portraits adorn, they fill a space, they make it possible to observe the devastations that age brings down on the head of the master of the house – added to which they provide a topic of conversation for visiting ladies and gentlemen. You'd have to be really heartless to suppress something so charmingly useless!

So we'll let them deteriorate in peace, and go and see the delightful *Portrait of M. Dailly, in the Role of 'Boots' from l'Assommoir*, plainly presented against a light grey background by M. Desboutin. Dailly, as the man who can't get enough bread,

M. Dailly in the Role of 'Boots' in L'Assommoir by Marcelin Desboutin.

Valtesse de la Bigne by Henri Gervex.

stands alive before you, with his jolly face and his loud laugh. After blue cotton breeches let's now move on, for a contrast, to the elegances of the demi-mondaine. Dressed in lilac and posed in the middle of a garden in which geraniums dot their red stars amid the green, Mlle. Valtesse de la Bigne[53] walks and smiles, her face gently illuminated by the light filtering through the blue fabric of her parasol. M. Gervex has painted her with a clarity that hints at the study of Manet. The flesh tones are a bit insipid, but the body fills out the dress well. It's a cheerful canvas, done by a man very skilled in his trade.

M. Fantin-Latour's style is more severe, but he has a very different scope. His canvas this year is, as usual, superb. There are two girls, one standing in the act of painting, the other seated and sketching a plaster head. What is really marvellous about this canvas is the naturalness of these figures. They are not posing for

portraits, they are drawing at home, without bothering themselves with the spectator. The atmosphere that surrounds them is astonishing. Air circulates around these two women, who exchange a few whispered

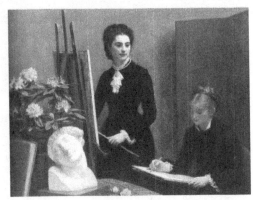

The Lesson by Henri Fantin-Latour.

words, calmly applying themselves to their labour. The tones are sober, harmonious and soft, with a certain discreet puritan charm.

M. Fantin-Latour is not a 'couturier' or a painter of accessories, he's a great painter who grasps and renders life. His painting is neither pedantic, nor strained: it is strong and simple. M. Fantin-Latour is one of the best artists we have in France.

It wouldn't harm M. Bastien-Lepage, whose *Portrait of Mademoiselle Sarah Bernhardt* seems to be painted with a magnifying glass and executed with tiny strokes on a sheet of ivory, to look at the work of M. Fantin-Latour. He would then perhaps understand – him and the other young official modernists – the difference that exists between paintings that are meretricious and artful, and works that are direct and honest.

Little space remains now to talk about the innumerable canvases gleaming everywhere. I cite at random: a portrait by M. de Ségur, in black on a black background, a soft and dreamy portrait of M. Carolus-Duran by M. Sargent, two faux Chaplins signed by Mlles. de Challié and Berthe Delorme, a canvas by Deschamps representing a woman in a brown dress who stands out against a background the colour of wine dregs, a half decent Charbonnel, two mediocre Dubois, and endless figures of doctors.

THE SALON OF 1879

The whole of the medical profession seems to have passed through here this year, with their sideburns and their overcoats adorned with the red ribbon of the Legion d'honneur.

The *Portrait of Madame Countess Berta Vandal* looks radiant in the middle of such paltriness. I don't have to describe the new work by M. Carolus-Duran, since that job has already been done in this newspaper;[54] I will limit myself to a few reflections.[55] The portrait by M. Duran is, as usual, theatrically posed; but it seems to me a little better this time than those of previous years. In addition to the fabrics that are always brilliantly captured, the flesh is more lively and the hands are beautiful. I hope that this painting doesn't deteriorate like its predecessors. The experience of the Exposition Universelle was a terrible one for this painter. The colouring had faded, everything had become cardboardy and metallic, flesh tones seemed brown and overcooked, even the fabrics had gone stiff. So we've seen how fragile and factitious his reputation as a fine painter is. I hope, I repeat, that this solemn work has a happier fate.[56]

Sarah Bernhardt by Jules Bastien-Lepage. *Berta Vandal* by Carolus-Duran.

IX

Patriotism is, in my opinion, a negative quality in art. I know well enough that the masses stamp their feet and break into a little sweat of enthusiasm whenever they hear 'Revenge' or 'France, my love' bawled at a concert; and I know well enough that a number of people swoon at the sound of M. Déroulède's[57] poems, but these are high-minded idiots, ready to cross all these patriotic bridges and who say of the poet-engineers who construct them: 'Here are truly noble souls!' But patriotism, such as I understand it, should consist in creating genuine works of art.

Delacroix and Millet have rendered more services to France with their marvellous canvases than all the generals and all the politicians put together. They have magnified and glorified their country, while Vernet, Pils, Yvon and the other military painters who have commemorated its victories, have lowered and degraded it with their daubs. Here is my opinion boldly stated. Baudelaire, in his *Aesthetic Curiosities*, wrote this sentence on the subject of soldierly paintings: 'I hate this type of painting as I hate the army, the armed forces, and all those who drag noisy weapons into peaceful places.'[58] I wouldn't go quite that far – from the artistic point of view, that is. The army exists and consequently it has the right to be represented in art, like all other classes of society, but what I would like is for painters not to always represent it to me under a melodramatic or a sentimental guise; what I would like is that they show it simply as it is. M. Guillaume Régamey has at least attempted this, and at times he has succeeded.

The battles exhibited at the Salon this year are all and without exception of a stupefying poverty. Here is M. Detaille, the public's favourite, who shows us a *Scene from the Battle of Champigny*; all these little gentlemen, overly drawn, overly neat, are posed in postures *unseen* at the time, a row of toy soldiers laid out by a man who is practised in this kind of thing. It's a certain bet that

M. Detaille captured two or three poses in his sketchbook, drawn during a parade or at an army camp, and that he's arranged the whole battle around them for the edification of artistic dilettantes. There's no smell of gunpowder in this canvas, it smells of varnish and above all it smells of the freshly-ironed rags used to dress up these military puppets.

The canvas by M. Detaille certainly has little in the way of backbone,[59] but no less so than those by Messrs Médard, Castellani and Couturier – and it's still better than that by M. Berne-Bellecour, who persistently continues to be mediocre. Only one picture approaches the divine, that by M. Reverchon: a sapper pointing out the sky to a rifleman who is dying on his knees. This painting is the most powerful disinfectant I know for spleen, and I recommend it to anyone who has difficulty laughing. There will be a formidable explosion of gaiety around it this year. And to anyone who doesn't have time to visit the Salon, I also recommend a very daring and very charming effort by a tinsmith located on the Left Bank: a battle between lead soldiers, on a terrain simulated by sawdust, next to a river imitated by a piece of mirrored glass. In the first place, it's all very charming, and secondly it has some

Scene from the Battle of Champigny by Édouard Detaille.

serious qualities as regards arrangement; the lead fortress, armed with canons whose mouths are garnished with pieces of cotton-wool for smoke, is remarkable, very lifelike. If it were exhibited at the Salon this year it would undoubtedly outclass all the huge tarpaulins painted by M. Castellani and his cohorts.

The same remarks apply when we come to tackle still lifes. Whether it's cartoon sappers or taffeta flowers, the best thing is to throw them all in the same bag. I make an exception for Mlle. Desbordes, whose flower arrangements have a beautifully energetic brushwork. Her *Souvenir of a First Communion* is prettily painted. That whole gamut of white tones playing on pale green is charming; and the veil thrown over the cup, rosary beads and book achieves the very curious effect of a floating cloud. A similar effect, but which nothing justifies, has been imagined by M. Monginot. His redcurrants and raspberries on a cabbage leaf are vague and without shape, as if seen through a muslin curtain. Added to which his fruits are terribly bruised, they ooze, without however having reached the degree of rottenness necessary to liquify in that way.

After this marmalade of overripe fruit, let's pass on to the figurines in ivory or stucco. The *Portrait of Madame Marquise de C.T.* is one of the more successful ivories in the Salon.[60] I wholeheartedly admire its firmness of flesh, however I would have preferred it if M. Cabanel had stuck more closely to the nature of ivory and bone. There are yellow striations, veins and little red fibrillae in these materials and it's not really acceptable to ignore them; moreover, why has he added a dress made out of tinplate? Such compromises are annoying. It would have been better to do the figure as well as the dress in tinplate.

I could say as much of M. Alphonse Hirsch, who – less meretriciously but, if possible, even more annoyingly – has constructed his *Portrait of Madame W.* from unglazed porcelain. So you see it's still springtime for lifeless still life painting – as long as

The Salon of 1879

M. Dubufe doesn't get involved, because he doesn't make it dead enough. Admittedly, it would be ungracious of me to deny that in his two portraits this year the dry nature of badly turned and imperfectly polished ivory hasn't been skilfully captured, but here, he really makes an error. Here, it's the fabrics that are carved in hard material and the faces that are gelatinous; they're like cold cream. By the devil, I've never seen ivory this insubstantial or this soft!

M. Desgoffe, a slave to still life if ever there was one, is more precise and more lifelike. Look at the extraordinary platter of objects he's furnished this year; all is rendered in the same manner: azaleas, onyxs and sards. It's a masterpiece of the monstrous, only Abraham Mignon, whose detestable canvases sprawl over the Louvre, can match M. Desgoffe. Couldn't one, in the interests of good public taste, lock these horrible things away in some abandoned armoire, some forgotten cupboard, or even pile them all up in some maritime museum, where only the odd artilleryman and one or two soldiers might wander in of a Sunday?

I'm also curious to know where they're going to put the gigantic still life, *Chez Don Quixote* by M. Hippolyte Delanoy, which was bought by the State. In the Luxembourg? It's worthy enough. It's yet another rehash of Vollon. The armour gleams pleasantly enough, which we know the formula for, it's just that if all this metalwork is carefully polished, it's not the same for the old books, whose pages seem to be cut from sheet metal rather than parchment.

Chez Don Quixote by Hippolyte Delanoy.

It's strange but the fact is that it's women who paint still

87

lifes most frequently these days. I've already spoken about Mlle. Desbordes, it just remains for me to point out Mlle. Ayrton, whose two canvases are good. *Sea Birds* is valiantly done and her *Kitchen Corner*, with its pretty spots of green and red, is simply and solidly painted, without one noticing the technique, which is so tiresome in painters like Jeannin, Bergeret and Claude.

A Party of Ladies by Pierre-Marie Beyle.

But let's leave all these inanimate objects aside for a moment and move as quickly as possible past the unbearable little paintings of M. Goupil,[61] that finicky peddler of old clothes, and his laughable portraits of M. Ruben's family; we can also neglect *A Party of Ladies* by M. Beyle, because all his women are borrowed from images in dressmakers' catalogues and ladies' magazines.

More worthwhile, all things considered, is M. Bonvin. His canvas represents the interior of a convent; the nuns, seated around a table, are peeling pears. It's posed and conceived like a Pieter de Hoog, with an open door in the background and a woman in full daylight. Except that the precise effect of the sun, characteristic of the

During the Vacation by François Bonvin.

great Dutch painter, is lacking here; added to which, M. Bonvin's nuns are painted awkwardly; in short, it's a polished painting, but cold and lifeless. I really don't know why everyone says – and they've been repeating it for years – that M. Bonvin is very modern. It's the exact opposite. His interiors are pale copies of the interiors painted by the old masters of Holland. M. Bonvin is dryness incarnated, he's a preacher of fake archaism and fake modernism.

X

In order to finish my account of the oils it only remains for me to say a few words about certain canvases that, for the most part, figure in the category of genre painting. I will be brief. Among the 'Fortunyists', I will cite only M. Casanova – he is, indeed, the disciple who has inherited the most defects from that very extraordinary acrobat named Mariano Fortuny. Admittedly, Fortuny was a dazzling colourist, a prodigious clown who, in spite of his perpetual juggling acts, sometimes came up with exquisite marvels of real life that were breathtaking and superb – witness the adorable little naked woman,[62] lying on her belly, shown at the Exposition Universelle in the Champ de Mars – but as the

Nude on Portici Beach by Mariano Fortuny.

chief of a school, as its master, he was really the most deplorable and the most dangerous. His pupils are unable to assimilate any of his good qualities and they limit themselves to the 'fireworks', the

salvos of which succeed one another with a shattering and monotonous flamboyance.

Marriage of a Prince by M. Casanova is a most unhappy specimen of the genre. Nothing can be seen, nothing can move in this canvas, it's a blinding dazzle of spangles stuck one next to the other.

Passing on, and since we're in the 'C' room let's look at Benjamin Constant's pictures, in which the Orient is depicted under the sun of a Batignolles-Clichy sky,

Marriage of a Prince by Antoine Casanova.

done up in a spicy preparation of bright colours to mask its insipid flavour. It seems to me that one could better spend one's time painting things that are more sensible and more sincere; for example doing a fine study, as M. Ribarz has, of the canal basin at La Villette; but above all what one really shouldn't do is watercolours in the style of Victor Pollet, finicky and overworked nudes, retouched under the microscope, Omphales[63] with hips shaped like spearheads, and miserable rooms in which prone women, dappled by fake shadows, turn their backs to us.

M. Pollet is the Desgoffe of watercolour; moreover, all his peers use the same method of glazing. The lamentable Durand-Ruel exhibition was the most convincing of proofs.[64] Leloir and Vibert odiously dominated this heap of shameful pictures, and M. Heilbuth, with his crude modernism and his leaden touch, almost shone like a man of great talent in the middle of the atrocious poverty of these strips of wallpaper. This exhibition was nothingness in all

The Ragman by Jean François Raffaëlli.

its glory. It's a nothingness we will find yet more of on the tiered walls of the official Salon.

I exclude from this, of course, a watercolour-gouache by M. Raffaëlli. Here, this artist shows us another one of those landscapes he loves, one of those vast plains animated by the factories that border Paris and which he does so well.

Theophile Gautier has written somewhere that engineers ruin landscapes,[65] but no, they simply modify them and give them, most of the time, a more penetrating and vivid aspect. The factory chimneys that rise up in the distance, in Pantin for example, give a stamp of a melancholy grandeur to the north of Paris that it would never have had without them.

Now M. Raffaëlli is one of the few to have understood the original beauty of these places, so dear to the intimists. He is the painter of poor people and noble skies – his ragman, alone with his dog, ready to forage around in a heap of refuse, has great presence; it is taken from life and is boldly presented. As with the oil paintings of this excellent artist, I see again in his watercolours lives of misery and toil; I see again, on plains in which an old white horse grazes next to an abandoned cart, its shafts pointing to the sky, those scenes that inevitably confront people who pass beyond the city's ramparts: babies sucking at withered breasts, and families mending ragged clothes and talking among themselves

about how difficult it is for the poor of the world to make a living.

After M. Raffaëlli's *Ragman*, we would also cite *An Interior* by Mlle. Haquette-Bouffé,[66] with its rather nervously slashed brushstrokes; an amusing sketch of people about to write by M. Bureau; and a furious caricature entitled *Souvenir of the Great Council of 1869*, representing the late pope and a nondescript bishop. This shop sign, which even the religious souvenir merchants of the Rue Saint-Sulpice wouldn't dare to display in their windows, bears the signature of Madame Blanche Juliane.

Against the exploits of this lady, the majestic painter who goes by the name of Signol can only struggle to regain the upper hand. After having invited the mockery of fashionable Parisian exhibition-goers by spreading out his ostentatious commonplaces at the Salon de Mars, here he is this time exhibiting *Psyche Looking at the God Love* and *The Death of Abel*. Did M. Signol wish to show that, among the members of the Academy of Painters, he was the most hopeless and the most insignificant? Well, we've known that for a long time! The comatose work that stammers on the walls of Saint-Sulpice[67] could leave us in no doubt; consequently unpacking his work this year was quite pointless.

A word now about *Nana* by M. Dagnan-Bouveret and we can then pass on, without further delay, to the engravers and etchers. This *Nana* profoundly amused me. Is this how painters understand the books they read?[68] This trembling figurine, this bundle of badly assorted rags represents Nana, and that ex-colonel of the light infantry sitting next to her mimics the old man she has possessed and consumed? Come on, Nana should at least have a certain piquancy, a touch of spiciness in her eyes or in her bearing. Here, nothing; the Independents are certainly the only ones who could render – or at least try to render – the Parisienne and the whore. There is more elegance, more modernity, in the slightest sketch of a woman by M. Jean-Louis Forain than in all the canvases by Dagnan-Bouveret and the rest of the fabricators of fake modernity put together. Indeed, I

know of watercolours by the Impressionist I've just mentioned that reveal a very particular and very vivid sense of contemporary life; they are little marvels of elegant Parisian reality.

We have now finally come to the room reserved for engravings. The first reflection that comes to mind is this: the honourable company of engravers is full of hardworking and capable craftsmen, but of true artists it doesn't count a single one. So I will be abstemious with names; time is short and it's quite useless to pile up judgements on all these more or less successful reproductions of paintings done by someone other than the person who engraved them.

It's more worthwhile to occupy ourselves with the etchers, who at least give us their own vintage, and, out of them all, with M. Desboutin, whose exhibition of etchings has been a veritable triumph for the artist. After being pitilessly refused over the years by the annual Salon, M. Desboutin has finally gained entrance and a medal. It is justice. The five[69] engravings exhibited this time are superb – his self-portrait especially, the style of which is magnificently powerful. This head, which looks at you as he smokes his pipe, lives and breathes, and is forthrightly executed.

Self-portrait by Marcelin Desboutin.

Also worth pointing out are some beautiful studies by M. Le Couteux, engraved according to the formula of the old masters, and some very remarkable dancers by M. Renouard, which appeared in *L'Illustration*.[70] His drawing of kittens is

also astonishing.[71] These marvellous animals have been captured in all their cute and impetuous movements. We are a long way, as you can imagine, from the cats playing in baskets painted by M. Lambert and

Ballet Dancers at the Opera Garner by Paul Renouard.

other feline-fanciers. Those of M. Renouard have the look of being taken from nature, there's a truth in their whimsical yet exact poses that recalls the lively drawings of these animals in Hokusai's Japanese sketchbooks.

Renouard's sketches from the Opera Garnier are also bold, and, to return to the *corps de ballet* I spoke about above, the pirouette exercises the apprentices carry out are fully and minutely depicted. The dancers are presented just as they are, briskly sketched in a few lines, doing their pointwork or their kicks, their legs extended in the fourth position front or raised high on the bar, practising their bow and their final curtsey. The effort and the fixed smiles are visible; all these articulated bodies palpitate and breathe. There's twenty times more art in these small etchings than in all those huge mechanical paintings of so-called history which we've had to give an account of for the last month.

XI

I often think with astonishment of the breach that the Impressionists, along with Flaubert, Goncourt and Zola, have made in art. The Naturalist school has been revealed to the public

by them; art has been turned upside down, freed from the official fetters of the art schools.

Today, we can clearly see the determined evolution in literature and in painting; we can also guess what the architectural conception of modernism will be. The monuments are there. The architects and the engineers who built the Gare de Nord station, Les Halles, the livestock market at La Villette and the recent Paris Hippodrome,[72] have created a new art every bit as elevated as the old, a wholly contemporary art, adapted to the needs of our time, an art which, transformed from top to bottom, practically eliminates stone and wood, raw materials furnished by the earth, in order to borrow from factories and forges the power and lightness of their cast iron.

Next to these products of an art that the terrible life of large cities has given birth to let's now place, like some marvellous specimen of the epoch that created it, the Sainte-Trinité church in Paris. All the sickly elegance of the art of the Second Empire is there. The notion of a cathedral erected by people who believe is dead. Notre Dame no longer has a reason to exist. It is scepticism and the refined corruption of the modern age that built the Trinité, this cross between a church and a smoking-room, between a praying-stool and a sofa, where the scent of Guerlain and Roger & Gallet[73] mix with the fumes of incense, where the holy water stoup smells of the perfumed hands that are dipped into it, this church of a religion of good taste where one has one's own box for visits, this boudoir where ladies straight out of the fashionable novels of M. Droz[74] flirt on their knees and aspire to mystical lunches, this perfumed Notre Dame in front of which one descends from a cab as if before the entrance to a theatre.

I have cited these monuments because they are the most characteristic of their century; I've deliberately passed over in silence the Opera Garnier, which is nothing but a miscellany of all styles, a linking of all periods, with its staircase taken from Piranesi,

its laborously assembled bulk, its disparate parts fitted together like a wood block puzzle. This has nothing to do with the new art, especially from the point of view of its external arrangement, which slices together two styles, one morbidly genteel and decadent, the other powerful and grandiose, enveloping with its large frame the superb grandeur of a construction whose enormous porticoes – which are nevertheless as light and airy as tulle – serve to shelter the prodigious swell of its customers and the multitudes enamoured with spectacle.

Music has also moved forward, so in terms of art it is only poetry and sculpture that have stayed stationary. Poetry is dying, that is certain. However great Victor Hugo might have been, however skilful, however much an artist Leconte de Lisle is, they are losing and will continue to lose – and in a very short time I believe – any influence over the new wave of poets. It will certainly not be through Alfred de Musset that poetry will escape the ditch in which it's floundering;[75] consequently I can't see – at least unless a man of genius is born – what will become of this art that Flaubert called an art of ornament, and I can see still less where this other art they call sculpture is headed. Such as it is today, it's the most appalling case of paralysis you can find.

It's high time to put away the old cliché trotted out every year that sculpture is the glory of France. Yes, painting is only barely progressing, that's true, but sculpture? No, a thousand times no. Admittedly, I hate with all my might the majority of paintings exhibited at the annual Salon; I hate the painting of Léon Bonnat and his cohorts, I hate the mystifications of great art, those bags of hot air that end up being accepted as the real thing through the cowardice of the public and the press; but I hate still more, if possible, those other bags of hot air one calls contemporary sculpture. Painters are men of genius next to these officially-sanctioned plasterers.

One of two possibilities: either sculpture can acclimatise itself

to modern life or it can't. If it can, then it must try its hand at contemporary subjects, then at least we'll know where we stand. If it can't, well so be it! Because it's perfectly pointless to keep returning ad nauseam to subjects that have been better treated in previous centuries; sculptors should limit themselves to being ornamenters and not encumber the Salon of Arts with their products. Everyone would gain then – them initially, because soon there'll be a general outcry against the solemn buffoonery of their statues, and the public still more so, because no longer being inconvenienced by these lumps of masonry, they'll be more at their ease looking at the incomparable wonders of the floral exhibition.

I have no intention to review, one by one, all the strange busts that preen themselves on their pedestals and immediately evoke in me the idea of pince-nez and tassled mortar-boards. Still less am I going to stop in front of the sculptural design for 'a basin or sink', whose fantastical centrepiece, a child coming out of a cabbage, is impudently displayed in the glazed garden pavillion. The author of this wretched affair didn't even have the courage

of his convictions. He didn't put his statuette in the zinc bowl it's destined for and didn't dare to connect the pipsqueak's umbilicus to a water jet, which would at least have enlivened and refreshed the plasterboard château where the families who buy such things strut about for several months during the summer.

Given the atrocious dearth of real sculptors, I have no difficulty in acknowledging that the jury was right to choose M. de Saint-Marceaux and award him a

Spirit Guarding the Secret of the Tomb by René de Saint-Marceaux.

medal. His *Spirit Guarding the Secret of the Tomb* is well set up and, in comparison to everything that surrounds it, could perhaps be impudently qualified as a large, virile work. We will cite now, while we're here, a few others: a curious wax statue by M. Ringel; some works by Mlle. Sarah Bernhardt, which hark back to the hydraulic sculpture referred to above; a good bust by M. Carrier-Belleuse…and what else? Nothing. Unless, in order to show that a sculptor's wit equals if not exceeds that of a painter's, I were to cite *Christmas Present*, a little girl who cries because instead of toys in the chimney she finds a bunch of twigs.[76]

Christmas Present by Adolphe Maubach.

It's a very fine piece of French wit, as you can see, and is in accord with the tone set by Mlle. Koch, M. Lobrichon and other daubers.

I will sum up because it's time to finish. This Salon is, like those of previous years, the shameless negation of modern art as we conceive it; in painting, as in sculpture, it's the insolent triumph of artful cliché.[77]

I'm beginning to reproach myself now for the indulgence I've shown in reviewing the majority of the canvases of the official young 'modernists', because in default of talent they've simply feigned a desire to cast off the ball and chain the Academy of Fine Arts had attached to their legs. But none of them had the strength necessary to break their irons. From Cabanel to Gérôme, from Gérôme to Bouguereau, from Bouguereau to Meissonier, we arrive at Firmin-Girard, at Toulmouche and Vibert.

The bottom rung of the ladder has been reached; the bilge pump blasts out its stale odour; if it's possible to go any lower I ardently hope they do it, because then the end of these Mardi Gras will be nigh.

EXHIBITION OF THE INDEPENDENTS
IN 1880

For almost a thousand years anyone dabbling in painting has taken their theories of lighting from the old masters. Some light a modern woman, a Parisienne sitting in a drawing room on the Avenue de Messine, with the daylight of a Gerrit Dou, without understanding that this daylight is particular to the countries of the north, determined by the proximity of the sea and by the mists rising off the water that laps – as it does in Amsterdam, Utrecht and Haarlem – at the feet of the houses, and which in addition is filtered through narrow sash windows with small square panes; it is correct in Holland, as are certain skies of a blue-green turquoise, fluffy with russet-red clouds, but it is absolutely ridiculous in Paris, in the year of grace 1880, in a drawing room overlooking a street the canal of which is a simple gutter, in a drawing room with large casement windows and clean panes with neither bubbles nor imperfections.

Others imitate the tenebrist style of the Spanish painters and of Valentin du Boulogne. Whether it's chefs, Samaritans in distress, or portraits of peasants or ladies, all exhibit flesh of a red

defined by the Goncourt brothers as 'fingernail red',[1] marinating in a bath of diluted floor polish and ink. When Jusepe de Ribera painted scenes in a cold cell, pierced by a thin arrow of light falling from a basement window, the cave-like lighting he adopted was correct; but transported to the current world, adapted to scenes of contemporary manners, it's absurd.

Others still assimilate the techniques of the Italian school without taking account, it goes without saying, any more than those who imitate the Dutch and Spanish painters do, of the differences in canvas, the loss of freshness, the variation of shades, and the deterioration of colours inflicted by time; finally, the rest are satisfied with the simple tricks taught at the Academy of Fine Art; they apply a 'standard' daylight following the usual methods, by manoeuvring curtains on poles, illuminating interiors in exactly the same way, whether it's supposed to be on the ground floor, in a courtyard, or on the fifth floor of a boulevard, whether in rooms that are bare or upholstered in fabrics, lit by a candle or by stained glass; and treating all landscapes the same regardless of season, whether it's midday or five o'clock in the evening, whether the sky is clear or overcast.

In short, with one as with the other, it's the same absence of observation, the same lack of scruples, the same thoughtlessness.

It is to the small group of Impressionists that the honour falls for having swept away all these prejudices and shattered all these conventions. The new school proclaimed this scientific truth: that broad daylight fades colours, that shadows and colours, of a house or a tree, for example, painted in an enclosed room differ absolutely from the shadows and colours of a house or a tree painted under the selfsame sky in the open air. This truth, which could not strike people accustomed to days working more or less confined to their studios, necessarily manifested itself to landscape artists who, deserting the tall windows dimmed by the serge drapes of their ateliers, would paint outside, simply and

sincerely, the nature that was surrounding them.

This attempt to render teeming beings and things in the pulverulence[2] of light, or to make them stand out using their raw tones, with no gradation, with no half-tones, in sunlight falling directly on them, shortening and almost eliminating shadows as in Japanese prints, was it successful at the time it was dared? Almost never, I have to say.

Starting from a valid point of view and – contrary to the usage of Corot who is flagged, I don't know why, as a precursor – fervently observing nature's appearance, how it altered according to the period, to the climate, to the hour of the day, according to the more or less violent heat of the sun, or the more or less likely threat of rain, they wandered and wavered, wanting, like Claude Monet, to render the troubled surface of a river churned up by the flowing reflection of its banks. The result was a crushing, opaque heaviness, where nature had a delicious finesse of fugitive nuances. Neither the vitreous fluidity of water, marbled by changing streaks of sky, whipped by reflected canopies of foliage and pierced by the spiral of a tree root that seemed to turn back on itself as it plunged into it, nor – on firm ground – the shimmering of a tree whose outline blurs when the sun bursts out behind it, were captured by any of them. Those iridescences, those reflections, those mists, that dustiness, would metamorphose on their canvases into a chalky mud, churned up with harsh blues, garish lilacs, aggressive oranges and cruel reds.

It was the same for painters of interiors and genre scenes. Observing that in a garden in summer, for example, the human figure becomes purplish under light filtering from green leaves, and that under gaslight, especially in the evening, the cheeks of women who use the white makeup that goes by the name 'Pearly White' become slightly purple when flushed, they plastered faces with a layer of intense purple, applying it too heavily, there, where the hue was more of a suspicion, where the nuance was barely perceptible.

Now add to an insufficiency of talent, the brutal clumsiness of the brushwork, a feeling of illness rapidly brought on by eye strain, by the loss of self-conrol that comes from struggle and a constant, relentless searching, by the all too human determination to capture a certain hue, glimpsed one fine day as if newly discovered, a certain hue that the eye ends up seeing again and again under the pressure of its own wilfulness, even when it doesn't exist anymore, and you have the explanation for the touching follies that were shown off during those first exhibitions at Nadar's[3] studio and at Durand-Ruel's.[4] The study of these works is primarily a matter of physiology and medicine. I don't want to name names here, suffice to say that the majority of them saw through the eye of a monomania; while one would see intense blue in all of nature and turn a river into a washerwoman's bucket of Reckitt's blue;[5] another would see purple – landscapes, skies, water, flesh, everything in his work would be tinged with lilac and aubergine; ultimately, most of them would have confirmed Dr Charcot's[6] experiments on the deterioration of colour perception, which he'd observed in many hysterics at the Salpêtrière hospital and in numerous people afflicted by diseases of the nervous system. Their retinas were sick; the cases noted by the occulist Galezowski,[7] and cited by M. Véron[8] in his scientific treatise on aesthetics regarding the atrophy of several nerve fibres in the eye, particularly the loss of the notion of green which is a premonitory symptom of this type of affection, undoubtedly applied equally to these artists, because green almost disappeared from their palettes, while blue, which impresses itself more widely and more forcefully on the retina, persisted and finally, from this disorder of the sight, came to dominate everything, to drown everything in their canvases.

The upshot of these ophthalmias and these neuroses was not long in coming. Those most afflicted, the weakest, foundered; others were restored little by little and have had only rare relapses;

but however deplorable from the point of view of art the fate of the incurables has been, it should be duly acknowledged that they gave rise to the current movement. Their theories, freed from the unhealthy application of them, have been recognised as being true by others who are more balanced, more sound, more knowledgeable, more resolute.

As Émile Zola has excellently pointed out, from being in a dismal state, painting has, thanks to them, become clear. The evolution has been slow, but finally clarity is beginning to break through, even amid those worthless paintings, amid the trash of fake modernity put on show every month of May in that warehouse of the State, the Official Salon. Today, the problem of lighting has been solved, or brought back at least within the precise proportions of the possible; finally, those hastily thrown off sketches have disappeared, for the most part, making way for finished and complete works; the practice that consists in leaving off a canvas that's barely even been started under the pretext that the desired 'impression' is there, in contenting oneself with too easily achieved rudiments, in dodging in this way all the difficulties of painting, the inability, in a word, to stand a solid and complete work of art on its feet, hardly exists today among the paintings exhibited in this suite of rooms on the Rue des Pyramides[9] – Mme. Morisot excepted.

The first room contains pictures by Pissarro and Caillebotte, two artists who figured in the first exhibitions by the rebels of art.

Leaving aside the works of M. Pissarro that are bordered by purple frames, which enclose a yellow paper – of that particular yellow hue of lithographic paper – on which dry points and etchings are scratched, and neglecting, too, certain paintings that affirm his mania for blue, I will stop in front of a canvas perched on an easel, a summer landscape in which the sun rains furiously down on a field of wheat. It is the best landscape I know of by M. Pissarro. There is a curious dusting of sunlight on this field, a

The Red Roofs, Corner of a Village by Camille Pissarro.

trembling of nature heated to excess. Also worth pointing out is another painting, a village flashing its red roof tiles through the foliage of trees.

M. Pissarro has a genuine artistic temperament, that's certain; the day it frees itself from the swaddling bands that cover it, his painting will be the true painting of modern landscape, towards which the painters of the future are marching; but unfortunately these particular works are the exception; he too, under the pretext of 'impressions', has produced vague motley-coloured canvases; he's an intermittent worker who jumps from bad to good (like Claude Monet, who is exhibiting now in the official Salon), a landscape artist of talent at times, but often unhinged, a man who either gets it completely wrong or else calmly paints a very beautiful work.

Such highs and lows are, moreover, one of the distinctive features of those few landscape artists who floated to the surface after the shipwreck of their Impressionist peers. No middle path; it's sheer folly or audacious truth, according to the state of their

eyesight, which never quite passes through a state of convalescence. This remark could also be applied to M. Sisley, one of the most gifted, and even to the much regretted Ludovic Piette, who was nevertheless the most sound and least afflicted of them all.

Indigomania, which caused so much devastation among the ranks of these painters, seems to have definitively spent itself in Bonnat's former pupil, M. Caillebotte. After having been cruelly afflicted, this artist has cured himself and, apart from one or two relapses, he seems to have finally managed to clarify his eye which, in its normal state, is one of the most precise and original I know.

He is a great painter, and certain of his canvases will later hold their place among the best – the series of works he is exhibiting this year proves it. There is among them a simple masterpiece. The subject? Oh my God, it's so ordinary. A lady standing by a window, her back turned to us, and a gentleman seated in an armchair, seen in profile, reading his newspaper next to her – and that's all. But what is really magnificent is the frankness, the life in this scene. The woman, who looks idly at the street, breathes, she moves; you see her loins stirring under the marvellous dark blue velvet that covers them; you could touch her with your finger, she is going to yawn, to turn around, to exchange a useless comment with her

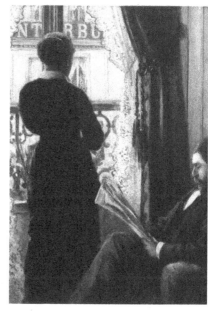

Interior, Woman at the Window by Gustave Caillebotte.

husband, who is barely distracted by the news item he's reading. That supreme quality of art, life, exudes from this canvas with an intensity that is really incredible; added to which – I spoke about light at the beginning of this section – it's here that one should see it, the light of Paris, in an apartment located on a street, the light deadened by window hangings, filtered by thin muslin curtains. In the background, through the window from which daylight streams, the eye glimpses the house opposite, the large gold letters that commerce makes crawl along the balustrades of balconies on window ledges, in this vista over the city. The air circulates, it feels like the loud rumbling of cabs is rising up, along with the hubbub of passersby tramping the pavement below. It's a slice of contemporary existence, fixed just as it is. The couple are bored, as often happens in life; the air of a financially comfortable household emanates from this interior. M. Caillebotte is the painter of the middle class at ease, trade and finance providing largely for their needs, though without them being very rich for all that, living near the Rue Lafayette or the environs of the Boulevard Haussmann.

As for the execution of this canvas it is simple, sober, I would even say almost traditional. No erratic splotches, no fireworks, no half-indicated intentions, no lacunae. The painting is complete, testifying to a man who knows his trade to his fingertips but who tries not to make a song and dance of it, to hide it almost.

Compare this work with another that produces a new variation on the same theme. In the background, by an odd and incomprehensible effect of perspective, a gentleman appears, microscopic, lying on a couch, reading a book, head posed on a cushion that seems enormous; in the foreground, a woman seen in profile, reads a magazine. Here, the idle boredom which we saw in the first interior is absent; this couple has nothing to say to each other, but they accept, without revolt, with a mild resignation, the situation that the habitual permanence of contact has created;

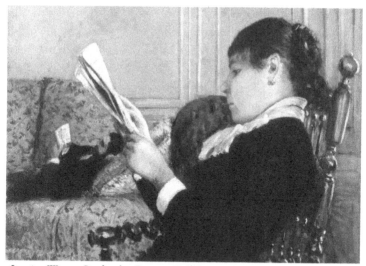

Interior, Woman Reading by Gustave Caillebotte.

they are killing time, placidly buried in reading something that interests them; given the intelligence, from the point of view of art, of the world that M. Caillebotte represents, there is even room to believe that the woman is reading *Le Charivari* or *L'Evénement,*[10] and that the husband is revelling in some novel by Delpit.[11] In any case they are occupied, without posing for the viewer, without that attitude of people preparing to have their portraits taken. The woman's hand, its dimpled and supple flesh, is a marvel, and I also recommend to all the painters who have never been able to render the artificial complexion of a Parisienne, the extraordinary skin of this one, a skin worked to a velvet smoothness, but without makeup. And here again it's a very exact observation. In this household there's none of that makeup commonly used by actresses and whores, but the simple compromise of a number of women of the middle classes, who don't tart themselves up like those others, but quite simply apply a face powder to the skin, tinted pink for blondes, or the shade 'Rachel'[12] for brunettes.

Now it shouldn't be imagined that, like the great majority of

his peers, M. Caillebotte repeats the same subject over and over again; we will see him tackling all sorts of different topics and treating them with the same good faith, the same flexibility.

I will recall first of all, as a proof, his unforgettable *Floor Scrapers*, previously exhibited at the Durand-Ruel gallery, then, passing by a small panel, *A Child in a Garden*, in which the awful blue sin has again been committed, I will stop instead in front of his canvas entitled *A Café*.

A man, looking at us, leans against the edge of a table on which stands a glass of that mediocre beer which, with its cloudy colour and its thin head of soapy foam, we immediately recognise as the infamously brewed donkey piss that goes by the name of 'Viennese beer' in beer cellars on the route to Flanders. Behind the table, a banquette in amaranthus-purple velvet, fading to the colour of wine dregs from the wear caused by the continuous rubbing of backsides; to the right, a pretty square of daylight tempered by a pink striped awning; in the middle of the canvas, set above the banquette, a large mirror in a patterned gilt frame reflects the shoulders of the standing man and reveals the whole interior of the café. Here again, nothing pre-planned, nothing arranged. The people glimpsed in the mirror are fiddling with dominoes or fingering cards, not aping that show of attention so dear to the wretched Meissonier; these are people sitting at a table, who have forgotten the anxiety of the circumstances in which they live, who aren't troubled by great thoughts, and who play quite simply to distract themselves from the unhappiness of a celibate, or a family life. The slightly unbalanced posture, the half-closed eye, the slightly trembling hand of the player who hesitates, his head leaning forward, the brusque, haughty gesture of the man who plays his trump card – all that is sized up and sketched, and as for the café regular, with his hat pushed back on the nape of his neck, his hands planted in his pockets, haven't we all seen his type in every brasserie, hailing the waiters by their first names, boasting

A Café by Gustave Caillebotte.

and joking over the clack of backgammon and billiards, smoking and spitting, sinking tankards of beer on tick!

Two portraits, a child in a garden, a landscape that's exactly right in tone, and an astonishing still life in a dining room, complete this painter's exhibition.

I will expand a little on the still life, which is conceived in this fashion: some oranges and some apples, stacked in a pyramid on fruit dishes with fake moss, some oversized glasses, carafes of wine,

Still Life by Gustave Caillebotte.

and bottles of Saint-Galmier mineral water fill a table covered with an oil-cloth that reflects the colours of the objects posed on it and loses its own.

The effect is nevertheless well observed; air fills the room, the oranges and the bottles don't stand out from the seasoned patina of centuries' old wealth. Here, nothing dominates, nothing jars, and the sheen of the fruit isn't limited to luminous points distributed without cause, it's neither exaggerated nor played down. Here, as in his other works, M. Caillebotte's treatment is simple, unfussy; it's the modern formula glimpsed by Manet, applied and achieved by a painter whose craftsmanship is surer and whose powers are stronger.

To sum up, M. Caillebotte has rejected the Impressionist system of splotches that forces the eye to squint in order to restore the equilibrium of beings and things; he limits himself to following the orthodox method of the masters but he has modified their application, he has adapted it to the demands of modernism and to some extent renovated it and made it his own.

Exhibition of the Independents in 1880

The same remark could apply to M. Raffaëlli. He, too, refused to accept, under the pretext of presenting an 'impression', deficiencies in drawing or defects in colouring. He has arrived, bringing to those branches of art which the impotent and the visually manic were wailing over, a painting that is correct and terribly intelligent beneath its simple style. He is one of the rare Independents who wasn't influenced early on by the eccentricities of blue and the mania for lilac; on the contrary, he had to rid himself of a tendency to bathe everything in chiaroscuro,[13] which had been instilled in him at art school by the oft-repeated nonsense of Gérôme, his former master; he went out into the open air and his painting, now free of its shadows, is becoming clearer each year; after being sacrificed in the official lumber-rooms of the annual exhibition (where he was generally relegated to spots under the diaphanous roof blinds, or over the tops of doors, as in 1877 when he brought

a large canvas, curt and acerbic, but already very personal, of a family of peasants from Plougasnou), he has had the courage to break with all these prejudices, to flee that distressing middle-class courtroom of art – to leave, in a word, the Salon – in order to join the reprobates and the pariahs.

Peasants from Plougasnou by Jean-François Raffaëlli

M. Raffaëlli is one of the most powerful landscape artists that we have today; the proof is in his admirable *View of Gennevilliers* which he exhibits here.

Imagine one of these gloomy days when the clouds gallop and jostle amid the grey of immense depths. The earth stretches out, pale, beneath a pallid sky; in the distance, the tops of poplars bend under the whip of the north wind and seem to lash the clouds swollen with rain rolling above a maisonnette, cheerlessly sitting in the dull plain. To the right, a series of factory chimneys vomit puffs of black smoke that break up and spread out, in the same direction, in unison.

Finally, then, an artist has come, who can render the melancholy grandeur of those anaemic terrains lying under infinite skies; here then, finally expressed, is the landscape's poignant note of spleen, the doleful delights of our suburbs. We are far, as you can see, from the merry operettas of the Vaux de Cernay valley,[14] or the dramatic dens of Fontainebleau, those melodramas of nature adapted by the Dennerys[15] of the palette, with all their dressings. Ah, you see, that's because that latter forest is part of noble nature, it's the kind of nature deemed 'distinguished' by the Academy of Fine Art. In truth, we're still being fed made up landscapes today; they put fewer nymphs and fewer ruins in them, but they still refine them, they tart them up, they make them sweeter, they season them according to their conventional recipe, as if it were a dish of broad beans. They have to have a site with something in the foreground, it has to have trees of a certain shape, a preplanned sky, a mild, parsimonious sun, a whole chorus of things without which the most skilful of landscape artists declare themselves incapable of painting.

All that is laughable, because ultimately there is no such thing as 'noble' nature, any more than there is 'average' or 'small' nature. There is just nature, which is as interesting to describe when it's bare and stripped as when it luxuriates and gleams in

the sun. There are no landscapes that are nobler than others; there is no countryside that is contemptible, no flowers that aren't worth gathering, whether they bloom in the artificial heat of a greenhouse and are as tempting as a lipsticked mouth, or whether they barely manage to poke through a heap of rubble and blossom, anaemic, in the airless gardens of the capital. We're fed up with bountiful landscapes, with pot-bellied nature; it would be good perhaps to vary it a little, and it surprises me that talented painters when starting down this path haven't tried to enlarge the formula they've inherited; there's a whole mine to exploit; the two contrary poles of the Parisian landscape, the manicured square of the Parc Monceau, and the wastelands of Montmartre and of Gobelins,[16] are both delicious in their own way; to paint them would certainly be as interesting as daubing an avenue of oaks, or knocking out shrub-covered rocks and mossy sandstone.

M. Raffaëlli, who fortunately cares little about distinguished and noble nature, understood that he could give a personal flavour to the working-class environs of Paris and, in addition to his *View of Gennevilliers*, he has also done a superb view of the Route de la Révolte[17] in the snow.

A still sky of a uniform grey, one of these skies charged with snow that seem to press down and weigh heavily on us, stretches out over the Route. Everywhere heaps of snow, white in some places, black in others, packed hard from the weight of carriages and horses' hooves. Skeletons of trees, in their green-painted, circular metal supports, stand lining the edge of the road, the track of which has disappeared under an accumulated layer of mud and ice: a carter shouts 'Gee up!' while pulling at his beast, and tries to get the tipcart moving, the wheels of which are slipping; in front of us, three unharnassed horses, heads lowered, wait, impassive, in a wind that gnaws at them, a dog barks and jumps, a man, his hands in his pockets, shivers, and in the distance, far off at the horizon, smoke from an invisible train rises, clear against the sombre sky.

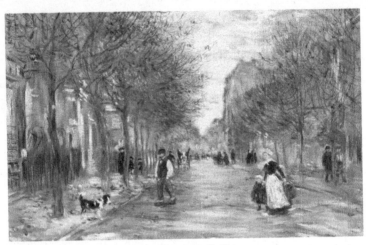

A Boulevard in Asnières by Jean-François Raffaëlli.

All the horrors of winter are here. Never has the impression of great cold that penetrates you to the marrow, never has the anxiety and the sort of unease that grips the human frame in weather like this, when, as they say, snow is in the air, never has all this been expressed with such intensity, with such breadth.

And then what observation! What fidelity in this sad and livid light which streams from a leaden sky, coming to life on the whiteness of snow, intensifying the hue of the horses, the trees, the men, turning them almost black.

I don't know of any landscape more exact than this one, just as I don't know any that are more doleful, more lamentable, more imposing than that *View of Gennevilliers* I spoke about earlier.

In his exhibition, which includes no fewer than forty drawings, panels and canvases, M. Raffaëlli has shown his original individuality in all its facets. Here, in beautiful and funereal landscapes, we see all the distress of poor wretches, all the back-breaking exhaustion of ragmen picking through refuse or carrying their sacks; there, amid the painter's customary melancholy, a sudden silvery burst of laughter springs out, a breath of joyful nature, hens clucking next to

a donkey, bathed in the sun, a clear, luminous and charming work, with its view of Asnières and its small spindly trees so particular to city terrains; and then everywhere there are roadmenders, street-porters, sweepers – one or two perhaps looking too much like Jean Valjean[18] – all the others surprisingly truthful and lifelike. I have already stated that M. Raffaëlli is the painter of poor people and noble skies; and I will add, so that you don't accuse him of being only infatuated by people in rags, that the exhibition also includes a ravishing head of a little girl, that plays across a whole range of pinks from salmon grey to sulphur yellow, a portrait of an old woman, a pastel of a fearsome temperament, and a pen-and-ink drawing, *The Mayor and his Advisor*, which recalls the method of Albrecht Durer interpreted by an English illustrator on *The Graphic*,[19] with, on top of all this, the energy and determination that belong properly to this artist.

In 1879, at the exhibition in the Rue le Peletier,[20] I'd been struck

by the appearance of a new painter, M. Zandomeneghi. Under the slightly insipid title of *Winter Violet*, he exhibited a very pretty portrait of a woman; this year, he shows us a few canvases, one of which, called *Mother and Daughter*, represents an aging mama, with the fine head of a housekeeper, who is doing the hair of madame, her daughter, who is seated in front

Mother and Daughter by Federico Zandomeneghi.

of the window in a dressing gown, and looking at herself in a mirror with a gesture that is well observed. The attentive caution of the mother, whose large fingers, with their grainy turkey-esque skin deformed by hard work, barely dare to touch the gold baubles of her hairband, and the pretty smile of the petite Parisienne, raising an arm adorned with a coral bracelet, or rather a snake-like coil of pink plastic, has to be seen! It's captured from the life, executed without those grimaces so dear to the ordinary daubers of genre scenes, and painted with a slightly lily-like tonality, carefully but without fussiness. A portrait of a man, his hat on his head, leaning against a mantlepiece, in a room full of bird cages, is also interesting for the sincerity it exudes. The Independents have made an invaluable new recruit in the conscientious artist that is M. Zandomeneghi.

Another curious painter of certain aspects of contemporary life is M. Forain. There is no one like him when it comes to capturing the stalls and boxes of the Folies-Bergère, to translating all of its corrupt attractions, all its libertine elegance.

Last year, in addition to his scenes of the Folies, he exhibited some backstage scenes of dancers with little turned-up noses, heavenly, provocative delinquents chatting with fat gentlemen, the Célestin Crevels[21] of our time, paternalistic and obscene, and also with youthful upstarts, stiff in their tight collars and black suits; everything is in movement, alive, exhaling the odour of the atmosphere that surrounds them.

But more astonishing perhaps than these watercolours was one representing a private dining room in a restaurant, seen at the moment when the gentleman and the lady are getting ready to leave.

In the red room, furnished with a worn couch and a chimney piece embellished with a stopped clock, the gentleman holds out his arms toward the waiter who, with a slightly knowing look in his eye belying the affected indifference of his face, stands behind him helping him with the sleeves of his overcoat, while the

woman adjusts her hat in front of a mirror engraved with initials and stamped with names.

To the right, is a whole corner of the table: the bill lying in a saucer, a cigar box, small glasses, the backs of chairs cut off by the picture frame; and below, the varnished shoes of the waiter, shining in the shadows.

This is the cheerlessness of the private dining room caught in the very moment, as the woman, arms raised, the tip of her snout poking out between her two elbows, carefully fiddles with her hair, not concerning herself any further with the gentleman who, after having settled the expenses incurred by this discreet refuge and its rich sauces, stares in front of him, stupefied by the remarks made over dinner, by the heat, by his disturbed digestion, harassed by the flunkey who is jiggling his arms and back.

How it reeks of the concentrated extract of the boulevard, this watercolour, the colours of which come to life and are infused with light in the evening. In daylight, the fabrics and wallpapers of these banal rooms in which one spends the evening, have the tone of things dulled by intoxication or by over familiarity. A sense of luxury is renewed with the return of gaslight. Well, in this watercolour, as in another I will talk about later, M. Forain has resolved this problem, following the truth step by step, arranging his work in such a way that there is a precise equality of lighting, whether one examines it by the glimmer of a candle or in the glow of daylight. But while he's often happy to give an impression of the drawing rooms of the beau monde, and he immediately grasped the charm of women at their toilette and the void behind their chatty smiles, the eagerness of some men, the timidity or the boredom of the majority, M. Forain is even more spontaneous, more original, when he tackles the whore.

She has found in him her true painter, because no one has more profoundly observed her, no one has more scrupulously captured her impudent laughter, her provocative eyes and her bitchy air;

no one has better understood the droll whims of her fashion, her enormous breasts, thrust forward, her arms as thin as matchsticks, the pinched waist, and the bosom creaking under the strain of the armour compressing and reducing the flesh underneath, in order to distend it and increase it on top.

And whether it's a rich society escort or a poor working girl, a kept woman or a streetwalker,[22] he's stripped them all with the same dexterity, with the same audacity; there are some dubious drawing rooms in his work, but one above all conquers you and fascinates you.[23]

In a room hung in imperial red, a gentleman is sitting on a divan, his chin resting on the handle of his umbrella. In front of him stand a group of women, their dressing gowns open, showing him their bellies, trying to persuade him to take them; a fat brunette, with dimpled, over-ripe flesh, resigned to failure; a tall one with black hair; a beautiful Jewess, who stares, indifferently, not even trying; a blonde with knock-knees, her legs sheathed in apple green stockings with red stripes, a cleaned-up tart from the

A Client by Jean-Louis Forain.

suburbs who laughs, and in default of being chosen, is on the point of requesting champagne. Vain effort, a waste of time – the gentleman won't go upstairs and he won't pay for any more drink. And if he can't knock out a polka on the old piano, they'll politely invite him to 'take Madeleine', which is to say, show him the door.

What's extraordinary in this work is the powerful sense of reality that emerges; these whores are brothel whores, not any other kind of whore, and if their postures, their provocative odours, and their gamey skin – under the gas flames that illuminate this watercolour washed in gouache with an uncannily precise truthfulness – are so firmly and so straightforwardly rendered, undoubtedly for the first time, then their character, their humanity, whether bestial or puerile, is no less so. All the philosophy of love for sale is in this scene, in which, after having voluntarily entered, driven by animal desire, the gentleman reflects and, his ardour cooling, ends up remaining insensible to their offers.

In a different order of ideas, one of Forain's watercolour sketchbooks illustrating a poem by Verlaine is sinister and odd.

It's called *A Pimp Strolls in the Countryside*. A short, stocky man in a long smock, his sideburns tucked under his three-decker hat, is walking with his lady, a tall prostitute with ballooning breasts and a sticking out belly that makes her dress ride up, in a countryside that's nothing other than a 'wall walk', forever bounded by the horizon of the city ramparts.

A Pimp Strolls in the Countryside by Jean-Louis Forain.

It's a rendering that brings back to reality the whim of a writer who put these words into the mouth of his pimp:

> *Paris, I ain't gonna spit on you. That's not nice,*
> *And as I've the soul of a poet,*
> *Every Sunday I quit my drinking*
> *And I go, with my ol' lady,*
> *Into the country.*[24]

The overly-contrived scoundrel of M. Verlaine's poem has been avoided by M. Forain, who has developed the scene and turned it into a dismal idyll. A small shiver runs through you when you look at the terrifying comportment of these two beings.

A student of Gérôme – who didn't teach him much – M. Forain studied his art with Manet and Degas, which is not to say that he imitated them or copied them, because he has a very particular temperament, a very special vision. On his good days, when he isn't too easily satisfied and when his drawing doesn't lean too much toward caricature, M. Forain is one of the most incisive painters of modern life I know.

Tea by Mary Cassatt.

EXHIBITION OF THE INDEPENDENTS IN 1880

It now only remains for me – before coming to the work of M. Degas who I've saved until last – to say a few words about the two female painters of the group: Mlle. Cassatt and Mme. Berthe Morisot.

A student of Degas – I see his influence in that charming painting in which the back of a redheaded woman, dressed in yellow, is reflected in a mirror on the crimson backdrop of a theatre box – Mlle. Cassatt is clearly also a student of the English painters, because her excellent canvas, two ladies taking tea in an interior, makes me think of certain works exhibited in 1878, in the English section of the Exposition Universelle.

Here, we're still with the middle class, but it's not that of M. Caillebotte; it's a world that's equally comfortably off, but more refined, more elegant. In spite of her personality, which still hasn't completely emerged yet, Mlle. Cassatt nevertheless has a curious quality that is especially attractive, because there's a frisson of nervous female tension in her painting that is more balanced, more tranquil, more intelligent than that of Mme. Morisot, a student of M. Manet.

Left in the unfinished state of sketches, the works exhibited

A Girl at her Toilette by Berthe Morisot.

by this artist are a chic jumble of white and pink. They're like Manet-esque Chaplins, with the turbulence of nervous agitation and strain added in. The women Mme. Morisot shows us at their toilette smell of 'New Mown Hay'[25] and frangipani; one divines silk stockings beneath their dresses, which seem to be designed by dressmakers of renown. A heady, fashionable elegance escapes from these morbid sketches, these astonishing improvisations, which might justly, perhaps, be qualified by the epithet 'hysterical'.

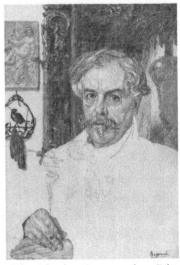

Edmond de Goncourt by Félix Bracquemond.

I now pass in front of the soft, whitish painting by Mme. Bracquemond, in front also of the portrait of Edmond de Goncourt executed by M. Bracquemond, a portrait done à la Holbein though of an excessive harshness in the flesh, especially the pores which are like the grain in marble, but an interesting portrait nevertheless because it captures the writer at home in the middle of his collection of precious *objets d'art*; and, neglecting a series of etchings on fine China paper destined to decorate a set of dinner plates, intriguing, it's true, but taken almost wholly from the sketchbooks of Hokusai, I finally stop in the room in which the canvases by Degas shine out.

I don't remember ever having experienced a shock similar to that I felt in 1876, the first time I found myself opposite the work of this master. For me, who had only ever been attracted to paintings of the Dutch school, in which I found my need for reality and scenes of private life were satisfied, it was truly as if I was possessed. The modern, which I would search for in vain

in the exhibitions of the time and which was only beginning to break through in fragments here and there, appeared to me here in its entirety, in a single blow. In the *Gazette des Amateurs*,[26] the journal cultivated by M. Bachelin-Deflorenne in which I made my writing debut, I wrote these lines:

> M. Degas exhibits two canvases representing dancers at the Opera Garnier: three girls in yellow tulle skirts, arms intertwined; in the background, the scenery rises and we glimpse the pink costumes of the corps de ballet; these three girls are poised on their hips and on *pointes* with an extraordinary fidelity.
>
> No creamy, artifical skin here, but real flesh, a little tarnished by a layer of pastes and powders. It's absolutely realistic and it's truly beautiful. I also recommend the painting above this one, the torso of a woman leaning forward and two drawings on pink paper, one of a ballerina seen from the back and the other of one tying the lace of her ballet shoe, which are carried off with a rare suppleness and vigour.

The joy I experienced then, wholly boyish, has since increased with each exhibition in which Degas has featured.

A painter of modern life has been born, and a painter who doesn't derive from anyone, who doesn't resemble anyone, who brings a wholly new flavour to art, wholly new techniques of execution. Washerwomen in their shops, dancers at their rehearsals, café-concert singers, theatre scenes, racehorses, portraits, American cotton merchants, women getting out of their baths, the paraphernalia of bedrooms and theatre boxes, all these diverse subjects have been treated by this artist, who nevertheless has acquired a reputation for only painting dancers!

This year, however, ballet scenes do in fact dominate, and this man of so fine a temperament, of so vibrant a nervous disposition, whose eye is so curiously obsessed and preoccupied by the human

figure in movement, whether in the artificial illumination of gaslight or in the pallid daylight of rooms lit by the melancholy glow of a courtyard, has surpassed himself – if that's possible.

Look at his *Dance Examination*, a bending dancer who is retying a ribbon, and another, head down, her aquiline nose, visible beneath a russet-red mane, pointing to the floor. Near

Dance Examination by Edgar Degas.

them, a friend in ordinary clothes, a girl of the people, freckled cheeks, a mop of hair drawn back under a hat bristling with red feathers, chats during the interlude with one of the girls' mothers, who is wearing a bonnet and a floral shawl and has the face of an old concierge. What truth! What life! How all these figures are arranged, how the light bathes the scene so perfectly, how the expressions on these faces, the boredom of tiresome mechanical work, the searching look of the mother whose hopes are raised when her daughter's body strains, the dancers' indifference to the tiredness they feel, are all laid bare, noted with the perspicacity of an analyst who is both cruel and subtle.

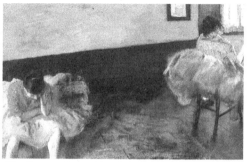

The Dancing Lesson (detail) by Edgar Degas.

Another of his paintings is more lugubrious. In an immense room in which they are exercising, a girl sits on the floor, her jaw resting on her fist, a statue of annoyance and fatigue, while her comrade, the back of her tutu puffing out over the backrest of the chair she's sitting on, stares stupefied at the group frolicking about to the sound of a squeaky violin.

But here now are the canvases in which they take up their double-jointed acrobatics again. The rest period is over, the music grinds up again, the torture of legs starts over and, in these paintings whose subjects are often cut off by the frame as in certain Japanese prints, the exercises accelerate, legs are raised in time, hands grip the bar that runs the length of the room, while the *pointes* of ballet shoes beat the floorboards frenetically and lips smile automatically. The illusion becomes so complete when the eye fixes on these leaping dancers that everything comes to breathless life, one can

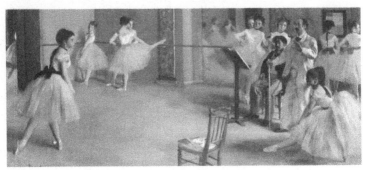

Dance Foyer at the Opera Garner by Edgar Degas.

almost hear the shouts of the teacher, cutting through the shrill din of the violin: 'Push out those heels, tuck in those hips, raise those wrists, and extend those legs', and at this last command the *grand développé* is performed, and the raised foot, carrying with it the seething mass of the tutu, rests, straining, on the high bar.

Then the metamorphosis is complete. The gangly giraffes who couldn't bow, the dumpy elephants whose knee joints refused to bend, are now supple and broken in. The time for training is over and here they are appearing in public, on the stage, pirouetting, leaping, advancing and retreating on *pointes*, in the glare of the gaslights, in beams of electric light; and here again, at least until such time as they become usherettes, fortune-tellers or walkers-on,[27] M. Degas vividly depicts them at the front of the stage, captures them in mid-flight when they leap, or taking their bows to left and right, blowing kisses to the public with their hands.

His observation of the girls in this series is so exact that a physiologist could make a curious study of the physical idiosyncrasies of each of them. Here, the plump ones who have slimmed themselves down and whose complexion fades under a miserable diet of meatloaf and cheap wine; there, the original anaemic types, pitiful consumptive girls who have to lie down in the wings, exhausted by the exercise of their craft, worn out by all that practising in their youth; and over there, the nervous, wiry

girls, whose muscles bulge under their tights, true mountain goats built to jump, true dancers, with tendons of steel and hams of iron.

And how delightful they all are, delightful with a special beauty made up of working class lubricity and grace! How ravishing, how almost divine they are amidst all these canvases of little slatterns ironing or carrying linen, amidst these singers in black gloves their mouths agape, amidst these acrobats who ascend into the roof of a circus.

And what a study of the effect of light! In this regard I could point out a pastel of a theatre box, an empty box next to the stage, the cherry-red screen half raised and the darker purple wallpaper in the background, and then the profile of a woman leaning over the balcony above, looking at the ham actors yapping below; the colour of her hot face in the heat of the room, the blood rising to her scarlet cheeks, burning up to her ears and attenuating at the temple, is of a singular exactitude in that beam of light that strikes her.

The exhibition by M. Degas this year comprises a dozen pieces; I've already cited a few, but I will point out two more superb drawings: one, a head of a woman that would absolutely be worthy to figure among the drawings of the French school at the Louvre; and the other – which I will now stop in front of for a few minutes – a portrait of the late-lamented Edmond Duranty.[28]

Edmond Duranty by Edgar Degas.

It goes without saying that M. Degas has avoided the idiotic background so dear to portrait painters, those hangings – scarlet, olive green, tulip-blue, purple, greeny-brown or ash grey – that tear a big hole in the fabric of truth, because at the end of the day one has to paint the person one's doing a portrait of in their home or in the street, in a real setting, anywhere, except in the middle of a polished sheet of bland colour.

M. Duranty is there, in the middle of his prints and his books, sitting at his table, and his slender nervous fingers, his keen, mocking eye, his searching, piercing look, his comical English primness, his little dry laugh into the stem of his pipe, pass through my mind again at the sight of this canvas in which the character of this meticulous critic is so well rendered.

It's difficult with a pen to give even a very vague idea of M. Degas' painting, it has its equivalent only in literature; if a comparison between these two arts were possible, I would say that M. Degas' accomplishment reminds me in many ways of the literary accomplishments of the Goncourt brothers. These men will turn out to have been, the former as much as the latter, the most refined and most exquisite artists of the century.

In the same way that to make visible, almost palpable, the exterior form of the human animal in the milieu in which he lives, in order to show the mechanism of his passions, to explain the march and the phases of his thoughts, the aberration of his devotions, the natural blossoming of his vices, to express the most fugitive of his feelings, Jules and Edmond de Goncourt had to forge an incisive and powerful tool, to create a new tonal palette, an original vocabulary, a new language; likewise, in order to express a vision of beings and things in an atmosphere proper to them, to show their movements, their postures, their gestures, their facial expressions, the various aspects of their features and their makeup according to the attenuation or the intensity of light, to translate effects that were misunderstood or considered impossible to paint

Miss Lola at the Cirque Fernando by Edgar Degas.

hitherto, M. Degas had to fabricate an instrument that was at one and the same time both broad and fine, flexible and firm.

He also had to borrow from all the vocabularies of painting, to combine various elements of oil and pigment, of watercolour and pastel, of tempura and gouache, to forge neologisms of colour, to break with the accepted arrangement of subjects.

An audacious and singular painting style that tackles the imponderable, from the slightest breeze that ruffles gauze on tights, to the wind of an *entrechat* that fans out the layers of tulle in a tutu, an intelligent and simple style of painting nonetheless, devoting itself to the most complicated and boldest poses of the body, to the tensing and relaxing of muscles, to the most unforeseen effects of perspective, and daring – in order to give an exact sensation to the eye that follows Miss Lola ascending by force of her teeth to the heights of the Cirque Fernando – to slant the roof of the circus completely to one side!

And what a definitive abandonment of all the techniques of light and shade, of all the old imposture of tones prepared on the palette, of all that trickery taught over the centuries. And what a new application of Delacroix's theory of 'optical mixing', which is to say producing a tone absent from the palette but achieved on the canvas by the juxtaposition of two others.

Here, in the portrait of Duranty, it's patches of an almost bright pink on the forehead, of green in the beard, blue in the velvet collar of the suit; the fingers are done with yellow bordered by episcopal purple. Up close, it's a slashing crosshatch of colours that clash and shatter against each other, that seem to overlap each other; at the distance of a few steps, all this harmonises itself and melts into the precise tone of flesh, of flesh that breathes, that lives, and that nobody in France has known how to do until now.

It's the same with his dancers. The one I spoke about above, the redhead whose aquiline nose almost touches her chest, has a neck shadowed in green and the curve of her calf outlined in purple; up close, her tights are a crush of pink pencil; at a distance, they are cotton stretched over a flexing leg muscle.

No painter since Delacroix – who he's studied for a long time and who is his true master – has understood the marriage and the adultery of colours like M. Degas; no one today has a drawing style so precise and so broad, a touch for colouring so delicate; just as, in a different art, no one has the exquisiteness that the Goncourts put into their prose; no one has fixed, like them, in a deliberate and personal style, the most ephemeral of sensations, the most fleeting finesse and nuance.

A question now arises. When will the high place that this painter should occupy in contemporary art be recognised? When will it be understood that this artist is the greatest we have today in France? I am not a prophet, but if I judge by the ineptitude of the enlightened classes – who after having reviled Delacroix for so long still don't even suspect that Baudelaire is the poet of genius of the 19th century, that he is head and shoulders above everyone else, including Hugo, and that the masterpiece of the modern novel is Gustave Flaubert's *Sentimental Education*,[29] even though literature is supposedly the art most accessible to the masses – I can well believe that this truth about M. Degas, which I am the only person to write today, will probably not be

recognised as such for many, many years.

One can say, however, that a change has taken place in the attitude of the public, who in the past just split their sides at the exhibitions of the rebel Impressionists, making no allowance for failed efforts, for the ravages of colour blindness[30] and other afflictions of the eye, not appreciating that these pathological cases weren't laughable, but were simply interesting to study. Nowadays, they wander more peacefully through the rooms, still scared and irritated by works whose innovation unnerves them, totally unaware of the unfathomable abyss that separates the modern as M. Degas and M. Caillebotte conceive it, and that manufactured by Messrs Bastien-Lepage and Henri Gervex, but in the main, in spite of the public's longstanding stupidity, they nevertheless stop and look and are astonished, and are even gripped a little by the sincerity these works exude.

One can even add that these days the visitors' laughter is directed at certain other canvases scattered throughout this exhibition, at mediocre canvases that are neither Impressionist, nor modern; and I wish, while we're on this topic, that the former would cleanse itself as quickly as possible, and sweep out the withered fruits that have escaped, how I don't know, from the official Salon.

One must also hope that at the same time as this banishing of the worthless is carried out, new talents will emerge and come to ally themselves with the Independents. The whole of modern life is still to be studied; if some of its multiples facets have been glimpsed and noted, it is barely a start. Everything is to do: official galas, soirées, balls, scenes of domestic life, lives of artisans and of the middle classes, shops, markets, restaurants, cafés, bars, in short, all of humanity, in whatever class of society it belongs and whatever function it fulfils, at home, in a hospital, in a dancehall, at the theatre, in public squares, in impoverished streets or in those vast boulevards whose Americanised aspect forms the obligatory backdrop to the desires of our time.

Besides, if some of the painters who we've occupied ourselves with have, here and there, reproduced a few episodes of contemporary existence, what artist will now render the imposing grandeur of our industrialised cities, will follow the way opened by the German, Adoph Menzel, by going into huge foundries, and into railway stations (which M. Claude Monet has, it's true, already tried to paint, but without managing to capture in his hesitant shorthand the colossal size of locomotives or depots), what landscape artist will render the terrifying and imposing solemnity of blast furnaces burning in the night, of gigantic chimneys crowned at their summit by pale fires?

All the work of man, striving in mills and factories, all the modern fervour that industrial activity presents, all the magnificence of machines – all this is still to paint and it will be painted, provided that modernists truly worthy of the name agree not to demean themselves or mummify themselves in the eternal reproduction of the same subject.

Ah, the beautiful part they have to play! The last pupils of Cabanel and Gérôme continue to patch up the moth-eaten finery of previous centuries in order to get a medal; among the most celebrated, a certain number have installed themselves in their studios, like courtesans, and, to the profit of their art dealer, give themselves up to vulgar 'quick ones' of painting.

Others still sit in their windows, working for themselves like the tarts in Amsterdam,[31] knocking out titillating works for the middle classes, who they arouse by lavishing on them the sentimental caricatures of real life that they adore.

To conclude, French art is at rock bottom; everything has to be rebuilt; never has a more glorious task been reserved to artists of talent, such as these painters whose submissions I've just looked at in the rooms of the Rue des Pyramides.

THE OFFICIAL SALON OF 1880

I

I pity the unfortunate painters who are neither exempt from the selection panel, nor *hors concours.*[1] Their canvases are piled up at random, higgledy-piggledy, one on top of the other, in lumber rooms and inaccessible dumps, at such a height you'd need a telescope to find them. By contrast, all the bigwigs divide up the good spots among themselves; they stretch out impudently along the picture rails, forming their own little insulated salons, like the receptions of old dowagers, in the middle of this marketplace where, amidst the impenitent stupidity of the exhibitors, a few works shine out at rare intervals, testifying to the fact that true artists still exist, destined for many years to come to be spurned by the individuals in charge of painting in France.

I don't want to blame or attack the administration whose childish regulations have brought about this state of affairs, but nevertheless I have to speak up, because this criticism is on everyone's lips – never has there been incompetence like this, never has administrative ineptitude been so gloriously on display as this. The Salon of 1880

is a bedlam, a confusion, a hurly-burly, made worse still by the incomparable maladroitness of the new classification system. Under the pretext of democracy, they have struck down the unknown and the poor. Such is the innovation authorised by the Under-Secretary of State for the Fine Arts, M. Turquet.[2]

But let's leave that aside as many of these painters are barely worth supporting anyway. They constantly demand assistance from, and validation by, the State, instead of telling it to go to the devil, instead of rejecting the infantilism called 'Mentions' and 'Medals', instead of trying to stand on their own two feet. So let them get themselves out of this mess as best they can. It's not my business; I'm simply going to limit myself to examining their work.

It is rather difficult, given the astonishing disorder that reigns in the exhibition rooms, to get a very clear idea of the whole. It appears, at first sight, to constitute a warehouse reserve, a stockroom in the Musée de Luxembourg, an outhouse where all the pretentious mediocrities of the art schools are piled up.

Fifty paintings, at most, deserve to be looked at. Out of this immense chaos of canvases I will disregard, intentionally, all the customary clichés and commonplaces. Indeed, what good is it to collect together thousands of these bits of signage that persist in constantly repeating all the same subjects, all the same habits, hammered into the poor brains of our artistic practitioners, from father to son and pupil to pupil, over the centuries?

Alas, mediocrity is in operation this year, even more furiously than ever. The same painters, using the same technique, repaint their same works from last year. Here, it's the 'Fortunyists' – Casanova, Gay and their ilk – who, with no more talent than before, start all over again on their little gentlemen dressed in gaudy colours, lifelessly stuck onto gilded panels or in gardens that spread out untidily from the background of the painting to the foreground; there, it's the genre painters, the vaudevillistes of art, Loustaunau, Lobrichon and all the other manufacturers of cut-price goods.

And everywhere there are pupils of Cabanel and Bouguereau, who equal if not surpass their deplorable masters in nullity. Add to this the virgins and the nudes of the history painters, the Charlotte Cordays and Marats that abound this year, each one more comical than the last, and we have an almost exact summary of the objects exhibited in 1880, in this official bazaar of art sales.

It only remains for us now to search out the few stray works of talent, for the most part hung up in the heights, under the muslin sky of the ceiling.

It certainly won't be in the entrance hall that we'll unearth them; it's here that the canvases that have no doubt been painted to order are hung; among others *A Christian Martyr*, by M. Becker, rudely dumped at the bottom of the stairs by some ill-bred functionary, a meagre painting beneath its apparent energy,

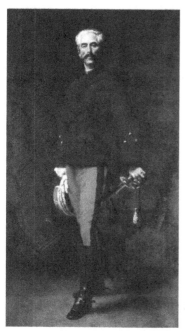

General Galliffet by Georges Becker.

but at least not grotesque, like the portrait by the same painter representing General Galliffet,[3] standing boastfully, against a dark background.

The opening square room is occupied, down one whole side, by an oversized piece of theatrical scenery, *The Battle of Gründwald*.[4] It's the most extraordinary hodge-podge you could dream up. It resembles a badly done chromo in which the oranges have mixed with the reds, and the yellows with the blues. The most violent and the most garish colours are put next to one another, on top of one another, swallowing

The Battle of Gründwald (detail) by Jan Matejko.

up the figures, which disappear amid this cacophony of tones. It is, in short, a pile of raw fabrics, a heap of uniforms and weapons thrown about everywhere in abundance, without order; nothing is alive in this canvas. M. Matejko has popped his pots and tubes of expensive colour to no purpose.

On the panel facing this battle scene, stretches M. Roll's *The Miners' Strike*. This artist is one of those worth taking an interest in because his work is indicative of a personality. In 1879, M. Roll exhibited a bold and turbulent *Feast of Silenus*; this year, he gives us a modern canvas full of good qualities and bad defects, but a canvas that is well and truly his own – which is certainly the highest praise I can offer. Although still trying to find his way, this painter has freed himself from the obsessional memories that haunted him in his *A Flood in Toulouse* and in his *Silenus*. From this point of view, he is still progressing.

His miners' strike is posed as follows: there are men and women in a crowd; on the left, close to the lugubrious brick buildings of the coal mine, troops are arriving; on the right, a gendarme has dismounted his horse and is handcuffing a miner, while the tall silhouette of another gendarme on horseback is

The Miners' Strike by Alfred Roll.

profiled against a lugubrious sky. The scene is skilfully arranged. A woman placed in the middle of the men, near a cart with its shafts in the air, holds a child to her breast and stares, frightened, stupefied by misery, comprehending that to all the daily hardships one more terrible will now be added: the arrest of her husband, her breadwinner. A single figure spoils the painting for me, that of the melodramatic miner, sitting on a pile of coal, his head resting on his fist. M. Roll managed to avoid the humanitarian emphasis which I feared might overwhelm such a subject; his gendarmes, quietly going about the unintelligent task that is entrusted to them, are excellent; why the devil then did he have to sacrifice the demands of the scene by posing this useless coalman so obviously, highlighting him in the foreground?

With this reservation, and despite the design being a bit weak in places, M. Roll's *Strike* is a brave work. He has dared to abandon cold-cream skins and plush cherry-red interiors in order

to paint the poor. He will hear it said that he is painting 'vulgar' pictures and that he lacks taste. He will be proud, I hope, to be judged so stupidly.

On the other hand, M. Bastien-Lepage can be quite assured that these attacks will not be levelled at his painting. The eternal model who has served him to represent – in the form of a woman – harvests of potatoes and of hay, is this year, exceptionally, upright. I am grateful to M. Lepage for being willing to at least vary the pose for once, because the clothing of his Jeanne d'Arc is exactly the same as that in which he dresses his fake country-women. These are not the genuine clothes of a poor woman, rather they're prettified rags made by a theatrical costumier. And Grévin[5] has even added for the occasion all sorts of affectations to it: the pretty, loosely-laced bodice, the fringes that are coming

Jeanne d'Arc by Jules Bastien-Lepage.

unstitched but are nevertheless carefully hemmed, all the bric-à-brac of material worn by Mignon[6] when she comes on stage. Thus equipped, Jeanne stands, like a sleepwalker, eyes to the sky, stretching out an arm and opening a hand, between the fingers of which, thanks to one of those spiritual fantasies so dear to painters, falls the carefully varnished leaf of a small tree.

By an optical effect no doubt observed in mental illness, this actress sees the figures that are behind her: three vague forms, one in armour from top to bottom and holding a sword, and two others, wrapped in long nightshirts and crowned with those little circlets of copper that the dictionary of technical terms calls, I believe, aureoles or nimbi.

Such is the mediocre disposition of this canvas, but what is worse is that all these people are cramped; the painter's usual lack of perspective is even more accentuated here. Planes overlap one another; the apparitions, clumsily painted, don't fly in the air, they hang like pub signs to the roof of the house they're touching, swinging in the wind on their poles; ultimately M. Lepage persists in his phony craftsmanship, it's the skill of a workman who can trace a letter in a single stroke. All these assorted flowerets are painted, one by one, petal by petal, by this effete[7] painter familiar with the techniques of the Pre-Raphaelites; moreover, his decorative thistles are, as he anticipated, much admired by the bulk of the crowd.

It is perhaps time to tell the truth: *Jeanne d'Arc*, like the other paintings by M. Lepage, is the work of a sly painter who is trying out a fake Naturalism in order to appeal to a certain category of the public, and who enlivens this appearance of truth with every insipidity imaginable so as to coax the remainder of the exhibition's visitors. This mixture of canny showing off and old practices has nothing to do with the sincere art that we love.

I could say as much of M. Gervex. He has chosen a sensational subject in order to strike a forceful blow;[8] he has absolutely failed, which was only to be expected given his miraculous banality, and

his work will go unnoticed. It is sad to have to say it, but M. Gervex – who like M. Lepage has become a phoney modern – had a certain bravura in the past; in short, despite a slackness that he acquired from Cabanel, he had talent. Where is it now? His girl shot during a riot, exhibited on the picture rail this year, has been painted by Mr Everyman; it could have been signed by the paltriest artist to feature on these walls. The punishment for this facile gimmick dreamed up by M. Gervex won't be long in coming.

II

M. Gustave Moreau is an extraordinary artist, unique. He is a mystic, closeted in the middle of Paris, in a cell into which even the noise of everyday life, which nevertheless beats furiously against the doors of his cloister, does not penetrate. Plunged into ecstasies, he sees resplendent fantastical visions, the bloody apotheoses of other times.

After being obsessed by Mantegna and by da Vinci, whose disconcerting princesses wander in mysterious black and blue landscapes, M. Moreau became infatuated by the hieratic arts of India and the twin currents of Italian and Hindu art; spurred on, too, by the feverish colours of Delacroix, he has brought forth an art that is truly his own, created a new, personal art, whose unsettling flavour is initially disconcerting.

In effect, it's because his canvases no longer seem to belong to painting in the strict sense of the term. In addition to the extreme importance that M. Gustave Moreau gives to archaeology in his work, the methods he employs to render his dreams visible seem to be borrowed from the techniques of old German engraving, from ceramics and from jewellery; there is everything in it, mosaic, niello work, Alençon lace work, the patient embroidery of the past, and it hints, too, at the illuminated missals of the medieval period

and the barbaric watercolours of the ancient Orient.

But it is even more complex, more indefinable. The only analogy that really exists between these works and those that have been created up to the present day would be with literature. Indeed, in front of these paintings one experiences a feeling almost equal to that which one feels when reading certain bizarre and delightful poems, such as the dream dedicated to Constantin Guys in *The Flowers of Evil* by Charles Baudelaire.

Yet it would be truer to say that M. Moreau's style is closer to the gilded language of the Goncourts. If it were possible to imagine Gustave Flaubert's admirable and definitive *Temptation of St. Anthony* written by the authors of *Manette Salomon*, perhaps then one would have the exact equivalent of the so deliciously refined art of M. Moreau.

The *Salomé* he exhibited in 1878 was alive with a strange, superhuman life; the canvases he is showing this year are

Galatea by Gustave Moreau.

no less original and no less exquisite. One represents Helen of Troy, standing erect, highlighted against a terrible horizon splashed with phosphorus and streaked with blood, clothed in a dress encrusted with precious stones like a reliquary; she is holding a large flower in her hand, like the queen of spades in a deck of cards, and she walks, staring, eyes wide open, in a cataleptic

pose. At her feet lie a mass of corpses pierced with arrows, and with her imposing blonde beauty she dominates the carnage, majestic and superb, like Salammbô appearing to the mercenaries, like a malevolent divinity who poisons, without even being conscious of it, all who approach her or all that she sees and touches.

The other canvas shows us Galatea, naked, in a grotto, watched over by the enormous face of Polyphemus. It's here above all that the magical brushstrokes of this visionary blaze out.

The grotto is a vast jewel box in which, under the light falling from a lapis lazuli sky, a strange mineral flora weaves its fantastic shoots and intertwines the delicate lacework of its incredible leaves. Branches of coral, sprigs of silver, grey-brown starfish in openwork filigree, spring forth at the same time as green stems bearing both chimerical and real flowers, in this den illuminated by precious stones like a tabernacle and containing the inimitable and radiant jewel, her white body tinged with rose at the breasts and lips, of Galatea, sleeping in the long tresses of her pale hair!

Whether one likes or dislikes these fantasies, hatched in the brain of an opium eater, it has to be admitted that M. Moreau is a great artist and that today he stands head and shoulders above the banal mob of history painters.

And yet all of the

Honorius by Jean-Paul Laurens.

latter are 'great artists', if I'm to believe the clichés bandied about every year at this time; Laurens, 'a great artist', is the painter of *Honorius*, a swarthy kid, dressed up in a red bedsheet and crowned with a diadem, a kind of street urchin who we've seen wandering the streets of Paris, jumping on one foot to play hopscotch on the pavement, or crawling around on his knees on a café terrace, collecting cigar butts and pipe dottle from between the legs of customers. A 'great artist', too, is M. Puvis de Chavannes, who is obviously superior to the former, but who continues his little joke which has lasted perhaps a bit too long. He works in the 'sublime': it's a speciality like that adopted by M. Dubufe, who works in the 'pretty'. M. Puvis de Chavannes poses in angular postures people who he awkwardly brings together in groups; he dispenses with looking for the right tone, he doesn't give his characters –

Ishmael by Jean-Charles Cazin.

or the milieu in which they display their heavy stiffness – any semblance of truth or life, and for the art critic this becomes the naïve quality of the Primitives, of the fresco painters, of mechanical decoration, it is 'great art', 'sublime', 'reminiscent of Bornier',[9] and I don't know what else!

On the other hand, I readily acknowledge the complete success of the great effort attempted by M. Cazin. Here, there is none of that affectation of simplicity which

offends me so much in the work of M. de Chavannes; and, in these soft and melancholy landscapes, blooming with yellow broom and bristling with green pine needles, the figures attain through their simplicity a true grandeur. M. Cazin has found the means to make a very bold, very original work, with subjects that have been beaten to death over and over for centuries. Not to hide anything, his titles lie, because his characters are hardly biblical. The Egyptian handmaid, Hagar, and her son Ishmael are, in the artist's painting, two modern figures, and it's not their abandonment in the desert, as told in Genesis, Chapter 21, that M. Cazin represents, but rather the distress of a poor country woman who sobs, distraught, her face in her hands, while her child stretches out his arms to embrace her. *Ishmael* is thus a contemporary work and the emotion which grips us in front of it comes precisely from the fact that we are not facing

legendary characters whose adventures barely touch us, but are actually opposite a terrible scene from real life, told frankly and sincerely by a true artist. *Tobit*, conceived in the same way, is painted like *Ishmael*, without effort, without trickery, in a charming tonality of pearl grey and pale yellow.

As for the other canvases belonging to the category known as history painting, what good would it do to talk about them? After I've cited M. Monchablon's

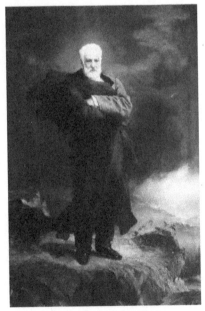

Victor Hugo by Xavier Monchablon.

laughable portrait of Victor Hugo standing on a rock in a full storm, holding on to the academician's gown with which his shoulders are adorned, and especially after I've spoken about M. Bonnat's *Job*, I will certainly have scraped the barrel – and even stirred up the bottom.

His Job has an unmistakable resemblance to the late-lamented 'Coelina', the man with the rats who used to perform on the Place des Invalides.[10] It's true that, in his turn, this much-missed artist resembled, like two peas in a pod, all the old male models who march from one artist's studio to another, from Vaugirard to Clichy, and from Clichy to Batignolles. There's been a lot of work this year for these fine gentlemen, judging by the considerable number of paintings in which their bearded mugs appear. I cite, among others, the old gent whose face appears on the top of a very mediocre Cain, exhibited by M. Cormon.

The Rat Man by Félix Régamey. *Cain* (detail) by Fernand Cormon.

So, to return to Job, this old man is kneeling on two wisps of straw, in an ecstacy that must have earned him at least five francs an hour. Never has trompe-l'oeil functioned to so little effect, never has a more belaboured, more pitiful painting come off the dull trowel of that mixer of mortar who goes by the name of Bonnat. This Job is painted, wrinkle for wrinkle, wart for wart,

Job by Léon Bonnat.

against the eternal black background that emphasises the pallor of miserable flesh illuminated by the purple-blue flame of a candle. And what to say about Bonnat's *Portrait of Jules Grévy, President of the French Republic*? M. Grévy is posed like a broom handle against a sombre background and again no doubt lit from above by a skylight, letting bluish glints drip onto the forehead and onto the hands, which are brushed with a thousand fussy retouches, a thousand preciosities of detail. It's a portrait in which the title says everything and the painting nothing, it's a piece of manual labour, the neat work of a foreman, and that's all.

This opinion could also apply to the canvases of M. Carolus-Duran; moreover, this latter has given himself a curious piece of additional athletic labour on top. He is like the man in the circus who, to the acclamations of the crowd, lifts barbells, or rather he's like the clown who, after this Hercules has finished his flourishes, parodies him by also juggling with barbells, but ones that are hollow and made of cardboard. After his portrait of a child in blue

Jules Grévy by Léon Bonnat.

last year, here, this time, is a portrait of a child in red, a child pretentiously posed in scarlet clothing against a crimson background. Red on red, such is the exercise. The trick is achieved, yes, but at what price? A figure of a doll that doesn't live, and a clash of colours that will fade before the year's out.[11] All these tones will harden more quickly than usual, turning clothes into metal, and flesh into leather; it's already happened in his portrait of a lady in blue against a dark red background. A leg painted by this former 'couturier' has now disappeared. The dresses he formerly brushed so dexterously now seem to be made of grainy wood and iron. Thus the weights lifted in this feat of strength are too obviously false; the tinfoil that covers their armature of cardboard is peeling; he'll have to change them or repaint them.

I arrive now at the portrait which is, in my opinion, by far and away the best in the Salon, that by M. Fantin-Latour. This portrait represents a woman dressed in black and sitting on a chair. The head looks at you, speaks to you; it is superbly achieved, without bluster and without fuss; it is a hard painting, almost austere, in some ways puritanical and grave, like certain canvases of the modern English school. M. Fantin-Latour has here created a beautiful work which, because of his discretion and his preference not to address his work to the passions of the vulgar, will unfortunately be savoured only by a few.

I willingly leave aside *The Final Scene from Rheingold* by the same painter, and I will cite, to close this section, a portrait by one of his pupils, a German, M. Scholderer, a portrait of a man standing out against one of those grey backgrounds M. Latour is so fond of. It is a full, very vivid painting which, in spite of its slightly wilful imitation of the master, shows that M. Scholderer has a very personal temperament as a colourist.

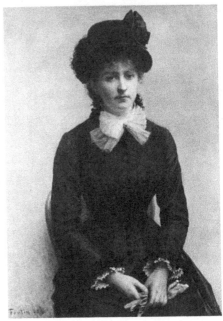

Louise Riesener by Henri Fantin-Latour.

III

After a rapid excursion through landscapes and still lifes, we will come to what is conventionally referred to as 'modern' painting. The truth that landscape artists have now arrived at an unequalled facility becomes more evident each day. Each one dresses his corner of nature with a sauce suited to the inclination of the buyer. There's no individuality with the majority of these painters, just the same, singular vision of a scene arranged according to the predilection of the public. Here, it's endless works by the brothers César and Xavier de Cock, those eternal reproducers of alleyways of trees in which, not far from a stream, the sun rains down in parsimonious drops

amid bright clumps of foliage. Alas, I sense that these landscapes are dashed off in a workshop, in a couple of sessions at great speed. No scent of leafy bowers or grass, no sense of place. Over there, it's works by Bernier, Mesgrigny, Daubigny Jr, and Rapin, painters whose brushes move of their own accord, without them even gathering their thoughts in front of the nature they deform, curling it and rinsing it with their shampoos; everywhere, practising artists are working in closed rooms, far from the light of day, far from the open air.

An exception can be made for M. Guillemet. After brushing his *View of Bercy*, now in the Musée de Luxembourg, where it's lost among a whole heap of clamouring things, this artist adandoned the Parisian countryside, and with a creditable flexibility painted the *Environs of Artemare* and the very moving landscape in last year's Salon. This time, M. Guillemet has returned to Bercy and, once again, but with a different emphasis, has painted the landscape bordering the Seine. The bitter melancholy of his first *View of Bercy* has been refined, it's more tender and less dulled by sadness, which this artist often imprints on some of his works.

The Old Quay at Bercy by Antoine Guillemet.

Lavacourt by Claude Monet.

The Old Quay at Bercy is certainly the most expressive landscape the Salon contains. It's a hardy painting by a well-balanced and healthy artist, a highly-strung artist who's in control of himself.

After him, the landscape artists who deserve to be cited are rare. Nevertheless, M. Yon exhibits a *View of the Canal at La Villette* during the freeze; I would also point out a *View of the Outer Harbour at Dunkirk* by M. Lapostolet; a Luigi Loir done with his usual light touch; a Claude Monet that has somehow strayed into this exhibition; two views by M. Klinkenberg, one of *The Hague* and the other of *The Spanish Quay in Rotterdam*; and lastly a Lerolle, *In the Countryside*, representing a woman herding sheep. Objections surge up in me in front of this canvas. This landscape, with its decorative allure, is incontestably the work of a good artist. The air circulates, the horizon retreats into the distance giving a vague flavour of nature, but what to say about the peasant woman? She looks like one of those pretty music hall divas fitted out by a fashionable couturier.[12]

She's as untruthful, as affected, as any of M. Bastien-Lepage's serving girls; the picture's a mongrel, another piece of phoney

In the Countrysde by Henry Lerolle.

realism. M. Lerolle will carry off a prize this year with his canvas; he shares with the painter of *Jeanne d'Arc* the infatuation of a public that prides itself on being modern, but which is scared off by any real attempt at it.

It matters little to me. After all, I'm going to see a dazzling still life by M. Vollon. This painter, who has allowed us to see some of his melancholy rainy landscapes, has returned this year to the genre that initially made him famous. In a black frame an enormous pumpkin spreads out, tumescent, next to a black iron cauldron and a yellow brass bowl. There it is, like a ball of fire, bursting from the wall, leaping out from the pale inadequacies that surround it; it's knocked out with great brushstrokes, beaten out like a Franz Hals; there's a thousand times more talent in this simple pumpkin than in M. Dagnan's *Saint Herbland*, than in all the ceilings painted by the yard by the son of M. Robert-Fleury.[13]

Vegetables, fruit and flowers now spread out in all the alcoves, corridors, rooms and stairways. They spring up, pell-mell, contemptuous of the season, signed, for the most part, in letters of red oxide, by Monsieur So-and-So – or rather by Madame

So-and-So, because it's mostly women who devote themselves to this form of cultivation.

First of all, I will leave to one side the customary panels in which a thin taffeta flower dips its wire stem into the belly of a limp vase. I will simply point out, in passing, that pleasant innovation adopted by painters both female and male: the still life conundrum, the still life riddle.

Pumpkin by Antoine Vollon.

Three canvases, among many others, are of a quite remarkable contrivance. One, by Mlle. Desbordes, represents a map of the world on which rests a flower that brushes a country or a sea: explanation, *In Memory of an Absent Friend*; the other, by M. Delanoy, shows us a book pierced through by the blade of a sword: solution, *Might Beats Right*.[14] Lastly, the third is designed as follows: a revolver is posed on a table beside an open letter announcing that the jury refuses this painting; part of a folded will completes the scene. This is what's called the 'painting of ideas', and some painters consider this annoyance to be witty.

Two paintings are however worth stopping for: *Chardin's Storeroom* by M. Hippolyte Delanoy, which I'll talk about first, and *At the Orientalist's*, by M. François Martin.

The first of these works betokens an extreme manual dexterity; all the objects – such as the red copper water container, the cask whose empty bunghole gapes in the shadows, the pot, and the bottle with red wax round its neck – are real enough to touch, so much is M. Delanoy a past master in the art of trompe-l'oeil; but as soon as it's a question of 'animate life', all this changes; the ray lying in the centre of the storeroom is made of rubber

smeared with lilac and egg white. This painter is either being very disingenuous or very heavy-handed in evoking Chardin's name and the memory of his famous ray that hangs in the Louvre.[15]

The other canvas is painted by a man who is more skilful and more deceptive still, if that's possible. On a table covered in Oriental fabrics, loaded with ewers, hookahs and weapons, a glass demijohn bulges its enormous sides, in which is reflected the workshop of the painter and the artist himself, sitting in front of his easel, his back towards us, in the act of reproducing the objects grouped in his canvas. This eccentricity is redeemed by the assurance with which it's done; the three-dimensional effect these objects have when you squint your eyes and look at them is astonishing; the effect, bizarrely chosen though it might be, is precisely rendered; nevertheless, the pitiless skill of M. Martin frightens me; we must remember his name and see if his personality, which hasn't emerged yet, reveals itself in his next work.

A question now arises. Never, as we've seen, have more expert technicians been involved in painting still lifes, but among them

Chardin's Storeroom (detail) by Hippolyte Delanoy.

all is there anyone who has broken with the traditional clichés of their trade? Where is the artist who, instead of making his objects or his flowers stand out as bright spots against a sombre background, has painted them simply, in the open air and in full daylight? Vollon, Ribot and the other painters in the exhibition in the Avenue de l'Opera, all incarcerate their objects in a cellar and light them by partial daylight, which, moreover, slants down from a skylight.

The only previous attempts to have been dared were those by M. Manet, who pulled off some paintings of flowers in real daylight. Another effort is the work of one of his students, Mlle. Jeanne Gonzalès, who this year exhibits her pots of geraniums in a garden. Poorly hung, tucked away in a corridor, the clarity of this work is astonishing. Another painter, M. Bartholomé, this time relegated to a space up in the cornices, also stands out amongst the neighbouring mass of paltry works. A sober talent, with an almost English self-restraint, he is a sincere artist; study his canvases and

The Orphanage at Katwijk by Adolph Artz.

the charm of his discretion, his frankness, will penetrate you, such is the impression that his *Meal in an Old People's Home* leaves. The nun who pours the wine is charming, and the poor old men sitting on benches are well observed and authentically posed. I doubt that M. Bartholomé will gain a success, even this time, because his canvas lacks the ingredients dear to the public – its characters are not made-up actors, they are genuinely poor people in rags, drawn from life and candidly painted.

I pass now in front of the strange triptych by M. Desboutin whose paintings, formerly so muddy, have lightened up and become better each year; I leave aside M. Bonvin's *A Corner of the Church*, which is as dry as tradition, and as contrived and polished as the worst paintings of the Dutch school, and before arriving at Messrs Manet, Béraud, Goeneutte and Dagnan-Bouveret, who will form the subject of the final section, I will pause in the room devoted to the foreign schools, in front of the canvas by M. Adolph Artz, *The Orphanage at Katwijk*.

The Eternal Giveth, the Eternal Taketh Away by Christoffel Bisschop.

Through a large window, daylight enters, bathing one of those large, peaceful Dutch rooms, with its floor of polished earthenware tiles, its large armoire, its old Bible on a lectern, its oak table and its brown chairs. Some women are sitting at the table near the window, sewing. This canvas is captivating; these orphans don't pose for the gallery, they quietly get on with their mending, talking in a whisper. If ever there was a delicate and uncomplicated painting, it's truly this one, and I will even add on this point that I almost prefer M. Artz, the pupil, to M. Israëls, the master, whose tendency to sentimentalism spoils his work for me at times.

Another equally interesting painting in the same genre is that by another Dutchman, M. Bisschop, entitled *The Eternal Giveth, the Eternal Taketh Away*. The scene is posed as follows: a seated woman cries in front of an empty cradle; another woman stands, silently, looking at her, tears in her eyes. Give a similar subject to a French painter and see how he would treat it; it would undoubtedly

Vegetable Peelers by Max Liebermann.

Female Sardine Worker in Concarneau by Peder Kroyer.

turn into a romantic vignette, a sentimental café-concert song: the postures of the women imploring the heavens and holding out their arms would either be annoying or comical. Inevitably, it would evoke the memory of a wailing clarinet in a brass band, and women sniffling noisily in front of their glasses of beer. Here, nothing of the kind. By the force of good faith M. Bisschop isn't ridiculous for a second. The unhappiness of his women isn't feigned, and in front of the tears that choke them, emotion gains hold of us. Added to which, this canvas is painted with a force that few artists today could match; it's a luminous painting in which all the characters and objects stand out in an astonishing way. It is highly finished and very spacious. In front of this silvery, lucid painting, I was inevitably reminded of Van der Meer of Delft – and to think that M. Bisschop is a pupil of Gleyre and Comte!

These two paintings are the pearls of the foreign schools at the present Salon. I must also give a special mention to M. Liebermann, who gives us *Vegetable Peelers* and *An Infant School in Amsterdam*; to M. Garrido, a Spaniard, who presents a pretty little picture, *At Fifteen*; and lastly to M. Kroyer, a Dane, who shows us a pleasing *Female Sardine Worker in Concarneau*.[16]

IV

The painting of modern life is personified, in the eyes of the unthinking public, by the canvases of M. Bastien-Lepage and M. Henri Gervex. Three other painters are also presumed to depict everyday scenes of contemporary life, they are Messrs Béraud, Goeneutte and Dagnan-Bouveret.

Well, if it comes to that, what about the pictures in illustrated newspapers and ladies' magazines, those by M. Grévin and M. Robida, by 'Crafty' and 'Stop'?[17] Why neglect to mention them? It's very true that they've never sketched anything modern, never observed anything modern, but do you really think the painters I've listed – and to whom I could also add M. Hermans,[18] the author of that monstrous folding screen, that epic advertising poster, *The Masked Ball* – aren't all equally as blind and incapable of interpreting scenes from real life?

To be fair, as regards modernism they're all as bad as each other, and I solemnly declare, in all good faith, that I don't see

The Masked Ball by Charles Hermans.

any difference between some of the drawings of dances engraved in illustrated newspapers, and the colourful open-air dance scene that M. Béraud exhibits for us.

Nevertheless, the subject is new and interesting, whatever one might think about it, and I still don't know any artists who have treated it naturally. Imagine for a moment trying to represent, under flaming lights, couples in each other's arms, twirling to the blaring sound of brass. It would have needed a bold, strong artist, and what we get in his place is an obsequious and timid painter, who has observed nothing. His characters are illuminated puppets; none of his whores smell of whores, and on none of the faces of his waltzers can one adduce the honest or dishonest profession they exercise during the day and the night; none of these puppets move, jump or twirl; all their strings are broken and the action of their legs and arms is hampered. The figures are lamentable, but what is one to say about the lights that illuminate them? M. Béraud has never, and I mean never, even noticed the pale green of leaves on trees when lit from below, or the harsh brilliance of

Open-Air Dance by Jean Béraud.

skies above the fierce gleam of gaslight. The illuminated globes of his street lamps are opaque and chalky and his leaves approach in tone that of emerald green; they are wrong, absolutely wrong! His treatment of character and decor are in agreement, however, the one being as unnatural as the other.

Soup Kitchen in the Morning, by M. Goeneutte, is little better. The beggars queuing in front of the Restaurant Vachette[19] are conventional starvelings. Alas, I too saw them during the hard winter we've just come through, those groups of unfortunates who would wait, tapping their feet, until the kitchens opened. It was very simple and it was very poignant. None of these men in rags grimaced like M. Goeneutte's actors; the horror of sustained hunger and the slow wearing down of vice can't be translated into stock poses and gestures; these poor devils were, even when talking or laughing, or even when just standing still, pitiful and sinister; there was no need for M. Goeneutte to make them look up to the sky, imploring it or cursing it – their ravaged faces said it all.

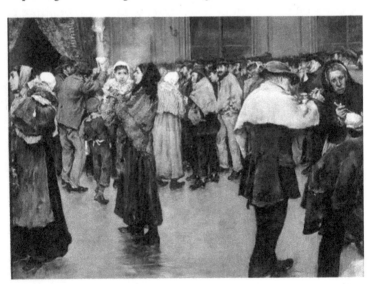

Soup Kitchen in the Morning by Norbert Goeneutte.

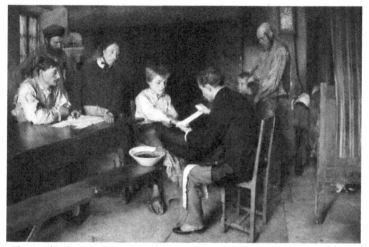

The Accident by Pascal Dagnan-Bouveret.

This picture by M. Goeneutte is another piece of fake modernity, it's contemporary life arranged and painted with models, rather than from reality, and it's the same with *The Accident*, by M. Dagnan-Bouveret. A child has cut his hand. What blood! There's a whole bowlful of it! What a pallid visage, what melodrama, what a theatrically composed scene! After the wedding in the photographer's studio last year, a cut finger this year: after the laughter, the tears. Success all down the line. Ladies choke back their sobs in front of this red basin, in front of these strips of stained linen.[20] But it's not blood that should be coming out of this pale puppet, it's sawdust, pretty yellow sawdust! Truth would have imperiously required such an offering, but as usual M. Dagnan refused. Ah! Messrs Bastien-Lepage and Gervex have a serious rival. From now on it'll be necessary to reckon with this artist, who seems to be determined, like them, to seize the affection of the good public by any ruse he can think of.

I can't repeat it too often – none of these canvases reveal any sense of personality or any application whatsoever, they are the

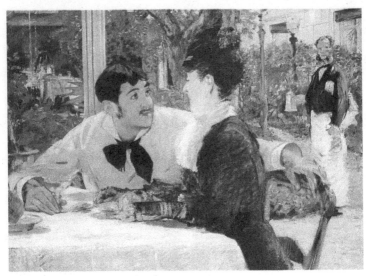

At Père Lathuile's Restaurant by Édouard Manet.

opposite of modernism. The Independents are certainly the only ones who have really dared to tackle contemporary life, the only ones who have given a particular and very clear vision of the world they wanted to paint, whether it's dancers like M. Degas, the poor like M. Raffaëlli, the middle classes like M. Caillebotte, or whores like M. Forain.

For reasons I'm unaware of, M. Manet exhibits at the official ritual of the Salon. Generally – and for reasons I'm still more unaware of – he has even managed to get one of his two paintings into a prime position, in the foreground of the room. It's very strange that they should have decided to place so respectably an artist whose work preaches insurrection and aims at nothing less than the ripping off of the pathetic sticking plasters this nursemaid of antiquated art has applied! This year, exceptionally, the jury has arranged it in such a way as to put a very exquisite painting by this artist, *At Père Lathuile's Restaurant*, way up on the third row, and moving down to ground level his less exquisite *Portrait of M.*

Antonin Proust, which is interestingly executed, but empty and full of holes; I write this with regret, but the head seems to be lit from within like a nightlight, and the suede of his gloves has been puffed up but doesn't enclose any flesh. By contrast, the young man and the young woman in *At Père Lathuile's Restaurant* are superb, and this canvas, so clear and so vivid, is astonishing because it explodes in the middle of all these official paintings that grow rancid as soon as your eyes land on them. The modern about which I spoke earlier? Here it is! In a true light, in the open air, two people are eating lunch, and the picture has to be seen in order to appreciate how alive the woman with the pinched face is, how telling and faithful is the expression of the young man, eager to embrace his good fortune or rather his misfortune! They are talking,

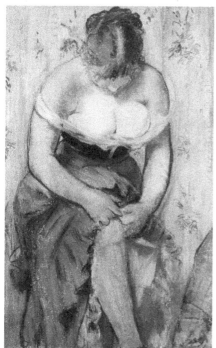

The Toilette by Édouard Manet.

and we know perfectly well what inevitable and marvellous platitudes they are exchanging in this tête-a-tête, in front of these champagne glasses, stared at by the waiter who is preparing to call out, from the depths of the garden, the 'Coming, Sir!' announcing the arrival, in a dirty cafetière, of a foul black infusion. It's life as it is, rendered without exaggeration, and by reason of it's very truthfulness a courageous work, unique from the point

of view of modern painting in this all-too copious Salon.

Other paintings, equal in boldness, have also been assembled by this artist in a separate exhibition.[21] One, *The Toilette*, representing a woman *en décolleté*, her breasts practically coming out as she leans forward to attach a garter to a blue stocking, the tip of her retroussé nose visible beneath the top of her chignon, gives a full flavour of the prostitute so dear to us. To envelope his characters in the aroma of the world in which they belong, such has been one of M. Manet's most constant preoccupations.

His lucid work, cleansed of the bitumen and tobacco-juice browns that have muddied canvases for so long, is marked by an often tender touch beneath its apparant bravado, by a concise but slightly unsteady draftsmanship, by bouquets of lively brushstrokes amid the silver-white and golden-yellow of his paintings.

Several portraits in pastel also appear in this exhibition, very fine in tone for the most part, but, it must also be said, a little lifeless and hollow. As always, despite his great qualities, this artist remains incomplete. Among the Impressionists, Manet has powerfully assisted the present movement, and to the realism established by Courbet, especially in his choice of subject, he has brought a new revelation – the attempt to paint in the open air. In general, Courbet confined himself to treating subjects that were less conventional, less acceptable – and sometimes more stupid – than those of other painters, using a conventional technique embellished by the misuse of a palette knife, while Manet has overturned all theories, all practices, and pushed modern art into a new path.

It's here the parallel between them breaks down. Courbet was, in spite of his out-of-date techniques and his ignorance of tonal values, a skilful workman;[22] Manet had neither the stamina nor the vigour to impose his ideas through a forceful body of work. After only partially ridding himself of the combined pastiches of Velasquez, of Goya, of El Greco and a good many others, he meandered, uncertain how to procede; he had indicated the

Victoria Embankment by Guiseppe de Nittis.

path to be followed, but he himself remained stationary, stalled in front of albums of Japanese prints, struggling with his own faltering technique, fighting against the freshness of his drafts, which he spoiled by overworking. In short, M. Manet has been outdistanced today by most of the painters who would formerly, and justifiably, have considered him their master.

Since we've gone so far as to amble outside the warehouse of the State, let's stroll through an exhibition of work by M. de Nittis, in the offices of the journal, *Art*.[23]

In 1878 M. de Nittis obtained a great success with his views of London, grouped together in the Italian section of the Champ de Mars.[24] Some of these canvases were deemed worthy of praise. Impressions of districts drowned in fog, bridges spanning gloomy rivers whipped by rain or immersed in mists, were singled out with enthusiasm. Here, in the Avenue de l'Opera, a whole series of pastels stop and charm us by their pleasing mix of lively colours.

Only the picture of the *Tuileries* is unrecognisable. The Obelisk and the Arc de Triomph seem to me to be miles away from the Carrousel. This landscape looks to have been viewed from the

height of a hot-air balloon or a tower. Added to which, there are sly misrepresentations: the basin of a fountain gets in the way, M. de Nittis removes it; there, on the quay, the pavement seems to him to be too narrow, so he widens it; the promenade at Invalides appears to him to be too short, so he lengthens it by a third.

On the other hand, one of his panels entitled *Woman in White Behind a Venetian Blind* – a Japanese woman in Paris, in her nightgown, holding a red fan, stares at you, smiling, while the shutters of the window-blind stripe her with alternate lines of light and shade – is really enticing.

To conclude, M. de Nittis has talent; in art, he's poised between M. Degas and M. Gervex. Neither official nor Independent, a happy medium. He is, in short, a charming fantasist, a graceful, feminine storyteller.

It only remains for us now to return to the Champs-Élysées and wander briefly through the white and black rooms of the engravings.

If, as I've already had to repeat, the poverty of the innumerable panels daubed with oil paint exceeds all measure, what can one say of the multitude of wood engravings, drawings, lithographs and etchings? The room in which this jumble piles up is the radiant apotheosis, the illustrious deification of printed nullity.[25]

First of all, one can divide the exhibitors of these types of work into two categories: those who reproduce pictures, by whichever technique, for so-called artistic journals; and those who work for the publishers of illustrated books.

The first category hardly gives one any reason to pause. The men who comprise it are, for the most part, competent workers. They diligently copy landscapes, still lifes, or whichever scene from human life is entrusted to them, interpreting as well or as badly, depending on the greater or fewer number of years they've spent training, a masterpiece by Rembrandt or a belaboured canvas by Lobrichon.

It's manual labour, that's all. Since the death of Jules Jacquemart,

M. Léopold Flameng is justly regarded as one of the most capable foremen in this factory.

The second category works exclusively in the 18th century genre. It's here that I will occupy myself more particularly.

All of them slavishly carry out commisions from booksellers, who themselves submit to the platitudes of public taste. Today, in order to satisfy that herd of customers who purchase so-called deluxe books to show off or because of fashion, they've had to resume the affectations of the eighteenth century, to use Elzevir fonts on chamois or fake wove paper, to match chapter headings, tailpieces, motifs of doves pecking ornate capital letters, cherubs brandishing torches and showing their buttocks, curlicues, fleurons, shells and fleurs-de-lis, all printed in black, red or brown, and the whole thing sewn between the covers of what looks like a box of bons-bons, its boards decorated with those garish vignettes so dear to French sweet manufacturers.

The present day deluxe book, in a limited and numbered edition, would just be unsellable old stock if it wasn't dressed up in the senile garb of a previous age. No need for these rehashes to be carried out by intelligent craftsmen. No need for these imitation Elzevirs to be meticulous and pure, or for the process mimicking etching – because we've finally got to the subject now – to be accurate or genuine. It would be money and effort wasted. The cheap imitation suffices. The majority of bibliophiles are oafs, unfit to discern a fine liqueur, and one could, without any mistake, compare all the people today who buy the pretentious mediocrities in our bookshops for their typographical opulence to those fine provincials who, eager to treat themselves in Paris to a refined feast, ask for a bottle of Chateau-Yquem in the *bouillons* and fixed-price restaurants of the Palais Royal. It's the same appetite for elegance satisfied by the same inauthentic wares, it's the same covetousness appeased by the same adulterated merchandise, by the same fake luxuries.

And so the martyrology of publishers who have tried to escape the monomania of their customers is always on the increase. Any bookseller who dared to substitute a Roman font for an Elzevir in an edition intended for bibliophiles would be a lost man. The most intelligent, the most artistic of them all, Poulet-Malassis,[26] was a victim of his own good taste – and I could cite the ruin of many others who know that the use of Elzevir in a modern book is a heresy, because that style of font belongs to an epoch that has nothing in common with our own.

That's the point I wanted to make. Yes, any individual who utilises these fancy watermarked papers, these italic scripts, these old fonts born in the womb of the 16th and 17th centuries to frame a contemporary work commits a monstrous anachronism. Can you imagine a *Madame Bovary* or a *Germinie Lacerteux* printed like the pastorals of Florian or the tales of Grécourt?[27] It would be absurd – and yet that's what happens every day, to the great joy of the collectors who throw themselves at these pieces of junk!

The future of deluxe books is a Roman font rectified and refined along the lines of the slender and elegant Anglo-American type. Some of the volumes published in London really show off the clear elegance of these letters, whose singular beauty adapts so perfectly to the original character of our modern works. It's much to be hoped that this alliance will be consummated and that the Elzevir will be definitively relegated to the reprinting of works that date back to its own epoque.

However futile these observations might seem to certain people, it's nevertheless necessary to state them, because they are intimately allied to the reflections it remains for us to make about engraving.

The rise of imitation etching has inevitably followed the rise of the imitation book, to which it is the indispensible 'added-extra' from the point of view of sales.

So what happens the day a bookseller wants to illustrate a

contemporary novel? He busies himself with matching the style of the edition to that of the images and, neglecting, obviously, the actual contents of the book, the very work itself, he looks to reputable engravers who, themselves possessed of the ineluctable mania of affectation and blinded by long habits of working from memory rather than actually reading the novel, immediately produce the most baroque incongruity between illustration and text.

Examples abound, I will take just one among them: Flaubert's *Madame Bovary*, illustrated by M. Boilvin.[28]

As we might have expected, this wretch has drawn a Manon-esque Emma Bovary;[29] but when it came to translating the other characters of the book a long hesitation came over him, confronted as he was by his paltry, emasculated vignettes; he didn't have the

technique to be free with his engraver's needle, so it was difficult to present us with a Chevalier des Grieux-esque Charles Bovary. So what did he do? Not understanding anything at all of the modern, incapable of looking around him, unsettled by the reality of this novel, not finding in it, obviously, the twaddle he was used to interpreting, he confined himself to a repetition of old Monnier[30] and knocked out a burlesque hash-up of the rococo and Monsieur Prudhomme!

Illustration for Gustave Flaubert's *Madame Bovary* by Émile Boilvin.

I hasten to add that I'm not putting M. Boilvin on trial,[31] he has neither more nor less talent than his fellows. Had his small plates been engraved by Lalauze or by Hédouin, they wouldn't have been any more comprehensible or any less ineffectual. Indeed, these engravers wouldn't have been able to avoid, any more than M. Boilvin could, the bergamot-scented brine in which amateur artists and booksellers have pickled them.

Consequently it's quite useless to enumerate all the prints scattered throughout the rooms devoted to engravings. In all this heap of frames there's nothing original, nothing new; moreover, specimens of these sheets of paper under glass fill the windows of all the print and book dealers in the streets; there, the public will easily be able to contemplate them and assure themselves that, except for a few austere and robust etchings by Desboutin, the rest of the prints on display here are more finely carried out, perhaps, but undoubtedly less genuinely interesting than the poorest image that brightens up a pub dining room.

Before closing this section, I can only advise people who are sick to death, like me, of this impudent display of engravings and canvases, to refresh their eyes outside, homeopathically as it were, with a prolonged halt in front of the railings on which those astonishing fantasies by Chéret explode, those fantasies in colour that are so briskly drawn and so vivdly painted.

There's a thousand times more talent in the least of these posters than in the majority of pictures I've had the sad privilege of reviewing here.

The Official Salon of 1881

I

He breathes his last thought over the barrel of an abandoned cannon, dusted with snow. Eyes to the heavens, mouth slightly clenched, his hand pressed to his uniform at the place where his sad heart feebly beats, the poor soldier thinks, before he expires, of France, whose maternal solicitude has led him to commit murder in a slaughterhouse.

This canvas is the work of a fine nature who bleeds over the misfortunes experienced by his country; each year, M. Reverchon re-opens his unappeasable wound by serving us up a vengeful, patriotic painting. Was it him who also invented that decoction of memory, that liquid one sees in certain bars, bottled in a mortar-shaped flask on which an image is displayed of two soldiers, guns at the ready, with these words printed in red: 'Never Forget'?

For the sake of his eternal glory, I hope so. To the gallant character and pompously chauvinistic spirit of his work, one also has to add the inestimable perfection of an artist who knows how to overcome, like no one else, the mysterious difficulties of the

art of painting…as applied to the decoration of chimney breasts and shop signs, that is. M. Reverchon would be a unique artist if his dangerous rival, M. Protais, would only consent not to paint any more.

This latter also feels a mother's pang in his guts for our troops. To military painting – which under the impulse of Vernet, Yon and Pils had become a series of episodic tableaux or glass slides[1] to which one would add a label to indicate the mugshot of General So-and-So, or the emplacement of such-and-such a division – M. Protais has brought this innovation: sentimental vapidity. He has been playing *The Last Post*[2] on his bugle for years: one time showing us officers hugging each other, soldiers staring pathetically at the sky, and another time an unfortunate Vincennes rifleman, lying on his flank, rolling his tear-filled eyes and staining the green grass red. This year, M. Protais has dried his tears, and virile resolutions have bloomed in that sentimental soul. Blood, not sighs! Foot soldiers bearing every kind of weapon are gathered together; behind them are massed the cavalrymen sorted into ranks; steel cannons gleam in a corner where the artillery men are standing; in the background, factories smoke. This appears aggressive, because all these recruits seem to shout: 'Let them come and see what they'll get!'

Such is the first impression produced by this group of soldiers;

The Flag and the Army by Paul-Alexandre Protais.

but when one has looked a bit longer, when one scrutinises the expressions frozen in the porcelain of their faces, one notices that the painter is much less savage than he seems. Dominated by a burning love of humanity, overtaken by the imperious habit of the elegies that he's been sounding over the years, M. Protais has endeavoured to paint soldiers who are threatening, but who in fact don't threaten at all. Moreover, I can add that the process employed to obtain this difficult result is really quite simple. M. Protais has confined himself to giving his uniformed troops the appearance of bladders inflated by bellows. One senses air behind their breastplates; a hollow beneath their cotton breeches; a void beneath their cardboard shakos. These people are scarecrows, rags stretched over poles. They appear to be fear-inducing, without being so. In short, they satisfy our instincts for chauvinism, but they're not seriously hostile enough to threaten the powers that surround us.

Like M. Protais, a number of painters have also made a point of celebrating their patriotic hopes or sufferings. At their head is M. Jundt. This Alsatian entitles his canvas *Return*, in which a maidservant in a tavern in one of the annexed regions, pours tankards of beer for French cavalry soldiers. It's a painting in advance of history, a painting of hope.[3]

To set these cavalrymen upright in their boots, M. Jundt has resorted to his usual method, an overlapping confusion of colours and a poetic uncertainty of line, all of which gives a faded tapestry aspect to his characters. It's vaporous painting, but not sufficiently so, unfortunately, to evaporate or disperse itself entirely.

After Jundt from Alsace, Bettanier from Metz. We've already had the soldier as ploughman, now we have the soldier as reaper. His canvas, entitled *In Lorraine*, shows a soldier turned peasant, scythe in one hand, cap in the other, his wife, a child and an old man in front of a cross in a field. It's the same scene as sung in concerts by a baritone, by an actor whose clean-shaven mouth

In Lorraine by Albert Bettanier.

disgorges plaintive howls about the annexation of our provinces; it's the same scene as put into verse by M. Déroulède, who has, moreover, inspired another painter, M. Delance, a lad with a lot of talent. The finest praise I can give to his *Return of the Flag* is this: the painting is absolutely on the same level as the songs trumpeted by our great poet.

Myriads of paintings of this kind still parade along the walls

Return of the Flag by Paul Delance.

A Spy Arrested by the Prussians by Alphonse de Neuville.

of these rooms; all have spirit, those of M. de Neuville more than most. His *Saint-Privat Cemetery*, for example, has resolved the difficulty of painting a 'storming' in static form. It's a frozen purée of combatants on the top of a knoll, urged on by three 'preachers', the inevitable three French soldiers who are fiercely resigned to death, and who have already adorned the same painter's *The Final Cartridges*. In another canvas, *A Spy Arrested by the Prussians*, M. de Neuville has given the most outrageous poses, the most baroque torsions of the body, the most self-satisfied and grotesque expressions to the German army officers, while the Frenchman is distinguished and noble, powerful and beautiful. I can't blame M. de Neuville for having, in this canvas as in others, inflicted on his non-commissioned Prussian officers a look of arrogance, because the epaulette often imposes itself on the brain and lets only flowers of ferocity or stupidity spring up there; only it should be said that the poses and expressions of brutal soldiers aren't unique to Prussians, they belong without distinction to the militarism of all nations.[4] As a painting, *A Spy* is a black mediocrity, but if I were to judge it by some of the cries of joy emitted by the ladies,

M. de Neuville is assured of a great success among this female audience, who are so good-naturedly appreciated by the indulgent Schopenhauer.[5]

However meritorious, from the point of view of patriotism, the works I've just reviewed might be, they don't testify to any serious artistic effort; we have to come to Édouard Detaille, finally, in order to find a really adventurous attempt. M. Detaille[6] has renounced oil painting and has squarely taken up colour printing. Given the extraordinary size of his *Trooping of the Colour* and the number of tones he employs, my admiration burst out without hesitation or reserve. What a tour de force to pull off, despite the difficulties inherent in successively printing so many layers! It's true his chromo is harsh, garish, blinding even, because a method of colour lithography that avoids painful lighting and backgrounds with neither perspective or a sense of space hasn't been discovered yet in France; but although the artifice is still crude, it nevertheless has to be admitted that M. Detaille's bravery deserves to be at least recognised and encouraged!

Leaving now all these elegiac and manly bits of flannel, we arrive at works of a purely democratic or patriotic nature.

Trooping of the Colour by Édouard Detaille.

A Memory of the Festival by Jean Cazin.

Skirting *The Conquerors of the Bastille* by François Flameng, who continues to paint the subjects recommended by M. Turquet, and who also persists in carving his men out of quartz and painting the flesh of his figurines and the copper trimmings on their drums the same colour, let's stop in front of *A Memory of the Festival* by M. Cazin.

Let's try to understand, if such a thing is possible, this bizarre enigma. The cupola of the Pantheon, illuminated by gas jets, stands out against a firmament of hard blue that is adorned with this inscription: *Concordia*. Perched on scaffolding are three female figures: one with a cavalryman's helmet on her head and a bathrobe over her naked body; another, seated in a white dress; and the third, standing, offering a golden branch to the bathrobe and helmet. Do you understand it? No. Moreover, M. Cazin also seems to have suspected the incomprehensibility of his canvas, because beneath a firework that describes its parabola in the sky he has written in gold letters above the cavalryman's helmet, *Virtus*, above the woman with the branch, *Labor*, and next to the seated woman, *Scientia*. Do you understand it any better now? I suspect not. Well, me neither. Let's see, Work gives a branch to Virtue, under the benevolent gaze of Science, and the whole is called

Harmony. It's a symbol of a virtuous and peaceful France. Or it's the Virtue resulting from the coupling of Harmony and Work. Or it's the personification of a century which is, so they say, a century of Science. Or it's the peace obtained through Work, thanks to the courage of the army, which is allegorised by the helmet – or if not that, what is it then? And what, in this obscure abstraction, is one supposed to make of the symbol of the noisy and useless festival? From whichever side I look at the subject it seems to me absurd and vague, but what's worse still is that the man of talent M. Cazin used to be has completely foundered. Let's say it, it's frankly bad: the figures are weak, hesitant in their poses, the drawing is heavy-handed, the colouring is bland, the tones congested, and the lighting comes from who knows where and seems to be borrowed from Schalken's candle.[7] So this is where the painting of feelings and ideas, the painting of supposedly profound subjects, leads one!

In his *Village Fair* in the Louvre, Rubens didn't try to do anything like this with his painting, any more than Brauwer or Ostade did. In their canvases people piss, they puke, and in one of Bruegel the Elder's, in Haarlem, as in an etching by Rembrandt, they go even further, carrying out an act considered to be the most repugnant of all by people in polite society.[8] And yet it is admirable painting, painting that is more elevated and broader in scope than that of M. Cazin. These men fertilised the land of their fathers, seduced and drank, without worrying over subtle or profound thoughts, and yet they painted in a superb style that neither the Laurens, the Puvis de Chavannes or the Cazins of this world will ever reach, in spite of all their learned proscriptions on how to make great art.

A woman by Jordaens wiping the backside of her brat, a cavalryman by Terburg offering money to a whore, the drunken prostitute by Jan Steen in the Van der Hoop museum, sprawling on the lap of an old drunkard, are all works of great style, because as

well as being exact, almost photographic reproductions of nature, they are also imprinted with a particular emphasis, determined by the personal temperament of each of these painters; by contrast, the Mignon and Faust pictures of Ary Scheffer,[9] or the religiosities of Hippolyte Flandrin, are expressed in a dull language, without style – which is only to be expected given that neither of the two has an individual palette or his own sense of vision.

It's therefore quite useless for a painter to try to ennoble painting using the methods commonly taught in art schools; it's therefore quite useless to choose subjects that are said to be more 'elevated' than others, because subjects are nothing in themselves. Everything depends on the way in which they are treated, and besides there is nothing so licentious or so sordid that it cannot be purifed in the fire of art.

As for the meditations and thoughts they might inspire, don't you think – to choose a modern example – that the canvases of Messrs Degas and Caillebotte are more fertile in matters for contemplation than all the constructions of M. Cazin? It's the life of a whole class of contemporary society that parades before us in the canvases of the former; we are free to reconstitute the life of each of their figures, his deeds and his gestures, whether in bed, in the street, or at table; whereas only incoherences of the imagination could haunt us in front of the marionettes so wretchedly arranged by M. Cazin. How, I ask you, can these puppets, occupied in I don't know what task, interest us? How can these mythologies applied to modern life touch us? Like a virus that won't die, the primeval stupidity of painters has reappeared and brutally invaded the brain of a man who had been vaccinated in his early years by M. Lecoq de Boisbaudran,[10] the only art master whose teaching didn't repress the intelligence or compound the ineptitude of the pupils fortunate enough to learn their trade under his system.

Since we have made so much of looking at riddles and myths in painting, let's take a look at the strange panel by M. Puvis

The Poor Fisherman by Pierre Puvis de Chavannes.

de Chavannes: *The Poor Fisherman*. A figure, with the form of a billhook, fishes in a boat; on the shore a child rolls around in yellow flowers next to a woman. What does the title mean? In what way is this man a poor fisherman? Where or when did this scene occur? I don't know. It's a twilight painting, an old fresco devoured by moonbeams, drowned by downpours of rain; it's painted in lilac turning to white, in lettuce-green soaked in milk, in pale grey; it's dry and hard, and, as usual, it feigns a naïve stiffness.

In front of this canvas I simply shrug my shoulders, aggravated by its mimickry of biblical grandeur, obtained by sacrificing colour to engraved contours whose angles stand out with the affected lack of sophistication of the Primitives; even so, I feel pity and tolerance towards it, because it's the work of someone who's misguided, but also because it's the work of a convinced artist who despises the passions of the public and who, unlike many other painters, disdains to wade in the cesspool of fashion. In spite of the revulsion which rises in me when I'm in front of this painting, I can't stop myself feeling a certain attraction when I'm away from it.

I can't say as much for the *Triumph of Clovis*, by M. Blanc.

The Triumph of Clovis by Joseph Blanc.

This represents, against a gold background and with their heads ringed by aureoles, Messrs Gambetta, Clemenceau, Lockroy and, in the background, appearing in the garb of a martyr, the profile of M. Coquelin. This fresco – since it seems that it's being called a fresco – is a contemptible work, at most worthy to appear in an exhibition of Swiss paintings.

Nothing is being spared us this year, however. A final monstrosity spreads itself out: a democratic and patriotic still life, *Citizen Carnot's Desk.*[11] About two or three years ago, after a comic circular advocated the incorporation of republican ideals into painting, Duranty circulated a rumour that still life was also going to be democratised, and he ironically predicted that the

Citizen Carnot's Desk (detail) by Hippolyte Delanoy.

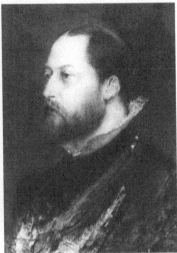

The Beggar by Jules Bastien-Lepage. *Prince of Wales* by Jules Bastien-Lepage.

day would come when the desk of a notable republican politician would be the subject of a painting. There was a general uproar, an outburst of laughter. Well, it's now been done. It has been perpetrated by M. Hippolyte Delanoy, and bought for the State by M. Turquet.

When will we see Robespierre's chamberpot or Marat's bidet in the Salon? When, supposing a change of government comes about, will we see Louis-Philippe's umbrella, Napoleon's catheter, or Chambord's hernia pads?

We have stayed too long in front of the atrocious miseries of these canvases, but, alas, it was necessary, because if the Salon of 1881 is perhaps even more laughable than those of previous years, it's due to this invasion of militarism and politics into art.

Now let's move on and come to paintings by artists deemed 'modern' by the public.

Messrs Bastien-Lepage and Gervex hold the inside lane. The first of these painters exhibits a beggar, one hand in an old bag slung over his shoulder, standing in front of a door which is being

closed behind him. M. Lepage has, at least, ceased strumming on M. Breton's rustic guitar;[12] he spares us this year his ecstatic representations of potatoes and hay, for which I'm grateful to him. Contrary to the majority of his fellow artists, he's looking for a new direction; he floats about here and there, pastiching Holbein in his *Portrait of the Prince of Wales*, calling in on Van der Werf and Mieris for his *Portrait of M. Albert Wolf.* Now in all this moving about has he found a tone of voice all his own, has he lost his habitual faults, his fastidiousness, his lack of atmosphere, his affection for rags borrowed from a theatrical costumier? No, certainly not, but he has at least preserved his old lightness of touch, retained the technical knowledge of his trade, something which is now, alas, lacking in M. Gervex. It's sad to have to say it, but this artist doesn't even know how to paint anymore. His *Civil Wedding* could have been signed by Santhonax, that astonishing man who daubs the signs over fairground booths. No design, no colour, nothing; M. Gervex is finished, and I regret it sincerely because after his first works I was among those who supported him and believed in him.

Civil Wedding by Henri Gervex.

This year is decidedly a bad one, because here's M. Manet who is likewise going downhill. Like a young wine, a bit rough but fresh and distinctive, the artist's early painting style was engaging and heady. Here, it's sophisticated, artificially coloured, stripped of any tannin, any bouquet. His *Portrait of Henri Rochefort*, fashioned according to semi-official precepts, doesn't hold up. You'd swear the flesh was

Henri Rochefort by Édouard Manet.

cream cheese mottled with peck marks, and the hair was grey smoke. No highlights, no life; M. Manet hasn't captured the nervous finesse of Rochefort's unique physiognomy at all. As for his portrait of M. Pertuiset, on one knee, directing his rifle into the room where he undoubtedly sees wild beasts, while a yellowish stuffed lion is stretched out behind him under the trees, I really don't know what to say. The pose of this lion hunter in the woods at Malmaison, with his sideburns that seem to be made of rabbitskin, is childish, and in execution his canvas is no superior to those of the sad amateurs that surround it. To distinguish himself from them, M. Manet took delight in coating the ground in purple; it's a novelty that holds little interest and is far too facile.

I am very seriously grieved to be obliged to judge M. Manet so harshly, but given the absolute sincerity that I have up to now given proof of in this series of Salons, I owe it to myself not to lie and not to hide, through a spirit of partisanship, my opinion of the work exhibited by this painter.

I'm in haste to arrive at some canvases that are more

nourishing, that have a bit more steel to them. I'm therefore going to rush through my review of the portraits that are staring at us. It's quite useless, I think, to repeat what I've said for the past two years about certain painters: about M. Bonnat, whose ponderous portraits stand out by means of glowing drops of phosphorus on the nose and forehead, against a foggy background of wine dregs and scorched brown that fades from top to bottom of the frame; or about M. Carolus-Duran, that fast and noisy pianist; or about M. Boldini, whose playing is more agitated and whose virtuosity is more expressive; or about M. Laurens, who has borrowed from Ingres' old-fashioned *Saint Anthony*, purged of any bright colours, the dull and unsatisfactory appearance of his portrait of a lady. Fortunately, to compensate us, the Fantin-Latours are close at hand. He has a soundness of eye that is notable at the present time, and a quite distinct personality as a colourist, because with his browns, blacks and greys, M. Fantin-Latour is a thousand times more a colourist than all the Boldinis and Carolus-Durans put together – because one isn't a colourist simply because one lays down vigorous harmonies of orange and blue, green and red, purple and yellow, or because one amuses oneself juxtaposing red

on red or blue on blue. Any more than Rubens was a great colourist because he employed full-bodied reds, strong blues, and almost pure whites and blacks, or Vélasquez because he moved between a range of silvery colours and dull browns that

M. Pertuiset, Lion Hunter by Édouard Manet.

were occasionally brightened by soft highlights of sulphur-yellow and pink. It's that both those masters knew how to combine their colours in skilful and judicious ways, it's that their eyes always perceived them, whether in a delicate or forceful state, in an exceptional way. M. Fantin-Latour has this gift of colour, the only thing is that his paintings this year are the same as last year; it's always the same lady who poses in the same room. There is, on the part of this painter, an invariability that is far too consistent.

I will not address this reproach to M. Renoir; as well as his *Dance at the Moulin de la Galette*, his landscapes, his views of Paris and his travelling acrobats in a circus, he has produced numerous different portraits. Those exhibited in the present Salon are charming, especially one of a little girl sitting in profile, which is painted with a surface colouring that one would have to go back to the old painters of the English school to match. Fascinated by the reflection of sunlight on velvety skin, by the play of light rays on hair and fabric, M. Renoir has bathed his figures in true daylight and one absolutely has to see what adorable nuances, what delicate iridescences have bloomed on his canvas. His paintings certainly

Garden in a Retirement Home, by Max Liebermann.

figure among the most appetising that the Salon contains.

Most of the foreign artists whose qualities of sincerity I signalled last year have returned. M. Artz brings us *The Old People's Asylum in Katwijk*, a sharp, clear canvas, very moving and very simple. On the other hand, I like less the two canvases by his master, M. Israëls. They are blurry in execution, like Jundt's work, too grey and too unrestrained in feeling to grip me. As for M. Bisschop, another Dutchman, I prefer not to speak about him; this artist painted an excellent canvas for the last Salon – let's hope he'll make up for the vexation he's caused us this year in 1882. We will remain just a short while longer in the Netherlands, but this time with a German, M. Max Liebermann, who shows us his *Garden in a Retirement Home in Amsterdam*. The brushwork is a little too thick and chunky, but it has some fine qualities; the old invalids sitting in the sun under the trees are captured in a lively fashion, without being grossly comic. Let's return now to France, after a brief stop in Belgium, just long enough to cast a glance on *Inspection of Schools* by M. Jan Verhas,[13] who one should not confuse with a certain Frans Verhas, whose talents seem to me

Inspection of Schools, by Jan Verhas.

more problematic. This *Inspection of Schools* is a gigantic canvas. The king is standing on a podium; the people, dressed in black, are spread out, a little on either side to suit the needs of the painter. In a serried rank down the middle a whole army of small girls dressed in white is passing by. The painter is extravagantly skilful; he has very adroitly broken up this enormous white streak by a few carefully spaced sashes, by the striking tone of the flowers, by the contrast with the dark suits. The young girls are a bit indistinguishable and simpering, too little varied, because one senses that five or six of them alone have served as models, but it's nevertheless a commendable and daring canvas. There's a good impression of the open air; the whole landscape of houses is excellent, executed with the clear tonality of the new school of painting. All things considered, I would wish for many more paintings of a similar quality in our official Salons.

I would also wish for some more like M. Bartholomé's *In the Conservatory*.[14] This painter is progressing; his qualities of simplicity and frankness, which had attracted me in the exhibitions of 1879 and 1880, have remained intact; his painting, formerly a little cold, has warmed up and become more luminous and clear; one scene he has painted is conceived as follows: a nurse shows a toy to a child, who holds out its hands in its little pram. A table, some books, a dog with a hairy muzzle and sharp eyes, and some large greenhouse plants complete the scene. One has to

In the Conservatory by Albert Bartholomé.

Regatta at Joinville by Ferdinand Gueldry.

be very sure of oneself to risk painting such a subject; put in the hands of one of our so-called modern painters, ninety-nine times out of a hundred he'd turn it into a picture about clothes and fall immediately into Romantic sentimentality and inane affectation. M. Bartholomé has passed, with flying colours, between these reefs; by force of good faith he has painted a woman and child in a pose that is neither pretentious nor conventional, and their smiles are delightfully truthful and elegant.

It's a very distinctive design, if a little dull in terms of colour. M. Bartholomé is, in short, one of the few painters who understand modern life; I won't surprise anyone when I add that his work has been carefully relegated to the fifth floor, on a terrace, while the overlords of the jury and their mass of vassals and minions strut about comfortably on the ground floor, in the best places.

Worth flagging up now is a painting by a student of Gérôme's, M. Gueldry. *Regatta at Joinville* is an open-air painting, very alive, very jolly. M. Gueldry is one of those rare painters who's tried to free himself from his memories of art school and to go directly to nature; he really deserves to be applauded. Also worth flagging up are: *The Seine at Bezons*, by M. de L'Hay, a canvas which, in

certain parts, could have been signed by an Impressionist; a fairly vigorous Ulysse Butin; a seascape by Eugène Boudin with its pretty patches amid a slightly bluish sky; and finally a couple of efforts betrayed by an insufficiency of talent – an attempt at flowers in the open air by M. Quost, a hazy, bleached-out canvas, and *Casting Steel at the Seraing Factory* by M. Meunier, a canvas

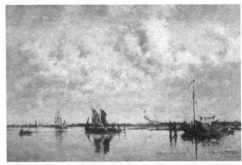

On the Meuse, near Rotterdam by Eugène Boudin.

Casting Steel at the Seraing Factory by Constantin Meunier.

the colour of cardboard and brick – but if these latter two painters have presumed too much on the strength of their legs, they at least dared to run, which one should give them some credit for.

I will pass over the landscapes in silence; these paintings are identical to those of preceding Salons, it's needless for me to harp on about it. The majority of landscape artists are supple mimics who are forever repeating the same thing, executed without letting a single impression affect their brain or eye. I will, however, mention M. Luigi Loir, whose *Showers* is pleasant, as well as *Old Villerville* and *The Beach at Saint-Vaast* by M. Guillemet, who continues to paint his skies artfully slicing the tops of cliffs. An impression of sadness and rainy days emerges from his canvases,

which are more expansive than those of his official landscape peers.

Is it also really necessary to talk about still lifes, to say what state of paralysis the painting of M. Philippe Rousseau has reached, or to praise the inconceivable jugglery of M. Martin? His *Oriental Interior* is as terribly calculated as his pile of weapons and his demi-john of last year. Except that the personality of this painter refuses to be quiet – his work may be that of a consumate magician, but of a genuine artist...? No. I much prefer *Dessert* by Mme. Ayrton, painted with great brushstrokes and with a power that is astonishing in a woman.

Before quitting the painting rooms, it only remains for me to speak about M. Baudry and M. Alma-Tadema.

A ceiling for one of the rooms of the supreme court of appeal has been commissioned from M. Baudry, it is called *Glorification of the Law*. The concept of the painter is neither very adventurous, nor very new. It's the eternal decorative ceiling, with a female figure

Glorification of the Law by Paul Baudry.

seated at the top of the steps of a temple, two women floating above her, another lounging next to a lion, the whole lot embellished with a flag and a president with an aquiline nose and a red toga, saluting the law with his cap; given that it's conventional for these vast machines to be cast in a uniform mould it must be admitted that M. Baudry's characters, although conceived on a single type which is

used indiscriminately for all of them, are elegant and well positioned. It's a harmonious and clear design, full of pastiches of the ancient Italian masters, but despite its flaws it's superior to other ceiling designs prepared by craftsmen charged to fulfil similar commissions.

On the Road to the Temple of Cérès, by M. Alma-Tadema, is less prominent, but is certainly more interesting and more original.

The case in favour of this artist is really deafening. I don't need to recall the

On the Road to the Temple of Cérès by Lawrence Alma-Tadema.

works that he exhibited in 1878 in the Champ de Mars: *An Audience at Agrippa's, Fête Intime, After the Dance*, panels wrought with the delicate artistry of an artist and an archaeologist. Certainly M. Alma-Tadema has nothing of the mysterious and exquisite art of Gustave Moreau, but he does have a singular note, a seductive style that plays with milk whites, antimony yellows and verdigris, and he throws into the pale and tender assonance of his hues peals of magnificent red, as in that field of peonies and poppies blooming in the sun, in his *Roman Garden*.

In front of these canvases I can't help but think of Balthazar Cherbonneau in *Avatar* by Théophile Gautier,[15] that strange miracle-worker who sends his spirit to travel in distant centuries of the past, while his body remains empty, collapsed on a mat. By

what bizarre faculty, by what psychic phenomenon, can M. Alma-Tadema abstract himself thus from his own era and represent ancient subjects for you, as if he'd seen them with his own eyes? I admit to not understanding, and admire, uneasily, the talent of this man who must find himself a stranger in the fogs of London.

On the Road to the Temple of Cérès is a repetition of his already familiar canvases, so I will therefore not stop to describe it, but since this painting has drawn the artist's name to my attention, I will benefit from it to broach the work of two of his pupils, two English illustrators who have engraved small jewels in their annuals for children: Walter Crane and Miss Kate Greenaway. As these English annuals are, along with Japanese sketchbooks, the only works of art worth contemplating in France once the exhibition of the Independents closes, this digression seems to me to be amply justified.

Published by George Routledge & Son, London, Walter Crane has been imported into France by the Hachette bookshop. One could divide his children's annuals into three series. The first, fantastical, concerned simply with the translation of fairy tales; the next, purely humorous, accompanied only by an explanatory caption; and the last, modern, attempting to render certain aspects of family life.

I'm not going to follow the artist through the whole course of his drawings, I will limit myself to choosing his most typical illustrations.

In his fairy tales there is a unique conception of female beauty. A straight nose making a single line with the low forehead, large pupils similar to those of Juno, a small mouth with a slight pout, a short chin, a high waist, robust hips, and very long arms with strong hands and tapering fingers. It's the model of Greek beauty. But what is odd is that the woman thus conceived appears in these books dressed in the most various costumes, belonging to all periods: classical Greece, in certain illustrations for *The Hind*

in the Wood and *Sleeping Beauty*; the Middle Ages, in *Valentine and Orson*; the Renaissance, in *Goody Two Shoes* and others; and the period of Louis XVI, in the second plate of *Beauty and the Beast*. With the merest nothing, a barely noticeable deviation of the girl's nose which turns up imperceptibly, the sculptural figure relaxes and, all the while preserving the artist's immutable character, becomes charming, with the grace of Marivaux's serving girl who chatters in a slight London accent, or again, in *The Forty Thieves*, she turns into a Roman type, still regular, but rather than being rigid she becomes supple, introducing into the amusing milieu of this Persian fantasy a Pompean elegance that is almost sprightly, almost sly.

Another curious fact to note is this:

Whereas in France, in contemporary paintings, the artist neglects all notion of composition and only seems to draw an anecdote suitable for an illustrated newspaper, in the albums under discussion, Crane composes genuine tableaux. Each one of his plates is a little picture, and that of Princess Formosa, in *The Frog Prince*, seated in front of a fountain, or that of the Princess Belle-

Hind in the Wood by Walter Crane.

Sleeping Beauty by Walter Crane.

Etoile, in the album of the same name, who finds her brothers hidden in the enchanted mountain, would have a great appeal and be closely studied if they were canvases in the annual Salon. And I could cite many, many pages from these picture books – signed with a monogram, a crane within a large 'C' – that are more deserving of a frame than the vast remnants of canvas in gilt surrounds that litter the walls of the Palais de l'Industrie each May.

It has to be said that in this series of books Crane seems to be haunted by the memory of Alma-Tadema. Whether he dresses his characters in brocaded robes, whether he presents them in Japanese costume, as in *Aladdin*, or whether he preserves an Empire-style dress, Crane can't escape his obsession with his master; if he uses a wider, more varied range of colours, if he goes so far as to use acerbic tones of the wildest orange, or greens so intense as to be almost black, if, by contrast, he utilises little of that whole octave of Alma-Tadema's ash-grey, his drawing can't free itself from the most flagrant imitation. He has the same manner of establishing a character, drawing them vigorously, using short cuts to show, in a few lines, the muscles beneath their clothes, to make their outline stand out in an ancient pose. But he doesn't go as far in his archaeological preoccupations, not matching, in *Blue Beard*, all the interiors to the costumes chosen for his figures, and, in *Aladdin*, copying storks and decorative flowers from Japanese albums, which isn't reminiscent at all of Alma-Tadema's pious care to place his characters in the milieu in which they should live and move.

Now a curious parallel could be made between the methods – otherwise so dissimilar in their way of understanding the fantastical – of Walter Crane and Gustave Doré,[16] and their different approaches would be all the more easy to establish in that both these artists have illustrated certain tales by Perrault, such as *Blue Beard* and *Little Red Riding Hood*. Doré is more imaginative, more dramatic, more outrageous; Crane is simpler,

Blue Beard by Walter Crane. *Blue Beard* by Gustave Doré.

less dissonant, following the truth step by step, always introducing an atmosphere of reality, even into his fairy tales, as in *Blue Beard*, in which the plate showing sister Anne on top of a tower looking down at the landscape attains a grandeur of style that is inaccessible to M. Doré. Add to that the ethnological interest of these albums for children – which makes them a treat for artists – and then put into the balance, on M. Doré's side, his amusing phantasmagorias of the countryside, his dramatic tricks with light, and his transposition of the art of theatrical scenery into drawing, and you have qualities that could not be further apart, two very divergent interpretations of the tales of Perrault.

Fundamentally, one is very English and works well for the children of that country, for minds already settled, with a need for reality that is maturer than ours, while the other is very French and works well for our children, whose imaginations are more nebulous and more credulous, with no wish to be rational, no attachment to the ordinary day-to-day events of family life. All the differences of race and education emerge from these tales, translated in this way.

But the incontestable influence of M. Tadema will fade and disappear. In his purely humorous and modern work, Crane comes more into his own; two types of old women – one monstrous, in *The Yellow Dwarf*, with her scarlet dress and bonnet, her viperish mop of witch's hair, her enormous eye rolling above a nose separated from a long, pointy chin by the bottomless pit of an abominable mouth, the Desert Fairy who is escorted by two gigantic turkeys with fanned tails; and the other, in the *Princess Belle-Etoile*, a bad-tempered old woman who contorts herself with a comical charm – already reveal a very particular note to his humour.

He has developed this note in three albums particuarly. One, which represents the seasons, is a casket of mad comicality: January is personified by a kind of Russian general, dressed in an outfit of the most baroque furs, doffing his formidable cocked hat, walking in snow shoes, eye squinting under a monocle, while his small groom, a treasure of solemn comportment, offers packages of titbits to adorable young girls who are frozen to the spot, hardly daring to touch such fine things; August is incarnated in the

The Desert Fairy in Walter Crane's *The Yellow Dwarf*.

King Luckieboy's Picture Book by Walter Crane.

person of a sailor whose head of hair blazes like a sun; September is a merry wine waiter, showing off with inexpressible joy two dusty bottles, who is followed by two men, one fat and one thin, in a superbly lifelike attitude; but it's impossible to describe and explain this album, the humour it contains is untranslatable; I can only urge the reader to see it, even though I don't think it has been translated into French yet by Hachette. In any case, it bears this title: *King Luckieboy's Picture Book*.

Another album recounts the daily life of a family of pigs. The father – his neck stuffed into a winged collar, his eyes hidden behind the tinted lenses of his spectacles, his upper body covered in a pistachio-coloured jacket, his buttocks bulging beneath lemon-yellow and white striped breeches from an opening of which curls a corkscrew tail, and his feet encased in cloven top boots – carries out all the activities of English family life. His hat set jauntily on his head, a jovial and satisfied look on his face, he goes to the market, then returns, baskets full, trailing after him one of his sons, a young boar dressed in red with a pastry chef's cap on his head; in another illustration, the enormous backside of the father fills the scene, sheltering with its rotundity his child who sobs, one trotter holding the tails of the pistachio jacket, and the other rubbing his eyes with that grouchy, irritated movement habitual to children. Then, once returned to the house, the father serves dinner to four small piglets sitting in a row, like a panpipe, at the table. While he carves, a great expectation fills the room; the piglets join their trotters and look on in excitement; one is so tempted he squints in anticipation, the others squeeze their small bellies, ears pricked, and dribble hungrily into the bibs they have around their necks, over their pinafores.

What is invaluable about the illustrations is the way these characters are brought to life, the wittiness of their faces, the skill of their expressions, the reality of their poses; there is in it a flavour unknown in France, one which exudes the honest taste of

This Little Pig by Walter Crane.

The Fairy Ship by Walter Crane.

its English origins and leaves far behind the heavy, insipid jokes of someone like Grandville,[17] that Paul de Kock of illustration, that vulgar translator of human attitudes and passions into the clothes and physiognomies of beasts.

But a third album, *The Fairy Ship*, is funnier still. A vessel is alongside a quay, in a port; gigantic cranes are working, crates encumber the walkways bristling with cast iron bollards wrapped in cables; men are on the bridge; shipowners and traders talk among themselves totting up figures, foremen bark orders, labourers rush around, all the regular hurly-burly of a port is before us; then the page turns, the ship has set sail and then appear the most unexpected, the most daring perspectives: the sky whipped by the wings of a gull glimpsed, almost vertically, from the bottom of a hold; then the sea, seen from the top of a mast where crouched sailors furl a sail filled with a furious gust of wind; then part the ship's bridge at a steep angle, cresting skywards on a wave while sailors climb up the rigging and disappear, cut off at waist-level by the frame of the picture. But in fact the whole crew is composed of rats and they are being directed by a penguin! It's a

little marvel of observation, a feat of skill of drawing, bringing out with a stroke of a pencil the simplest and most inconspicuous of the human body's poses, a feat of skill such that to find another as expressive or agile, one would have to look to the Japanese albums of Hokkei or Hokusai.

The third category, that in which Crane treats the modern, contains the essential details of life in London. Here, it's an apple seller, squeezed into his chair, his pipe resting on his trousers; there, it's a corridor in a house, a well-lit hall from which, through an open door, one glimpses the right half of a cavalry soldier in uniform courting a maid, while some prodigious servants' bells, one hanging next to the other, ring menacingly in the air; over there, it's the interior of a kitchen or scullery, with maids standing, wiping dishes and cups, or on their knees, drawing hot water from an oven illuminated by the red and blue flames of a coal fire; elsewhere, it's a dining room, its large window in the background opening onto a garden, where all the family are sitting, father, mother and children, a jolly tableau showing the thousand little comforts of the English table, noting the diverse ways, dextrous or maladroit, that kids have of holding their cups or their spoons.

My Mother by Walter Crane.

In another, it's the city of London that appears, initially seen through the glass pane of a coach, then, as in a kaleidoscope, the tableaux change. We enter Madame Tussaud's and the Crystal Palace, we attend a pantomime of clowns, and finally some sharply-etched ice-skating exercises, with their flights, their abrupt stops and

their falls; the poses of the feet of not very skilful skaters, their tottering steps, the shaking of heads and wavering of arms, are captured with an extraordinary vivacity. In the final album, *My Mother*, one illustration represents a family bathing in the sea and children running on the beach, while another, in the middle of a garden in London, of a woman lifting up her fallen baby, is an astonishing surprise of reality and elegance.

It is in these two series of albums that Crane's own personality affirms itself. As I mentioned above, in his fairy tales the filiation is all too obvious, and I could further add that Alma-Tadema's spiritual father – and consequently Crane's grandfather – the Belgian painter Hendrick Leys, also reveals himself in the artificial naïvety of certain albums, such as *Goody Two Shoes*; but the traces of this heredity die out in the modern work. Here, nature is consulted directly, and entirely in good faith. Moreover, these qualities of exact observation and indisputable veracity, in common with most of the illustrators of talent across the English Channel, have made *The Graphic* and *The Illustrated London News* newspapers without rival among the illustrated press of both the New and the Old World. Crane therefore only had to let himself be carried along by the current of modern English art in his scenes of contemporary life, but in *King Luckieboy's Picture Book*, in *The Fairy Ship*, in several of his alphabets and in the drawings with which he has decorated books of music, he conveys a good naturedness, a delicacy of nuance and a finely-crafted imagination that make them works apart, unique in art.

The sole album produced by Miss Greenaway, *Under the Window*, has been translated into French under the title *La Lanterne magique*. This artist was fortunate enough to succeed at first go, and in Paris her collection has become quite celebrated among a certain class of people.

Miss Kate Greenaway has drunk from the same glass as Walter Crane. Irrefutable reminiscences of Alma-Tadema come

to mind in a number of her illustrations, as well as unshakeable recollections from the albums of Hokusai, but on top of this skilfully beaten together mixture hovers a distinctive tenderness, an amused delicacy, a refined wit, which marks her work with a wholly loving, wholly graceful feminine stamp.

Added to which, it has to be said that only a woman can paint childhood. Crane seizes it in its most tormented and most naïve attitudes, but he lacks in his watercolours what I find in Miss Greenaway, a kind of tender love, a maternal enthusiasm; you only have to leaf at random through any of her pages – such as that in which young girls are playing badminton; or that of a Nuremberg landscape in which a delightful girl stands, speechless and ashamed, in front of an implausible king who seems to be made of painted, articulated wood; or another, in which a tall girl holds a baby in her arms; or another, finally, in which five young misses look at you, hands buried in their muffs, their bodies hidden in their green fur-lined cloaks – to assure yourself of the character and the sex of their author: indeed, no man would dress a girl or arrange her hair under a large bonnet like that, or give

Two illustrations from Kate Greenaway's *Under the Window*.

her that easy petulance, that pretty turn of the apron and dress, moulded to the slightest movements of the body, restraining them almost, so that they remain motionless for a few instants.

And then what an art of decoration there is in this album, what artistry in laying out the pages, what a ceaseless variety in the motives of ornamentation, borrowed from fruits, flowers, household utensils, and a range of domestic animals. What diversity there is in the decorative borders, which change on each page of the book. Here, the stems of sunflowers stand in a corner; there, the lances of reeds rise up from the bottom of the page, the top of which features a bridge and a river; or there again, a basket of tulips branches out beneath the small house of a tidy, respectable pensioner; then the conventional ordering of the page is broken, here a hoop-and-stick race[18] runs around the text, or there, in lieu of a tailpiece, the painter lays out the cups of tea of the people in the scene; or she uses shuttlecocks as fleurons, flying over her printed verse to the great joy of the children brandishing their racquets at the bottom of the page.

An emblem of the talent of Miss Greenaway – who in addition to this album has offered us a few little illustrated notebooks, books given to English children for their birthdays, small plaquettes containing a few minor colour plates – seems to me to be engraved on the first page of *Under the Window*. A Japanese bowl full of pink roses and tea roses is set in a kind of Greek frame; it's very Alma-Tadema, very Hokusai, and from this assortment exudes a fresh perfume of delicately nuanced flowers.

A third illustrator, Randolph Caldecott, has, for his part, also painted some collections in colour for small children. He doesn't derive from Alma-Tadema, but rather from the greatest – and the least known in France – of the English caricaturists: Thomas Rowlandson. Caldecott's *John Gilpin* was, it's true, inspired by the *John Gilpin* of Cruikshank, but it's as well to add that this latter artist also descends in a straight line, at least in this particular

John Gilpin by Randolph Caldecott.

fantastical tale, from Rowlandson. The history of this fellow carried off by a horse, who's dragged through meadows and villages, stirrups awry, losing his riding crop and his wig amid a cloud of geese that fly away, frightened, from under the feet of his horse, pursued by a whole pack of dogs, and finally caught up with by a whole cohort of friends who succeed, after a mad chase, in joining him and bringing him back home where he collapses, exhausted, into the arms of his wife, is interpreted with a formidable joviality, a ferocious mirth. There is in it the last few drops of old Flemish blood, like the persistant echo of Jan Steen's hearty laughter, shaking the window panes and beating on the doors.

To this overflowing laughter Rowlandson added a cold, particularly English mockery. Leaving moral and utilitarian ideas to Hogarth (which Cruikshank would later take up), and, after numerous attempts, abandoning political subjects to James Gillray, he attacked contemporary manners and painted them in incomparable satires that were engraved and etched and coloured by hand. The whole series – *Doctor Syntax*, *The Miseries of Human Life*, and *The English Dance of Death* – proves what an individual artist this man was, whose illustrations, formerly discarded as junk, achieve solid prices at auction

today.[19] Information on his life is unfortunately lacking; one can summarise it in six lines. He was born in the month of July, 1756, in the Old Jewry quarter of London, lost his parents, came to Paris, inherited money from an aunt which was quickly devoured, frittered away on women and gambling, returned to London, where he continued in his debaucheries, working only when in need, and died on 22 April 1827, in blackest poverty, leaving us – in addition to his political caricatures, some book illustrations and some studies of manners – a series of illustrations that are pure masterpieces of obscene invention.

No one more than Rowlandson delighted in the deformities of fatness and thinness. With a few strokes he inflates a paunch, swells some cheeks, clenches a buttock, outlines a dropsy of the skin, polishes the dome of a cranium, dulls the gleam in an eye, liberates the comical from adiposity, or brings out the heron-like carcass of the emaciated man. No one captured like he did the ludicrous aspect of these people when on horseback, either crushing their nags under their weight, or flying like a feather off its rump at every bound. And finally no one – above all in his early work – drew such exquisite figures of women who are a little bit plump. One of his political prints is, from this point of view, characteristic: Charles Fox in the arms of two women, two marvellous treasures of an adorable

Doctor Syntax by Thomas Rowlandson.

charm. On the other hand, nobody has also ridiculed woman more cruelly after the devastations of age have set in. The engraving known under the title *The Trumpet and Bassoon* is proof. The bloated face of the woman sleeping next to her husband, whose nose rises above his toothless mouth like a pyramid perforated with two doors, would make the least fastidious and the bravest man recoil in horror.

Like Rowlandson, Caldecott devotes himself to a burlesque of obesity and rickets; like him, in his album the *Three Jolly Huntsmen*, he makes big-bellied people gallop over mountain and vale; he hasn't yet grappled with the monstrosities of old age among women, but he could never outdo Rowlandson in the elegance of their youthful delights.

Despite everything, Caldecott is not just a direct echo of Rowlandson; in some albums, over which I will pause for a moment, he has shaken off the influence of his master and gives us a more personal note; and, moreover, he has a gift – more so than Walter Crane and Miss Greenaway – of breathing life into his characters. Everything else seems a bit stiff compared to his

The Devonshire, or most approved method of securing votes by Thomas Rowlandson.

Trumpet and Bassoon by Thomas Rowlandson.

figures, who charge about and shout; it's life itself captured in its very movements. And what a landscape designer this painter is! Take a look, in the book entitled *The House that Jack Built*, at those buildings that have established themselves under a dappled sky, amid the tall trees that border the meadows and gardens; look at this sun rising over the countryside, while a cock crows and a smiling man opens his window; take a look, in another book representing children abandoned in a forest, at the form of the large, stormy clouds, the robust power of the oaks, the delicate leaves of the ferns turning autumn red, and in yet another, *Sing a Song for Sixpence*, telling the story of a whole chirping brood of birds, look at the winter landscape in which, under a leaden sky, hayricks stand capped with snow while two frozen urchins hunt for birds.

And the nature artist in Caldecott is equal to the landscape artist. In one of his albums, a rat gnawing a sack of barley is chased and then eaten by a cat, which is stalked in its turn by a dog that is finally eviscerated by a cow – all of which is carried off in a few witty and decisive strokes; later in the album there's

The House That Jack Built by Randolph Caldecott.

a little black cat which leans, in an extremely accurate feline gesture, against the hand of the man stroking it; and in *An Elegy to the Death of a Mad Dog*, a whole page is devoted to the dogs, where the demeanour of the various breeds, and the serious and defiant air that dogs have among themselves when they don't feel they've been sufficiently sniffed under the tail, are sketched with a dazzling agility.

Illustrations from *Sing a Song of Sixpence* (left) and *Babes in the Wood* (right) by Randolph Caldecott.

But where M. Caldecott rises to the rank of a great artist, no longer owing anything to his precursors, is in *The Babes in the Wood*, in which a husband and wife are dying, while their two children play with a Punchinello puppet at the side of the bed. If the faces of the doctors didn't border on exaggeration, it would be a simple masterpiece. The man, sitting up in bed, emaciated, pale, his hands blue, such that the veins can be seen under the thin, wasting skin, is painfully sticking out his tongue.

He is very ill, but one feels he still has a few days to live. As for the woman, she is going to die and her face is terrifying. Head on the pillow, unable even to raise her arm while they take her pulse, her face is as white as linen, almost swallowed by two large eyes, whose fixed look of suffering makes one uncomfortable. I don't know of a picture in which the spectacle of death is so cruel and so poignant; it's because here the artist has suppressed all the theatrical attitudes adopted by painters, all the conventional modes of mortuary poses, all the expressions learned in the art schools; he has, simply and with great pity, followed nature and tackled a lamentable scene, and he describes it to us in several

pages, sparing us no horror, no anguish; showing us the mother embracing her little boy at the final moment, and in this woman's gesture, in the expression of this face whose eyes are closed, in this sobbing embrace, can be seen all the immense sorrow of a mother who leaves her children alone in the world.

These illustrations are unfortunately rare in Caldecott's work; in his other albums, the plump joviality of the cartoonist is delightful, but this rollicking, mocking style of drawing is not his own; and if certain sketches, like that of a toddler being washed in a tub, no longer resemble Rowlandson's, they could nevertheless have been drawn by one of the Edo artists.

Like those of *Under the Window* by Miss Greenaway, these chromos are magnificent: none of them could be mistaken for watercolour, they are so fine and white. The art of coloured images, so rudimentary in France that it's exclusively confined to commercial illustration, has attained an unqualified perfection with the English. Looking at these prints, M. Chéret, who, in addition to his original talent, is the most expert of our chromolithographers, would sigh and say to me: 'There's not a workman here in France capable of drawing such pages.' And it's true that those I've just spoken about are marvels of blending and smoothness, achieved by the printer Edward Evans,[20] and they are much superior to those of Crane, whose colours are still discordant and raw.

In short, these illustrated annuals – so despised in France that they are entrusted by makers of children's toys to the first workman who comes along, and whose cheap and nasty images make me bitterly regret the old naïve and sometimes jolly Épinal prints, with their large slabs of Prussian blue, pepper green, ox-blood red and gamboge yellow – have become true works of art in England, thanks to the talent of these three artists, because I am obviously leaving aside the more or less successful pastiches of Miss Greenaway's *Under the Window* that have recently appeared in London.

Although we know the sources they've drawn from, Crane, Greenaway and Caldecott each have a personal flavour, a different complexion and nervous temperament – very balanced in Crane, more full-blooded in Caldecott, and a little anaemic in Miss Greenaway.

Without wishing to establish here a comparison between their works, one can nevertheless assert that on the day they become as popular in Paris as they are on the other side of the Channel, it will be artists who prefer Crane,[21] whose talent is more varied, more ample and more flexible; women and the lovers of the pretty and tender will be attracted to the delicate jewels of Miss Greenaway, while the general public will adopt Caldecott, whose lively buffoonery and sonorous laughter will seduce them more.

But we have lingered too long, because we must now return to the Salon of 1881, where we still have to see the rooms devoted to watercolour, sculpture and architecture. I will be as brief as possible.

Among the drawings are two charcoals that are out of the ordinary, *The Quartet* and *The Tavern* by M. Lhermitte; *The Quartet*

The Quartet by Léon Lhermitte.

especially, in which some amateurs have gathered round to play chamber music just as they are, not in the carefully prepared groups of a photographer. I confess I prefer these easy drawings to the more strained and tentative paintings of this artist. After him, I can also point out *The First-Aid Post*, a pastel by M. Cazin in which I find qualities that were absent from his *A Memory of the Festival*; next is a rather pleasant *Temptation* by M. Fantin-Latour, two watercolours by M. Heins…and then what? Nothing, unless one counts five watercolours by a Japanese pupil of M. Bonnat. Imagine recollections of Japan translated into the language of our art schools! M. Goseda Yoshimatsu is lost; his eye

is obliterated, his hand unthinking. I dare not beg him to return to his own country and study nature and the work of his masters, because I know how indelible the habits learned in our art classes are. Oh this poor unfortunate who came to France only to lose his talent, if he had any, and who has acquired no semblance of it, if he hadn't!

The watercolours exhibited this year are therefore practically nil; the pastels are few, and of a mediocrity that is discouraging. In order to

Racing at Auteuil by Guiseppe de Nittis.

discover some that are

interesting one would have to leave the Salon once again and push on to the Place Vendôme, where those by M. de Nittis are being exhibited. I don't have time to give a full review. Let's just say that this painter is making progress, that his customary affectations and his inferiorities of perspective are less noticeable; that among his pastels of horse racing at Auteuil, one representing a woman standing on a seat, and another – a view of the grandstand in the rain, in which, as in certain Japanese prints, a cloud of open umbrellas like mushrooms runs along the bottom of the frame – are of an amusing and pretty colour.

Let's descend now into the sculpture rooms. Always the same gathering of busts, allegories and nudes. No attempt at the modern; it would be better to be silent than keep repeating the same subjects every year. Let's pass on, casting a glance nevertheless at M. Ringel's bizarre enigma entitled *Splendours and Miseries*, a group in painted terracotta, life size, showing a harlot standing under an umbrella, and sitting at her feet, a sort of crippled pimp, wearing a Yokohama straw hat, his nose sporting a pair of real spectacles with blue lenses, who is yelling I know not what! Nevertheless, there is something in this Vireloque[22] who resembles a Yankee, but the girl is detestable; she is a dummy, ungraceful, lifeless and dressed up in a ridiculous manner.

Architectural drawings? Well, there are some. In solitary rooms architecture exhibits its washes, evoking the idea of a considerable consumption of bowls of Chinese ink; for the most part they are projects for the restoration of churches and colleges, the refurbishing of hospitals and schools, and plans for funerary chapels: nothing, in short, that would lead you to believe that these exhibitors are even aware of a determined movement in architecture.

It's true that it's the pusillanimous who operate here; they all patch up worm-eaten buildings or recopy, line for line, previously conceived models of villas or barracks; no one tries to walk in

his own boots; I shall not, therefore, bother myself with these re-heelers of other men's shoes, I will simply limit myself to supporting and completing the statements I made in my Salon of 1879 on the subject of architecture, by showing the uninterrupted succession of monuments erected in Paris according to the records of the new school, and in this way pointing out the road already travelled and that which remains to be followed.

The Second Empire – a great builder, as every one knows, but of an irremediable ineptitude from the point of view of taste – dreamed of making an architectural art bloom that would bear its name. To this end it encouraged disparate amalgams of every style; it pushed this abuse of leaden ornamentation to such a degree that it rendered the commercial courts one of the most miserable palaces of the century. It refused to recognise, as M. Boileau[23] so justly put it in his extremely interesting book, *Iron*, that 'the inherent combinations of stone as a fundamental material for monuments were exhausted; there persisted a desire to produce new effects, but without the realisation that in order to achieve the proposed goal, one must extend the use of a new material element which, although only employed in a restricted way by modern architecture, has nevertheless furnished positive results: iron.'

The bureaucratic routine thus continued on its fine way, but this advice was not, however, ignored. Léonce Regnaud, Michel Chevalier, César Daly and Viollet-le-duc[24] declared many times that iron and cast iron could alone command new forms. Hector Horeau,[25] who was the most audacious architect of our time, drew up gigantic plans for iron and steel monuments: nothing was made. The movement had well and truly proclaimed itself, but the State, which was in charge of all the commissions, was obstinate in its ideas and, sustained by the old School of Architecture which would only sanction the combined use of iron and stone in rare instances, resolutely pushed back on the

idea of metal being used as the primary material for building.

Little by little, however, cast iron imposed itself. The work of engineers helped to reveal it; the metallic constructions they carried out shook the routine apathy of architects and public alike, and hybrid architectural works – which is to say those in which the two elements of stone and iron are combined – proportionately increased.

Among these works one can cite from memory the Sainte-Geneviève library, built by M. Labrouste.[26] Since then, this artist has made metal play a larger role, as when he erected the splendid room in the National Library,[27] which I will speak about later. Artistic ironwork has affirmed itself in his work by an originality of form impossible to achieve with other construction materials. In 1854 metal entered, for the first time, into the structure of monuments dedicated to religion: M. Boileau built Saint-Eugène. At the time – even though Les Halles, built the previous year, had been a complete revelation in this new art – the adoption of steel and cast iron as a principal element of a church was seen as astounding. Although the style was, as always, imposed on the artist and his work was necessarily a bastardised one, it was nevertheless a new contribution to be adduced in support of the theories of the ironworkers. A polemic began, but the innovator won his cause, and later, in 1860, we see the State accept steel for the construction of Saint-Augustin church, and a bit later still in one of its own buildings, that of the Academy of Fine Art, refurbished in cast iron by M. Duban.[28]

For their part, the big railway companies contributed to the movement in a big way. The Gare d'Orléans, the gateway to the north, built in 1863 by M. Hittorf,[29] testified to the new effort; I will leave aside, in this roll call, the Palais d'Industrie, which is only a small-scale version of the Crystal Palace in London and which in any case was only an unhappy amplification of the greenhouses of our natural history museum. This unfortunate experiment, with

Les Halles market in Paris.

its dreadful glazed roofs, doesn't concern us from the artistic point of view, which is the sole criteria in question here.

But after these albeit limited examples of the employment of metal, we're no longer dealing with combined works, but works that are completely of iron.

Les Halles, built in 1853, was, as I mentioned above, a decisive success for the new school. But even here the Empire dithered, guided by its architect M. Baltard.[30] It wanted to continue the old mistakes, and they were forced to demolish the stone huts this architect had initially erected in the guise of a market. It was under the pressure of public opinion, which supported the projects of Horeau[31] the architect and Flachat[32] the engineer, that M. Baltard became a sudden convert, adoring what he had previously scorned; he melded the proposed projects into a single plan and, in concert with his colleague M. Callet,[33] and with the assistance of Joly[34] the master of the ironworks, raised this monument that is one of the glories of modern Paris.

Les Abattoirs de la Villette — La Place aux Veaux

The slaughterhouses at La Villette.

Next it was the cattle market and the slaughterhouse of La Villette that took on the iron framework of Les Halles, and which M. Janvier,[35] following M. Baltard's plans, enlarged still further. Here, iron reaches imposing proportions. Enormous roads stretch out, broken by slender columns that spring up from the ground, supporting light ceilings, flooded with sunlight and air. It's an enormous courtyard, the flanks of which swallow up thousands of animals, a vast plain whose covered ceiling floats over a feverish activity of trade, over a ceaseless coming-and-going of cattle and men, it's a series of immense pavillions whose sombre colour and slim yet squat appearance is well-suited to the infatigable and bloody industries that are exercised there.

After that, rebuilt to the plans of Ernest Legrand,[36] came the clothes market at the Temple,[37] which rises up in slender jets of cast iron, a smaller market, neater and more coquettish. Here the aisles are narrower, the arches spring less high, the colour is less sombre; the flow of life that furrows through it is less heavy, less brutal than in La Villette, more fastidious and more gossipy. It's a jolly edifice, composed of six small pavilions, of which two, joined

by an arcade, form a façade flanked by square towers topped by turrets; it's a series of lanes which, with its clever use of daylight, brightens up the poverty of the clothes on display. There's almost a brothel-like atmosphere of gaiety in this sprightly building,[38] where the iron seems to put on airs and graces to match the chic, noisy colours of the ribbons and trinkets piled up in the boutiques beneath its vaults.

Now come the Exposition Universelles, enveloping whole worlds in their immense, airy vessels, in their gigantic avenues rising up as far as the eye can see, above all the machines on display. In spite of its glass domes, the form of which mimicked the shape of a diving-helmet, the 1878 Palais de l'Exposition, built by M. Hardy,[39] had a certain sense of magnitude that is quite rare in the architectural works of our time.

Finally, it's the splendid interior of the Hippodrome,[40] built by the engineers Fives-Lille; here, with the prodigious altitude of a cathedral, cast iron columns fuse with an unmatched boldness. The lithe, thin stone pillars so admired in certain old churches seem timid and lumpy next to the jets of these light stems that rise up into the gigantic arches of this rounded ceiling, linked by an extraordinary network of iron that divides on all sides, connecting,

The Hippodrome d'Alma in Paris.

crossing and entangling their formidable beams, inspiring a little of that feeling of admiration and fear one experiences in front of certain enormous steam engines.

If the outside of this circus had been of an originality, of an artistic worth, equal to the interior, the Hippodrome would certainly be the masterpiece of the new architecture.

Changing the perspective now, the iron reading room contained in the stone buildings of the National Library is a marvel of agility and grace; it's a vast room surmounted by spherical cupolas and pierced by large bays; a room poised as if on tapering stalks of cast iron, a room of incomparable distinction, rejecting the uniform grey-blue in which metal is almost always dressed, allowing whites and golds on the arches that support the lanterns, accepting the decorative contest with the majolica.

One could almost say that between the interior of this reading room and the interior of the Hippodrome there's a difference analogous to that which exists between Temple market and the market at La Villette: one is elegant and flexible, the other is superb and imposing.

The Reading Room in the National Library, designed by Henri Labrouste.

In all these monuments I've passed under review there is no borrowing from Greek, Gothic or Renaissance formulas; it's a new, original form, inaccessible to stone, possible only with the metallurgical elements fabricated in our factories.

My fear is that M. Charles Garnier[41] will turn out to be right when, in his book *Across the Arts*, he wrote these sentences: 'The hangar, that is iron's destiny…Some people base the hope of a new architecture on iron. I will say this straightaway, it's a mistake and a big mistake: iron is a means and will never be a principle. If the great buildings, the halls and stations built almost exclusively in iron, have a different look than constructions in stone…they do not for all that constitute a distinct form of architecture.'[42]

But what does it constitute then? Is it the bastardisation of styles that were painfully yoked together in his Opera Garnier, that last gasp of Romanticism in architecture, with its use of polychrome, here, there and everywhere; with its assemblage of thirty-three types of granite and marble which jostle against each other and which are inevitably destined to deteriorate under our rainy skies; with its massive staircase that doesn't belong; and finally with its doors that look like those of a cellar, crushed by the weight of its masonry, which is massive and pompous but lacks true grandeur?

But then nothing is less surprising than this architect's opinion, because this crazed devotee of Romanticism – who described the Paris he dreams of like this: 'Gilded friezes run along the buildings; the monuments will be dressed in marble and enamel, and mosaics will instil a love for colourful movement… our eyes will demand that our costumes adapt themselves and become more colourful in their turn, and the whole city will be like a harmonious reflection of silk and gold'[43] – would never be able to accept the magnificent simplicity of an art that is so little concerned with a motley of colours and gilding.

No, modern art cannot permit this retrogressive element, this return to a meretricious beauty touted by M. Garnier. The era

of Véronèse's ostentatious costumes is long gone and will never return, because it doesn't have any *raison d'être* in a busy century, fighting for its life like ours.

One fact is certain: the old architecture has given all it could give. It's therefore quite useless to overuse it, to want to appropriate out-of-date materials and styles to modern needs. As M. Viollet-le-duc has written, it's a question now of seeking monumental forms that derive from the properties of iron.[44] Some have already been discovered. The efforts of the so-called rationalist school have carried through to the present day, especially as regards the form of stations, circuses and markets; tomorrow they will tackle the form of theatres, town halls, schools, all the buildings of public life, abandoning servile copies of domes, pediments and spires, forsaking forever the impoverished combinations of stone.

Like painting, which in the wake of the Impressionists freed itself from the desolate precepts of the art schools; like literature which in the wake of Flaubert, Goncourt and Zola has thrown itself into the Naturalist movement, architecture has also got out of the rut and, more fortunate than sculpture, has created a new art with new materials.

So the prophesy of Claude Lantier in Zola's *The Belly of Paris* has in part been realised already, demonstrated in Les Halles and Saint-Eustache:

'It's a curious conjunction, the stone apse of a church framed by this avenue of cast iron; this will kill that, iron will kill stone and the time is close. You see, there is in this a whole manifesto, it's a modern art that has grown in opposition to the old art. Les Halles is an outstanding work, nevertheless it's only a timid revelation of the 20th century to come.'[45]

Exhibition of the Independents
in 1881

M. Degas has shown himself to be singularly parsimonious. He has contented himself with exhibiting a view backstage of a theatre – a gentleman holding a woman close, almost forcing his leg between her thighs, behind one of the flats illuminated by the brazier-red glow of the auditorium, which can just be made out – and a few drawings and sketches representing singers on stage, like grotesque porcelain figurines, holding their paws out over the heads of the muscians, as if in an act of blessing, while in the foreground the headstock of a cello emerges like an enormous '5', or rather swaying and bellowing in those amateurish convulsions that have procured a quasi celebrity for that epileptic puppet, La Bécat.[1]

Add two more sketches: criminal physiognomies with animal snouts, low foreheads, projecting jawbones, snub chins and shifty, lashless eyes; and an astonishing nude of a woman at the back of a bedroom, and you have a full list of the drawn or painted works contributed by this artist.

In his more carefree sketches, as in his finished works, the

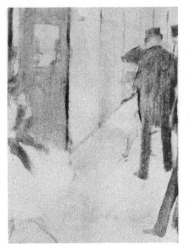

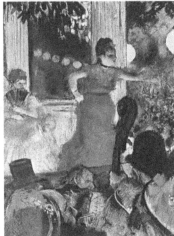

In the Wings by Edgar Degas. *The Café-Concert* by Edgar Degas.

personality of M. Degas leaps out; this brief, nervy drawing, capturing like a Japanese print a movement in flight or a momentary pose, belongs only to him; but the intriguing thing about his exhibition this year is not in his drawn or painted work, which adds nothing to that which he exhibited in 1880 and which I've already given an account of, it resides wholly in a wax statue entitled *The Little Fourteen-Year-Old Dancer*, before which a confused public has fled, as if in embarrassment.

The terrible reality of this statuette produces an obvious unease in the public; all its ideas about sculpture, about those pieces of cold inanimate whiteness, those memorable clichés that have been recopied for centuries, have been overturned. The fact is that, in a single blow, M. Degas has toppled the traditions of sculpture, in the same way that he has long since shaken up the conventions of painting.

Returning to the method of the old Spanish masters, M. Degas has, by the originality of his talent, immediately made sculpture completely individual, completely modern.

Like certain statues of the Madonna that are clothed in dresses

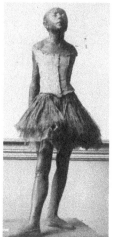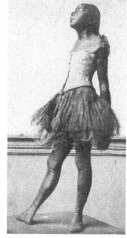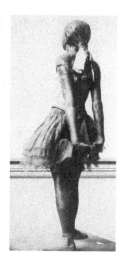

The Little Fourteen-Year-Old Dancer by Edgar Degas.

and wear makeup, or like the statue of Christ in Burgos Cathedral whose hair is made of real hair, the thorns of real thorns, and who is draped in a genuine fabric, the dancer of M. Degas has real skirts, real ribbons, a real corsage and real hair.

A painted head, thrown back a little, chin in the air, the mouth half opening in a sickly brown face, drawn and aged before her time, hands stretched out behind her back and joined, her flat chest moulded by a white corsage whose fabric is kneaded wax, her legs in position for action, admirable legs broken by exercise, nervous and twisted, topped by the tent-like muslin of the skirts, the neck stiff, ringed with leek-green ribbon, the hair falling down over the shoulder and sporting, in a chignon decorated with a ribbon similar to that at the neck, real tresses – such is this dancer who comes alive under your glance and seems ready to leave her pedestal.

At once refined and barbarous in her machine-made costume and her coloured flesh which palpitates, furrowed by the working of the muscles, this statuette is the only really modern attempt at sculpture I know of.

I'm leaving aside, of course, those attempts already ventured

at peasant-women holding out a drink or teaching children to read, at Renaissance or Greek peasant-women rigged out in costumes by someone like Draner;[2] I'm also ignoring that abominable sculpture of contemporary Italy that features on the tops of clocks, those cute women made out of stearin, constructed along the lines of illustrations in fashion journals – I will simply recall an attempt by M. Chatrousse. It was in 1877, I believe, that this artist tried to bend marble to the requirements of modernism: the attempt failed, this cold material suitable for the symbolic nude, for the stiff shafts of old spears, froze the Parisienne's snazzy coquetteries. Although M. Chatrousse was not an inferior spirit, what's certain is that he

La Parisienne by Émile Chatrousse.

lacked a sense of the modern and the necessary talent, but he also made a mistake in choosing this monochrome and icy material, incapable of rendering the elegance of contemporary clothing, the softness of a body stiffened by corsets, the spiciness of features animated by a dash of makeup, the mischievous tone lent to a Parisienne's face by a curly fringe poking out from under one of those small bonnets, enlivened on one side by a pheasant's feather.

Reverting to the technique of painted wax – following in the wake of M. Henry Cros who used it to transport figures painted in the old missals into sculpture,[3] and of M. Ringel, whose work belongs to no epoque – M. Degas has discovered one of the only

formulas that might be suitable for contemporary sculpture.

Indeed, I don't see what path this art could follow if it doesn't resolutely reject the study of the antique and the use of marble, stone and bronze. A chance to leave this well-beaten track was offered a number of years ago by M. Cordier, with his polychrome works. But this invitation was rejected. For thousands of years sculptors have neglected wood, which can adapt itself marvellously, in my opinion, to a living and real art; the painted sculptures of the Middle Ages, the altarpieces of Amiens Cathedral and in the Hall museum, for example, prove it, and the statues which stand in Sainte-Gudule and in the majority of Belgian churches, the life-size figures by Pieter Verbruggen of Antwerp and of other old Flemish sculptors offer more affirmation still, if that's possible.

There is in these realistic, human works, a play of features and a bodily life that have never been recaptured by sculpture. Added to which, see how malleable and supple, flexible and almost smooth wood becomes under the will of these masters; see how light and precise the fabric of costumes carved in oak are, how it cleaves to the person who wears it, how it follows her pose, how it helps to express her function and her character.

Well, transfer this process, this material to Paris, now put them into the hands of an artist who, like M. Degas, has a feel for the modern and for the Parisienne, whose very special beauty is formed of a balanced mix of the natural and the artificial, of a single blend of all the charms of her body and graces of her toilette, and M. Chatrousse's aborted *Parisienne* would come to full term.

But today wood is only carved by makers of ornaments and furniture; it's an art one wishes they would return to – in preference even to that of wax which is so expressive and malleable, but so ephemeral and fragile – an art that should combine elements of painting and sculpture; because in spite of its warm, lively tones, wood in its natural state would remain too incomplete and too restrictive, since the features of a face attenuate or strengthen

according to the colour of the decoration that supplements them, since I know that what makes the character of a woman's face is in large part given by the tone of the makeup she wears. Inevitably, this conclusion asserts itself: either the inescapable necessity of employing certain materials in preference to others, and the despotic need to combine two arts – recognised since antiquity because even the Greeks adopted painted sculpture – will be understood and recognised by contemporary artists, who will then be able to tackle scenes of modern life, or else sculpture, worn out and faded, will get more and more sclerotic, year after year, and will end up falling into a drivelling paralysis.

To return to M. Degas' *Dancer*, I have strong doubts that it will obtain even the slightest success; no more than his painting, whose exquisiteness is unintelligible to the public, the originality and boldness of his sculpture will not even be suspected; moreover, I know that M. Degas, either from excess of modesty or of pride, professes a haughty disdain for success; well, I greatly fear that once more as regards his work he'll have no occasion to rebel against the taste of the crowd.

I wrote last year that the majority of the canvases by Mlle. Cassatt recalled the pastels of M. Degas, and that one of them derived from the modern English masters. From these two influences an artist has now emerged who owes nothing to anyone, a wholly spontaneous, wholly individual artist.

Her exhibition is composed of portraits of children, of interiors, of gardens, and it is a miracle how in these subjects dear to the English painters Mlle. Cassatt has avoided the sentimentalism against which the majority of them ran up against, in all their written or painted works.

Babies! My God, how many times have their portraits given me the shivers! A whole series of English and French daubers have painted them in such stupid and such pretentious poses. So much have the 'moderns' outdone the stupidity of dead painters in this

Susan Comforting the Baby by Mary Cassatt.

area that one even ends up tolerating the picture of Henri IV on all fours playing horsey with his kids.[4] For the first time, I have, thanks to Mlle. Cassatt, seen likenesses of gorgeous toddlers, quiet, middle-class scenes painted with a kind of delicate tenderness that is wholly charming. All the same, it's worth repeating, only a woman is capable of painting childhood. There is in her a particular feeling that a man wouldn't know how to render; unless he's singularly sensitive or highly-strung, his fingers are too large not to leave his clumsy and coarse prints all over it; only a woman can pose a child, dress it, and pin up its hair without pricking herself; unfortunately, she then turns to affectation or to sentimentality, like Mlle. Elisa Koch in France and Mme. Ward in England; but Mlle. Cassatt is, thank God, neither one nor the other of these two dauberesses, and the room in which her canvases are hung contains a mother reading surrounded by her kids, and another mother kissing her baby on the cheeks, which are irreproachable pearls of the softest lustre; it's family life painted with distinction, with love; one thinks involuntarily of those discreet interiors by Dickens, of Esther Summerson, of Florence Dombey, of Agnes Copperfield, of Little Dorrit, of Ruth Pinch, who cheerfully dandle children on their knees while a copper kettle hums in the peaceful room, and the light beaming down on the table animates the teapot and the cups, and cuts in two the plate on which slices of bread and butter are piled. There is in this series of works by Mlle. Cassatt an emotional

comprehension of the tranquil life, a penetrating feeling of intimacy such that, in order to find its equal, one would have to go back to the painting by John Everett Millais, *Sisters*, exhibited in 1878 in the English section of the Exposition Universelle.

Two other paintings – one called *The Garden,* in which a woman reads in the foreground, while behind her, at an angle, a mass of green pricked with red stars of geranium

The Cup of Tea by Mary Cassatt.

and bordered with the dark crimson flowers of China grass, leads up to a house, the base of which forms the edge of the canvas; and the other entitled *The Cup of Tea*, in which a lady, dressed in pink, seated in an armchair, smiles, holding a small cup in her gloved hands – add to this calm and collected tone a fine hint of Parisian elegance.

And it's this that is the special inherent mark of her talent – Mlle. Cassatt, who I believe is American, paints us Frenchwomen, but in their so very Parisian apartments she gives them a benevolent *at-home* smile; she manages to extract from Paris what none of our painters know how to express: the joyous quietude, the calm good-naturedness of an interior.

Now, here we are in front of the Pissarros. And what a revelation this artist's exhibition is too.

After having groped around for so long, throwing out at random a canvas like his *Summer Landscape* of last year, M.

Pissarro has suddenly rid himself of his errors, of his shackles, and brought us two landscapes that are the work of a great painter: the first, *Sunset Over a Field of Cabbages*, is a landscape in which a flocculent sky disappears into infinity, battered by the tops of trees, in which a river runs next to smoking factories and paths climbing through woods, it's the landscape of a powerful colourist who has finally embraced and cut down to size the terrible difficulties of full daylight and the open air. It's the new formula so long sought for and realised in full; the true countryside has finally emerged from these assemblages of chemical colours, and in this nature bathed in air there is a great calm, a serene plenitude going down with the sun, an enveloping peace that rises from this robust site in which striking tones transform themselves under a vast firmament, into unthreatening clouds. The second, *Cabbage Path in March*, has an eloquent and joyous aspect with its geometric planes of vegetables, its fruit trees with twisted branches, its village in the background fanned by poplars. The sun rains down on the houses which brings out the red of their roofs against the green tangle of the trees; this is a fecund land worked on by the action of spring, a solid land in which the plants grow furiously; it's the 'Alleluia' of a reviving nature, whose sap boils; an exuberance of countryside, scattering its violent tones, sounding explosive fanfares of bright green, sustained by the blue-green of cabbages – and all this quivers in a dusty sunlight, in a vibration of air unique until now in painting; and what a fascinating technique, what a novel execution, different from that of all known landscape painters; what originality, emerging from the combined efforts of the first fighters of Impressionism, of Piette, of Claude Monet, of Sisley, and finally of Paul Cézanne, that courageous artist who should have been one of the promoters of this new style. Up close, *Cabbage Path* is a brickwork of bizarre rough dabs, a ragoût of all kinds of tones covering a canvas of lilac, Naples yellow, madder red and green; but from a distance, it is circulating air, it is limitless

Cabbath Path in March by Camille Pissarro.

sky, it is gasping nature, it is water evaporating, it is radiating sun, it is earth that ferments and steams!

M. Pissarro's exhibition is substantial this year. Here and there, a few canvases testify again to the artistry of the marvellous colourist this painter is. Others are more hesitant, for them the blossoming didn't happen; others still, stutter completely, among them a pastel of the Boulevard de Rochechouart, where the eye of the artist doesn't grasp the gradations and the nuances, and restricts itself to putting brutally into practice the theory that light is yellow and shadows are violet, with the result that the whole boulevard is absolutely drowned in these two colours; lastly, some gouaches representing peasants complete this series, but they are less personal; in M. Pissarro's work the human figure takes on the look and appearance of those in Millet; some, such as *The Harvest*, also recall in execution the gouache panels of Ludovic Piette.

All things considered, M. Pissarro can now be classed among the small number of remarkable and daring painters we possess. If he can preserve his perceptive eye, so agile, so fine, we will certainly have in him the most original landscape artist of our time.

M. Guillaumin is also a colourist and, what is more, a wild

colourist; at first glance, his canvases are a muddle of conflicting tones and rough contours, a mass of vermilion stripes and Prussian blue; stand back and squint your eyes, and it all falls into place, the planes become solid, the screaming tones are assuaged, the hostile colours are reconciled and one is astonished at the unforeseen delicacy that certain parts of these canvases take on. His *Quai de la Rapée* is especially surprising from this point of view.

The day the exasperated eye of this painter settles down, we will be confronted by a landscape artist, albeit a Fortuny-esque landscape artist if one can say such a thing; in other words, a visionary for whom the impression of colour doesn't reveal itself in the brain, but locates itself on the retina. In his landscapes there will be neither melancholy, nor gaiety, neither serenity, nor the torment of nature, only the impression of bright splodges of bodies in full light, in the broad light of day.

I have every reason to believe that the visual balance M. Guillaumin lacks will come to him, because his works, which until now were just an incomprehensible mish-mash of jarring tones on top of jarring tones, are already beginning to sort themselves out. It perhaps won't be much longer before he, too, succeeds in the realisation of his efforts.

Last year, M. Gauguin exhibited for the first time; his series of landscapes was a dilution of the still hesitant work of Pissarro; this year, M. Gauguin introduces himself with a canvas that is truly his own, a canvas that reveals the undeniable temperament of a modern painter.

It bears this title: *Study of a Nude.* In the foreground is a woman, seen in profile, sitting on a couch in the course of mending her shirt; behind her stretches a backdrop of purplish wallpaper that is cut-off by a glimpse of an Algerian curtain.

I have no fear in affirming that among the contemporary painters who have worked with the nude no one has yet given such a vehement note of reality; and I'm not excluding Courbet

from these painters, whose *Woman with a Parrot* is as little true to life, both as an arrangement and as a piece of flesh, as Lefebvre's *Reclining Woman* or Cabanel's creamy *Venus*. The Courbet was harshly painted with a palette-knife during the reign of Louis-Philippe, while the flesh of the two more recent painters wobbles like a hastily-made patisserie; but when all is said and done, that's the only difference between these paintings, if Courbet

Study of a Nude by Paul Gauguin.

hadn't placed, at the foot of the bed, a modern crinoline, his woman could have equally well been called a naïad or a nymph; it was by a simple trick of detail that this woman was regarded as a modern woman.

Here, the case is quite different; this is a girl of our time, and a girl who isn't posing for the gallery, who is neither lascivious nor simpering, who occupies herself quite simply with repairing her clothes.

And the flesh is conspicuous; there's none of that flat skin, smooth, without bumps, without granulation, without pores, that skin uniformly dipped in a vat of pink dye and pressed flat by a warm iron that every other painter resorts to; it's a skin reddened by blood and beneath which the nerves quiver; and finally, what truth in depicting all the parts of the body, in that slightly too big belly which falls on the thighs, in those wrinkles running below her swinging breasts ringed with bistre, in those little angular

Woman with a Parrot by Gustave Courbet.

Reclining Woman by Jules Lefebvre.

Birth of Venus by Alexandre Cabanel.

knee joints, in that jutting wrist bent over the shirt.

I am happy to acclaim a painter who has experienced, like me, an imperious feeling of disgust for those mannequins with their restrained, pink breasts, with their small, hard bellies, those mannequins measured out according to so-called good taste and drawn to a formula learned by copying from plaster models.

Ah, the naked woman! Who has ever painted her superb and real, with no premeditated arranging, with no falsifying of features or flesh? Who has made us see, in an unclothed woman, her nationality and the period to which she belongs, the position in society she occupies, her age, the state of her body, whether virgo intacta or deflowered? Who has thrown her onto a canvas so alive, so true, that we dream of the life she leads, that we can almost see on her flanks the stretchmarks of childbirth, can reconstruct her pains and her joys, can incarnate ourselves in her for a few moments?

Despite his mythological titles and the odd ornaments with which he dresses his models, only Rembrandt has up until now been able to paint the nude. And with Rembrandt it's the opposite of Courbet; it's necessary to remove the pompous affectations that

trail through his canvases in order to restore to his figures the stamp of the modern they had when the painter was alive. Rembrandt's Venuses are Dutchwomen and no other sort of women, girls one has to scrub clean the feet of and whose hair one has to rake with a boxwood comb, paunchy gossips whose big bones bulge beneath the elastic of their grainy skin, in beams of golden sunlight.

In the absence of the man of genius that this admirable painter was, it would be well to wish that artists of talent like M. Gauguin would do for their epoque what Rembrandt van Rijn did for his; that in those moments when the nude is plausible – the bed, the studio, the amphitheatre and the bath – they'd reveal Frenchwomen whose bodies weren't built up piecemeal, whose arms weren't posed by one model and the head or the belly by another, without, on top of all these joins, the fraud of using a technique belonging to the ancient masters.

But alas, these wishes will remain ungranted for a long time, because the powers that be persist in imprisoning students in classrooms, spouting the same twaddle about art to them, making them copy antiquity, not telling them that beauty isn't uniform and invariable, that it changes according to the climate, according to the century, that the *Venus de Milo*, to name but one, is neither more interesting, nor more beautiful now than those old statues from the New World with their variegated tattoos and their feathered headdresses; that both the one and the other are simply diverse manifestations of the same ideal of beauty pursued by different races; that now it's no longer a question of attaining the beautiful according to Venetian or Greek, Dutch or Flemish principles, but to try to distil it from contemporary life, from the world that surrounds us. And it exists, it is there, in the very streets that those unfortunates who slog away in the rooms of the Louvre don't see when they leave, in the girls who pass by, flaunting the delicious charms of languid youth, as if deified by the debilitating air of the city; the nude is there, under that tight armour which

cleaves to arms and thighs, which moulds the pelvis and projects the bosom, a nude other than that of former centuries, a weary, delicate, refined, vibrant nude, a civilised nude that despairs at its own strived-for elegance.

Ah, they make me laugh the Winckelmanns[5] and Saint-Victors[6] of this world, who weep in admiration in front of Greek nudes and even dare to declare that beauty has found an eternal refuge in these heaps of marble!

So I repeat, M. Gauguin has attempted – and he is the first for many years to do so – to represent the woman of today, and in spite of the heaviness of the shadow that falls from the face of his model over her bosom he has fully succeeded, and created a daring and authentic painting.

In addition to this work he has also exhibited a Gothically modern wooden statuette, a painted plaster medallion, a *Head of a Singer* who recalls in a way the type of woman adopted by Rops, an

amusing chair full of flowers in a sunny corner of a garden, and several views of that intimist district par excellence, Vaugirard: a view of a garden and a view of a church whose dark interior makes you think of a factory chapel, of a splenetic church from some industrial city that's strayed into this joyous, homely corner of the provinces; but although these paintings have qualities, I will not stop in front of them because the personality of M. Gauguin, so trenchant in his study of the nude, finds it more difficult to free itself in landscape from the embrace of M. Pissarro, his master.

Let's return now to the room in which the Raffaëllis are hung. I've already talked about the emphasis this painter has given to certain sites in our suburbs; the series that he exhibits

Wooden statuette by Paul Gauguin.

this year reinforces the note of that splendid painting of Gennevilliers, which I spoke about last year; a canvas entitled *View of the Seine* is more poignant still, if that's possible, a canvas in which water flows, glaucous, between two banks of snow, beneath a pale, impermeable sky scumbled with sooty smoke. We are a long way from that apple-green taffeta stream

The Singer by Paul Gauguin.

and those white cotton-wool drifts that the official snow-painters[7] arrange so nicely. In M. Raffaëlli's painting the Seine inspires terror; it rolls, slow and heavy, and it seems as if it will never again be clear and blue between its banks, so acute remains the impression of anguish left by this desolate landscape, lit by the twilight rays of a dead sun, buried under a layer of heavy cloud.

Also worth noting is a mechanical crane that stands out melancholically against the sky; a stalled locomotive near a station; a horse standing on an elevated mound, a typical nag that amateur suburb-watchers always see against the skyline, cutting the horizon with its carcass; and finally a *View of Clichy* in the snow.

The execution is, as always, incisive and sober, the drawing is tight, attempting to make the outline of the body stand out, giving the desired impression almost without the aid of colour.

There is a curious rapprochement between Pissarro and Raffaëlli, who with their completely opposite temperaments and methods, manage to paint landscapes that are, the one as much as the other, masterpieces. The former, principally a colourist, employs an unusual, abstruse technique, one that succeeds in rendering the vibration of the atmosphere, the dance of luminous dust in a ray of light, tackling head-on the full light of day, making you doubt the truth of all other landscapes which seem conventional in the face of these pulsations, these very gasps of nature finally caught in the act;

the latter, principally a draughtsman, preserves the old system but makes it his own by the force of his personality, confining himself to the melancholy of overcast days and pallid weather; they are the two antipodes of painting joined together in the same room, face to face – and never have two landscapes figured in a Salon that are more disparate and more beautiful than this *Cabbage Path* and that *View of the Seine*.

I will pause now in front of one of the aspects of M. Raffaëlli's talent that I have almost deliberately left in the shade until now: I want to speak about the figures that animate his landscapes. Hitherto, a tendency to a kind of humanitarian sentimentality, which spoils Millet's peasants for me, was conveyed in the faces, in the attitude of the ragpickers painted by M. Raffaëlli; this useless emphasis has now disappeared, his old man painting a gate is, in this regard, telling; he thinks neither of the earth, nor the sky, he curses no fate, he implores no help; he has only the green in his paint pot and he quite simply wonders if he can use it to give a lick of paint to a shutter, a stake, a bench, to any utensil in his house whose colour might have faded.

This is a face, excellent in its good-naturedness, which never exceeds the proper limits of painting by mixing in philosophical or literary elements; and the execution is calm without losing anything of its rigour; its contours are less harshly outlined than in metalwork and less violently engraved than in etching.

Since the Le Nain brothers, those great artists who should hold a high place in French

Man Painting a Gate by Jean-François Raffaëlli.

art, no one has truly made himself the painter of unfortunate city wretches; no one has dared to install themselves in those sites where they live, and which are of necessity adapted to their poverty and their needs. M. Raffaëlli has taken up and completed the work of Le Nain; he has also attempted an incursion into a world no less painful than that of ordinary people – the lamentable country of the dispossessed, and he shows them to us, seated at a table in front of glasses of absinthe, in a tavern under an arbour of twisted climbing creepers, thin and leafless, with their filthy clothes in rags and their boots in tatters, with their black top hats, the naps of which are discoloured and the cardboard armature buckled, with their untrimmed beards, their sunken eyes, their watery and dilated pupils, one with his head in his hands, the other rolling a cigarette. In this painting, the position of a scrawny wrist supporting a pinch of tobacco in a cigarette paper, says much about everyday habits,

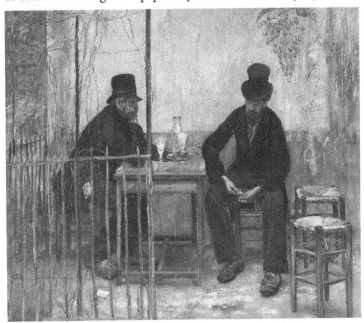

Absinthe Drinkers by Jean-François Raffaëlli.

about the incessantly repeated sufferings of a hard life.

I'm not afraid of going so far as to declare that, out of the immense mass of exhibitors of our time, M. Raffaëlli is one of the rare few who will last; he will occupy a special place in the art of this century, that of a kind of Parisian Millet, that of an artist whose work is imbued with a certain melancholy, about humanity and about nature, that has remained intractable to all painters until the present day.

With M. Forain, we enter into a strand of the dispossessed different from that broached by M. Raffaëlli. Here, it's no longer pallid faces ravaged by disappointment, bile spilling into the complexion by persistent attacks of ill fortune; here, faces are masks, worn down, almost sublimated, by the triumph of vice; it's elegance as a revenge for hunger endured, it's distress veiled beneath frills and flounces and the glamour of makeup; the whore appears, face plastered, her eye alluring in its net of blue powder smudged at the lids.[8]

This year, M. Forain has exhibited two watercolours: one, a corridor of a theatre, populated by men in black suits, in the middle of whom advances a tall woman in a garnet-red dress, and the men part or stare at her, while the man on whose arm she rests her gloved hand, inclines towards her the idiotic smile habitual to those who put on graces. The other shows us an actress sitting, in her dressing room, in front of a washstand. Not yet made up and rejuvenated, she appears very pale against the suffocating background of the walls, in a gleam of light filtered by one of those vast, now fashionable lampshades, the form of which recalls the pleated dresses worn by our grandmothers. A gentleman, standing, his hand leaning on the back of an armchair, examines her while she looks at herself in the mirror, dishevelled, her head tilted a little backwards by the hairdresser whose prodigious bosom bulges.

What startles and disconcerts is the suffocating fug, a mix of woman's perspiration and unstopped perfume, that springs

from these lively, unrestrained watercolours; everything shifts and smoulders, one hears the remarks that are exchanged, the soft creak of boots on carpet, one recognises these people from having seen them, everywhere where the smart set assembles, and they are captured with such a correctness of posture that one can't imagine them holding themselves in any other way than that in which the artist presents them to us at that moment.

What I doubt, however, is that these watercolours will be appreciated by the majority of visitors, because they belong to a kind of artificial and affected art, which in order to be admired demands – like many works of literature – a certain initiation, a certain sensitivity.

And never – and I mean never – will the public accept M. Forain as a painter, for the sole reason that he uses watercolour, gouache and pastel, and only rarely devotes himself to oil. Now among the ineradicable prejudices of this world, taught by a school of fine art that disdains all other mediums, oil painting alone is considered a superior art. If Latour, Chardin or Rosalba were reborn and sent pastels to the next Salon, its members would gang up to relegate them – even supposing the jury agreed to admit them that is – to some corridor or some unfindable spot, as being lesser works of art.

The incorrigible stupidity of the public! There are painters who have talent and others who don't – and that's it. A pastel by M. Forain is a work of art, and an oil by M. Tofani, the immortal author of *Alone at Last!* isn't; and if you take two painters of the same stature, the one who paints with linseed oil will make art that is neither grander, nor less grand, than the one who paints with water; they are different processes of execution, each of which has its *raison d'être* and each of which has worth only by the talent of the artist who employs them.

Moreover, one would have to be singularly obtuse to regard Chardin's pastels as being inferior in scope to his oils; and, if we enter the modern period, weren't the portraits in coloured

pencil exhibited a while ago by M. Renoir a thousand times more captivating, more individual, more penetrating than all the oleaginous portraits shown in the official Salon?

The truth is that today each one of these methods of painting corresponds directly to one of the various facets of contemporary existence. Watercolour has a spontaneity, a freshness, a spicy brilliance inaccessible to oil, which would be impotent to render the tones of light, the piquancy of flesh, the specious corruption of that dressing room by M. Forain; and pastel has a bloom, a velvety smoothness, like a delicate freedom or a dying grace, that neither watercolour nor oil can touch. It is thus simply a question for the painter to choose among these various processes whichever seems to be the best adapted to the subject he wants to treat.

And this is yet another proof of the intelligence – the artistic superiority, even – of the Independents, so varied in their methods, over the official painters who, whether painting a still life, a portrait, a landscape or a scene of history, resort indifferently to the same technique, to the same material.

One has to have attended successive exhibitions of the Independents in order to really appreciate all the innovations that these artists have brought from a material point of view to the arrangement of their works. Aside from the fact that almost all of them use watercolour, pastel and gouache, they have also corrected the shininess of oil paint coated in varnish by adopting, for the most part, the English system, which consists in leaving the painting unvarnished and protecting it with glass. This way they avoid the sheen of the parquet floor on which the eye slips, and they confine themselves simply to ridding the painting of its matt, woolly appearance.

And what a variety in their framing, ranging over all the various tones of gold, all the known nuances, matching painted borders with a complementary colour in the frame. The series of Pissarros, especially this year, is surprising. The frames are a

motley of copper green and sea green, of corn yellow and peach, of fungi brown and wine dregs purple, and the tact with which the colourist has matched all these hues in order to better uplift his skies and bring out his foregrounds has to be seen. It's the most acute of refinements, and though the frame can add nothing to the talent of a work, it is nevertheless a necessary complement, an accessory that gives it merit. It's the same thing with a woman's beauty, which requires some finery; or with an expensive wine, which demands to be tasted in a fine glass and not in the bowl of a pipe; it's the same thing, too, with certain delicate and refined books that would shock the sensitive if they were printed on poor quality paper or cheaply bound. There exists, in short, a harmony to be established between the container and the contents, between the painting and the frame, and all the Independents understand this so well that, in addition to M. Pissarro, they all long ago rejected the invariable florid gilded frame,[9] and adopted the most diverse framings: completely white frames, or white bordered with a seam of gold, frames where gold is applied equally to the grain and to the knots, as if it's coated with gold emery paper, frames the colour of cigar boxes, like that on the portrait of Duranty exhibited last year, or even copper yellow and blackened pearwood, surrounding plain paperboard mounts, onto which, to break the dull monotony, M. Raffaëlli has dashed off – in the Japanese manner anglified by Kate Greenaway – an insect or a branch on the mouse-grey window mount that helps to give the full value to his pale grey skies.

But let's leave these material details, the importance of which is obviously only perceptible to a handful of people, and continue our course through the rooms.

To be honest, we have singularly skimmed through them. M. Caillebotte unfortunately did not exhibit this year and M. Zandomeneghi sent two canvases and a drawing in which I find none of the qualities of his painting *Mother and Daughter* of last

year. His *View of the Place d'Anvers* is simply ordinary and his bust of a seated woman, her back against a tree, is hardly distinguishable from the paintings of M. Béraud and M. Goeneutte. Finally, there remains Mme. Morisot, who has submitted some sketches equal to those of last year, pretty splotches that come alive and exhale a feminine elegance from their frames when you narrow your eyes.

Like her master M. Manet, Mme. Morisot undoubtedly possesses an eye with a natural squint, a special provision of the eyelid that allows her to grasp the finesse of the most tenuous movement of the body on the ambient air; but, as always, she limits herself to improvisations that are too summary and too constantly repeated without the slightest variation. In spite of these objections, Mme. Morisot is a lively colourist, one of the few painters who understand the adorable delights of the fashionable woman's toilette.

I now pass in silence two small rooms in which are stacked, in a few comical rows, some journeyman works[10] by Cals, Rouart, Vidal and a few other daubers of the more official sort, whose oils

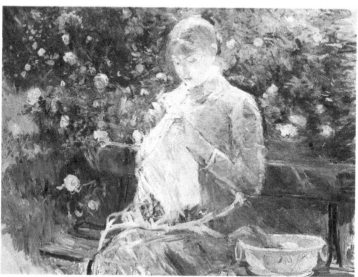

Pasie Sewing in Bougival by Berthe Morisot.

are well worth being cleaned up by M. Toulmouche.

Now that our visit is finished, it seems to me to suggest some reflections. First of all, a great fact dominates, the blossoming of Impressionist art has arrived at its maturity with M. Pissarro. As I've written many times, until now the retina of the Impressionist painters was problematic. It could ably grasp all the changes in tones of light, but it couldn't express them, and their nervous papillae had reached such a state of irritability that we frankly entertained little hope for them.

In short, purely Impressionist art was becoming aphasic when, by a miracle, it suddenly started to speak without any incoherency.

Now two painters, Mlle. Cassatt and M. Gauguin, who previously hesitated to walk unaided, have forsaken their crutches and their sticks and taken some positive strides forward with real confidence; for his part, M. Raffaëlli's talent is in full flow; and no sooner than M. Degas is pleased to turn his hand to sculpture than he suddenly opens up a new path.

The Exhibition of the Independents will therefore count for something this time; it's the revelation of a new form of art that has now begun, and it seems to me to bring an irrefutable argument to the continually unresolved question of the relationship that should be established between the State and Art. The situation of the painters which the government encourages is now this:

Tired of their perpetual complaining, of their continual recriminations, the State, after its failure last year, ended up saying to these mass-producers of art: 'Here is a huge hangar ceilinged in glass, I will rent it to you for one franc per annum; I renounce organising the Salon in your favour, since it seems that I commit nothing but injustice and unfairness, but I will agree nevertheless to distribute, according to the advice of the people you designate, all the prizes and the medals: now act as you deem fit. You demanded, with a lot of hue and cry, reform? Well put them into practice. You accused me of blindly following the self-interested

opinions of Bonnat, Cabanel, Laurens, of all the celebrated tradesmen in oil? Well then, exclude these caliphs from your jury and vote for others who are more intelligent and more eclectic; in a word, prepare your exhibition yourself, be your own boss.'

But like horses broken in by domestication the painters refused to shake off their saddle, to run in freedom, and they returned meekly to their stables, declaring that everything was for the best in the best possible stud farm in the world, and that, after all, they wanted to retain their Loyals, their Franconis and their Fernandos,[II] all their former ringmasters in the art circus.

Consequently, Bonnat, Cabanel, Laurens, all the great horsebreeders, were re-elected as members of the jury by the vote of the very people who had for so long been demanding they be sent to the knacker's yard; nothing has therefore changed, it'll be the same men who will accept or reject the canvases, and who will give the crown to this or that exercise done by their pupils.

Such is the end result of all those liberal intentions. To tell the truth, the State has taken the wrong path; it wants to be both runner and rider, to continue, in spite of its appearance of disinterest, to sponsor and reward painters instead of lumping them in with other trades and letting them manage for themselves, to let them open their own stalls if they want and distribute their own prospectuses.

Indeed, there's no longer any reason to protect and give medals to painters, any more than to help and decorate writers and musicians. Those who have an individual style will probably end up breaking through, and in any case their fate will remain the same whether one abolishes or preserves the medals and the commissions, since anyone with genuine talent is certain never to win them; as for the others, they will be employed in trade if they're competent enough, or in the production of cheap junk and rubbish if they can neither count nor read. In any case, I'm not anxious about their fate, they'll continue to daub their paintings,

because in art the less talent one has, the more likely one is to earn a living!

In short, the benefits of the State go to schemers and to the mediocre; the Prix de Rome is never given for the talent of the painter who obtains it, since this prize is reserved only for those with a respect for convention and a lack of individuality. Paul-Louis Courier's[12] words still hold true: 'What the State encourages, languishes, that which it protects, dies.'

Now compare the situation of these painters with that of the Independents; the latter are, with few exceptions, the only ones who have talent in France, and it is precisely these painters who spurn control by, and aid from, the State; from a material point of view their exhibitions are well attended and show progress; from an artistic point of view they are advancing down their own chosen path, able to give themselves up to all sorts of experiments, all sorts of audacities, unafraid of being rejected by the ill-will or the fear of those who uphold convention; by making an appeal to the judgement of the public they can at least ensure that their work is examined, that they aren't condemned unseen; and it's thanks to this system of specific exhibitions that Impressionist art, constantly rejected by the official Salon, has been able to develop and finally to assert itself and bloom.

Confronted by this success due to private initiative, the State can, if it really considers the issue, recognise the inanity of the praise it has until now lavished on the pupils in its art classes. It has tried every reform, proffered every possible excuse, but in vain. There only remains now one path to take: to simply wipe out these official circuses of art with their medals and commissions, along with the Academy of Fine Art in the Rue Bonaparte and the management of M. Turquet.

The example of the Independents triumphantly demonstrates the inutility of a budget and the uselessness of management when applied to the arts.

Appendix I

Exhibition of the Independents in 1882

This year 1882, neither M. Degas, Mlle. Cassatt, Messrs Raffaëlli, Forain or Zandomeneghi have exhibited. On the other hand, two deserters have rejoined the contingent: Messrs Caillebotte and Renoir, and finally, the so-called Impressionist painters M. Claude Monet and M. Sisley, have returned.

From the point of view of contemporary life this exhibition is unfortunately very succinct. No dancehalls or theatres, no intimate interiors, no tours of the Folies-Bergère and its whores, no dispossessed or ordinary people – one note absorbs all others, that of landscape. The sphere of modernism has really been shrunk, and one can't deplore this diminution enough, brought about by petty quarrels over the communal work of a small group that has hitherto held sway over the innumerable army of its official members.

What the devil is going on? They loathe each other, but they're

marching in the same ranks against a common enemy; they even insult one another afterwards, backstage as it were, away from the spectators, but they're in the same play together and it's madness to disperse your forces when each of them is fighting against a whole crowd. And to ban the admission of a group like this, under the pretext of gathering together works that are more homogeneous, to admit only artists using a similar technique, without taking into account their individual temperament, without acknowledging that the same goal can be achieved by different means, will result in a deadly monotony of subject, in a uniformity of technique, and to be blunt, in the most complete sterility. Be that as it may, while continuing to deplore above all the departure of M. Degas – who no one is big enough to replace – let us enter the sad rooms of the Reichshoffen panorama,[1] where the Independents have set up their tent this year.

M. Caillebotte

I have already written at length on the work of this painter in my Salon of 1880; I said how well founded the attitudes of his subjects

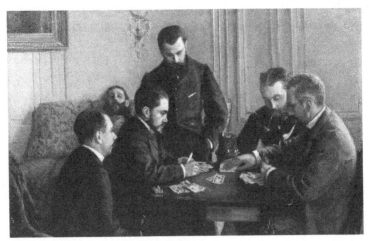

A Game of Bezique by Gustave Caillebotte.

were, how true to their surroundings and the milieu in which they operated; the paintings that he is exhibiting this year testify that his great qualities have remained intact; it's the same refined sense of modernism, the same modest bravura in execution, the same scrupulous study of light.

Two of his canvases are commanding: one, *A Game of Bezique*, is even more veracious than those of the old Flemish masters, where the players almost always seem to be looking at us out of the corner of their eye, where they more or less pose for the gallery, especially in the work of the great Teniers. Here, there is nothing of the kind. Imagine a window opened in the wall of the room, and that facing us, behind the cross of the window frame, you can make out, without being seen by them, people who smoke, absorbed, brows furrowed, hands hesitating on the cards, contemplating a triumphant score of 250 points.

The other painting places us in a bedroom, on the balcony of which a gentleman, with his back turned to us, contemplates a stretch of boulevard that extends as far as the eye can see, enclosing, between the two banks of its roofs, a flood of foliage, rising from the trees planted below on the pavement.

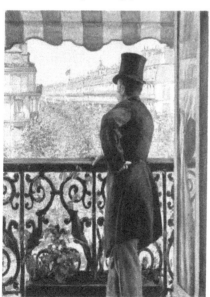

Man on a Balcony by Gustave Caillebotte.

These two paintings belong in the same category as those I've already spoken about, I'm not going to insist on the originality they reveal, because I want to

Fruits by Gustave Caillebotte.

limit myself in this appendix to my preceding Salons to simply showing the flexibility and variety of this painter's talent. At the Panorama, he is exhibiting examples of all genres: interiors, still lifes, landscapes and seascapes.

Contrary to the majority of his fellow painters, he continually renews himself, not adopting any speciality and in this way avoiding the risk of certain repetitions or the inevitable diminution in quality; his groups of fruit standing out against sheets of white paper are extraordinary. The juice flows beneath the peel of his pears, coloured on their pale gold skin with large gashes of green and pink; the skins of his wet grapes are tarnished with moisture; everything is of the strictest veracity, of an absolute fidelity of tones; it's still life exempt from the tithe paid to routine, it's the annihilation of those hollow fruits that swell with impermeable skins against well-worn backdrops of rubber-grey and soot-black.

We will find the same probity in a pastel seascape, and in a view of Villers-sur-Mer, in which all rough blemishes disappear under the full light of the sun, as in a Japanese print. Although literary and artistic injustices no longer have the power to move me, I'm still surprised despite myself at the persistent silence that the press preserves towards such a painter.

M. Gauguin

No progress, alas! This artist brought us, last year, an excellent nude study; this year, nothing worth mentioning. At most, I will cite, as being more worthwhile than the rest, his new view of the church at Vaugirard. As for his interior of a studio, it is of a dull, sour colour; his sketches of children are curious, but they recall, and could be mistaken for, the interesting sketches of Pantazzis, the Greek painter, who exhibits in the artistic circles of Brussels.

Interior of the Artist's Studio by Paul Gauguin.

The Port at Nice by Berthe Morisot.

Mlle. Morisot

Always the same – expeditious sketches; the tones are fine, charming even, but then what? – no certainty, no whole or complete works. If it were a dinner, her painting would be always the same insubstantial vanilla meringue dessert!

M. Guillaumin

Little by little, he's disentangling the chaos he's been charging about in for so long. Already, in 1881, amid the coloured storms of his canvases, solid sections were coming through, capturing the impression of lively sunsets; this year his *Châtillon Landscape* and his *Feeding Trough at the Quay de Célestins* are almost balanced, but M. Guillaumin's eye remains singularly agitated when it considers the human face; his rainbow colours, with which he was formerly so lavish, reappear in his portraits, dazzling brutally from top to bottom of his canvases.

M. Renoir

A gallant and adventurous charmer. Like the American, Whistler – who gave his paintings titles of this sort: *Harmony in Grey and Green, Harmony in Amber and Black, Nocturne in Silver and Blue* – M. Renoir could bestow several of his canvases with the title *Harmony*, and then add the names of their freshest colours.

This artist has produced a lot; I remember in 1876 a large canvas representing a mother and her two daughters, an odd painting where the colours seemed as if they'd been blotted out with a linen pad, where the oil vaguely imitated the fading tones of pastel. In 1877, I came across M. Renoir again in works that were more solidly founded, with a more resolute colouring, a surer feel of modernity. Certainly – and in spite of the visitors who laughed like geese in front of them – these canvases revealed an inestimable talent; since then, M. Renoir appears to me to have definitively found his place. Enamoured, like Turner, of mirages of light, of

those wisps of gold that sparkle, tremblingly, in a ray of sunlight, he has succeeded in fixing them, despite the poverty of our chemical ingredients. He is the true painter of young women, rendering, in this joyous sun, the flower of their skin, the velvetiness of their flesh, the lustre of their eyes, the elegance of their adornment. This year, his *Woman with Fan* is delicious, with the fine sparkle of her large black eyes; though I like less his

Woman with Fan by Auguste Renoir.

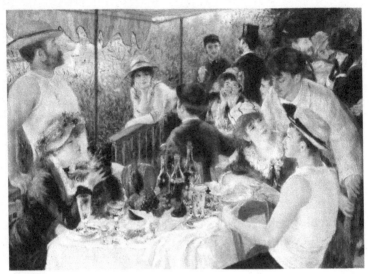

Lunch in Bougival by August Renoir.

Lunch in Bougival, a few of his boatmen are good, some, among his women, are charming, but the painting doesn't smell strong enough; his whores are chic and merry, but they don't give off the odour of a Parisian whore; these are springtime whores freshly disembarked from London.[2]

M. Pissarro

His *Road from Pontoise to Auvers-sur-Oise,* his *Setting Sun*, his *View of Pontoise Prison*, with their large dappled skies and their spray of trees so robustly attached to the ground, are pendants to the splendid landscapes he exhibited last year in rooms on the Boulevard des Capucines;[3] they have the same personal interpretation of nature, the same clear-sighted syntax of colours. In addition to his landscapes of Seine-et-Oise, M. Pissarro exhibits a whole series of countrymen and countrywomen, and it is here that the painter reveals himself to us under a new guise. As I've already written, I think, the human figure in his work often has

Peasants Resting in a Field Near Pontoise by Camille Pissarro.

a biblical aspect, now it is even more so. M. Pissarro has entirely freed himself from the memory of Millet; he paints his countrymen simply, as he sees them, without any fake grandeur. His delicious young peasant girls in red stockings, his old woman snoozing, his shepherdesses and his washerwomen, his countrywomen lunching or making hay, are all genuine small masterpieces.

M. Sisley

One of the first, along with M. Pissarro and M. Monet (about whom I will speak later), who went straight to nature, who dared to consult her, who tried to faithfully render the emotions he experienced before her. Less hesitant, less nervy in his artistic temperament, with an eye initially less feverish than that of his two fellow artists, M. Sisley today is less obviously determined, less personal than them. He is a painter of very real worth, but here and there he still preserves some foreign influences. Certain reminiscences of Daubigny strike me in front of his exhibits this

Windy Day at Véneux by Alfred Sisley.

year, and occasionally his autumn leaves bring to mind memories of Piette. But in spite of everything his work has resolve and emphasis; it has also a pretty, melancholy smile and often even a great blissful charm.

M. Claude Monet

Of the landscape artists, along with Messrs Pissarro and Sisley, he is the one for whom they especially created the epithet 'Impressionist'.

M. Monet stammered for a long time in his work, blurting out short improvisations, dashing off bits of landscape, bitter salads of orange peel, green chive and ribbons of intense blue, all of which was supposed to simulate the flowing water of a river. The artist's eye was undoubtedly exasperated, but it should also be said there was a carelessness in him, a lack of preparation that was all too manifest. In spite of the talent indicated by certain of his sketches, I increasingly lost interest – I admit it now – in his unmethodical and hasty painting.

Appendix I

Impressionism, such as M. Monet practised it, led straight to a dead end; it was always the poorly hatched egg of realism, a real work attempted, but abandoned halfway through. M. Monet is certainly the man who contributed most to persuade the public that the word 'Impressionism' referred exclusively to a painting left in a rudimentary and confused state, a vague outline.

Fortunately, a sudden change in direction took place in this artist; he appears to have decided not to daub away at a pile of canvases for his own amusement; he seems to me to have composed himself – and it's good that he's done so, because this year he has given us some very beautiful and very complete landscapes.

His ice floes under a russet-red sky are of an intense melancholy and his studies of the sea, with waves breaking on the cliffs, are the truest seascapes I know. Add to these canvases the landscapes, the views of Vétheuil, and a field of poppies burning under a pale sky of an admirable colour. Certainly, the painter who painted these pictures is a great landscape artist whose eye, now cured, grasps all the phenomena of light with surprising fidelity. How true is the spray of his waves whipped by sunlight, how his rivers flow, iridescent with the swarming colours of the things

The Church at Vétheuil by Claude Monet.

reflecting in them, how in his canvases the little cold breath of dew rises off the foliage and passes over blades of grass! M. Monet is a seascape artist par excellence. For his works, as for those of M. Pissarro, the time of blossoming has come. We are far now from his old paintings in which the liquid element seemed to be made of spun glass, with its striations of vermilion and Prussian blue; we are far, too, from his pseudo Japonism, exhibited in 1876, of a woman costumed as if for Mardi Gras, surrounded by fans, whose dress was so studded with red that it resembled bricks of cinnabar.

La Japonnaise by Claude Monet.

It is with joy that I can now praise M. Monet, because it is by his efforts and those of his Impressionist landscape peers that the redemption of painting is particularly due; more fortunate and better gifted than poor Chintreuil, who was audacious in his time but who died in penury without having managed to capture those effects of rain and sunlight that he strived so desperately to render, Messrs Pissarro and Monet have finally emerged victorious from the terrible struggle. One could say that the problem of light, so difficult in painting, has finally been figured out in their canvases.

APPENDIX II

THE OFFICIAL SALON 1882

When you've seen one Salon you've seen them all; successive official exhibitions resemble each other – if an artist obtains a success one year you can be sure that, one by one, the other painters will imitate the painting by that artist the following year.

This time it's Messrs Cazin, Puvis de Chavannes and Bastien-Lepage who have served as models. Pallid milky confections in rustic wooden moulds à la M. Puvis, pretty anaemics à la M. Cazin, and meticulous affectations à la M. Lepage, are spread out over every partition, larger or smaller according to the means of the copyist, or the greater or lesser credit he has with his framer.

Add to that the inevitable consequence of men who persist in lauding history according to the art school formula; take a look, if you want to, at those guitarists who continue to bawl Fortuny-esque *habaneras* in ear-piercing tones; note, too, that small group attempting – unsuccessfully it goes without saying – to mimick the disconcerting delights of the works of Gustave Moreau, and you'll have a fairly clear idea of the collection of canvases exhibited at the Salon of 1882.

Is it really of any use now to go into details, to stir up each of these jars of oil, to distinguish their trademarks, to point out the counterfeits, to test and analyse these dubious products? I don't think so; besides, I don't have the space and I would only repeat the theories I've already spouted, or once again arouse 'my righteous anger', as Baudelaire puts it.[1] I will thus restrict myself to citing a few works that can't be confused with the worm-eaten fruits of this bargain basement painting.

The *Bar at the Folies-Bergère* by M. Manet astounds the visitors crowding around it, who exchange confused observations about this mirage of a canvas.

Standing in front of us is a tall girl in a blue, low-necked dress, cut off at the waist by a counter littered with a cluster of Champagne bottles, liquor flasks, oranges, flowers, and glasses. Behind her stretches a mirror which shows us, at the same time as the girl's reflected back, a gentleman seen face on, talking to

Bar at the Folies-Bergère by Édouard Manet.

her; further off, behind or rather beside this couple, the optical perspective of whom is somewhat approximate, we can make out the surroundings of the Folies, and, in the corner, at the top, the pear-green boots of an acrobat standing on her trapeze.

The subject is very modern and M. Manet's idea of placing his female figure in her milieu like this is ingenious, but what's the meaning of that lighting? Is that supposed to be gaslight or electric light? Come off it! It's as if it was set in the open air, it's bathed in pale daylight! As a result, everything collapses – the Folies-Bergère only exists, and can only exist in the evening, so however knowing and sophisticated the painting is it's absurd. It's really deplorable to see a man of M. Manet's quality sacrificing himself to such subterfuges and, to be blunt, making a painting as conventional as those of everyone else.

I regret it even more because despite the plastery tone of its colours, his *Bar* is full of fine qualities, his woman is well posed,

Jeanne by Édouard Manet.

his crowd swarms intensely with life. But in spite of all its flaws, the *Bar* is certainly the most modern and the most interesting painting this Salon contains. I will also point out M. Manet's wholly charming portrait of a woman, in which his oils take on the softness of pastel, where the flesh is of a delicious downiness and surface colour.

After M. Manet's *Bar*, it's M. Sargent's *El Jaleo* (*Spanish Dance*) that attracts the crowd and

El Jaleo (*Spanish Dance*) by John Singer Sargent.

incites the admiration of the pen-pushers, whose speciality it is to dole out praise to mediocre men in their broadsheets; this canvas represents a tall woman leaning backwards in a white dress. In the background, macabre Spaniards scrape at the guitar and clap. These bizarre figures, mouths twisted and hands in the air, are certainly taken from Goya. The woman's flesh could have been painted by anyone and the fabrics unmistakeably resemble those that M. Carolus-Duran manufactures.

I much prefer honest and calm works to these turbulent pastiches, the portrait by M. Bartholomé for example, a portrait of a woman standing in the doorway of a conservatory; year by year, this painter is coming into the light and his earlier cold manner is beginning to thaw; unfortunately, his portrait, like that of his peasants in the open countryside, has been relegated to 'the gods' in a room full of artistic junk.[2]

M. Duez, whose reddish canvas borders colour lithography, is in a better position. In his picture of chessplayers there's no longer even an attempt to capture the elegance of the Parisienne, which he sometimes would succeed in doing, more or less. Here's another

Appendix II

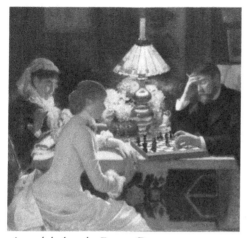

Around the lamp by Ernesto Duez.

painter – and he isn't the only one – who's foundering. We could say as much of Mlle. Abbéma, who formerly produced such merry fireworks from her box of colours. As a concept, her *Four Seasons,* represented by four actresses, is of a particularly female silliness, but what is worse still is the slapdash execution, the impersonality of this flabby, acidic painting.

On the other hand, I can't help but recommend the brilliant still lifes of a silver tea service by Mme. Ayrton, and of fish by Mlle. Desbordes, a quasi Japanese canvas, amusingly and joyously painted.

Leaving the ladies to one side now and returning to the men, we fall on some boatmen by M. Gueldry, who have drifted like those of last year from the canvases of the Impressionists, and

Four Seasons by Louise Abbéma.

on a portrait by M. Whistler, who returns to the Salon after an absence of more than ten years.

Black on black, that is the theme. His woman is painted with a sparseness and a superficiality of colour that hasn't been equalled since that formerly employed by the late M. Hamon; nevertheless, despite everything, this work attracts and fascinates; you can't like it – and, for my part, I don't like it much – but it nevertheless possesses the savour of certain rare dishes.

Madame L.M. by James Whistler.

Looking around from room to room I hoped to discover a painting that would compensate me a little for the overwhelming abominations spread out over the length of the picture rail. It certainly won't be *The Festival: 14 July 1880* by M. Roll, with its vulgar arrangement that will help me to bear my pain with

The Festival: 14 July 1880 by Alfred Roll.

patience; M. Roll has talent, but, by God what exuberance, what an inflated bag of wind this enormous canvas is! Neither will it be M. Béraud, who really should go and study under M. Caillebotte the way to paint a bird's-eye view of Paris; nor M. Gervex, whose *Canal at La Villette* is nevertheless, despite the marmoreal aspect of his tall coalmen scrubbed clean with herbal soap, superior to his recent canvases; nor even, among the clan of foreigners, Messrs Liebermann, Artz and Israëls, who have learned nothing new and teach us nothing new, that I'm going to find anything to graze on that suits my taste. There remains M. Fantin-Latour, whose portraits are superb but which never change, and M. Lhermitte; but I must confess I much prefer his drawings – so open-minded and so liberated – to his incurious and unadventurous paintings. I would certainly do better to quit the Palais d'Industrie and occupy myself with two special exhibitions that are taking place alongside

Portrait of Madame Léon Maitre by Henri Fantin-Latour.

that of the Independents: one at the Liberal Arts club, in which, lost amid a heap of other things, there are some resplendent views of Asnières, Courbevoie and Saint-Ouen by M. Raffaëlli, as well as an amusingly observed canvas of guests attending a wedding and being helped to put on their floss silk gloves in front of the town hall doors; and the other, at the offices of *Le Gaulois*,[3] where M. Odilon Redon, about whom I already said a few words last year, is exhibiting a whole series of lithographs and drawings.

There are some restless prints here: inconceivable, hallucinated visions, a battle of bones, strange visages, pear- and cone-shaped faces, heads with craniums lacking cerebellums, with receding chins, with low foreheads joining directly to the nose, and then there are the immense eyes, insane eyes, springing out of deformed human faces, as if seen through the glass of a bottle or in a nightmare.

A whole series of prints entitled *The Dream* take on, through the medium of this macabre imagination, a disconcerting intensity; among them is one representing a sort of acrobat, with a conical skull like a sugarloaf, a sort of feline Englishman, a sort of simian Mephisto, twisted, seated near a gigantic figure of a woman who

Battle of the Bones by Odilon Redon. *The Dream* by Odilon Redon.

stares at him, hypnotising him almost with her large, deep black eyes, without a word seeming to be exchanged between these two enigmatic characters.

Then there are charcoal drawings belonging even more obviously to fearful dreams tormented by hyperaemia; here, it's micro-organisms and flagellates, the animalcules in vinegar, swarming in a glucose tinged with soot; there, a cube in which a sullen lidded eye palpitates; and elsewhere, a desert, arid and desolate, like a landscape on a lunar map, in the middle of which a stalk rises up, bearing, like a host or like a round flower, a bloodless face with pensive features.

M. Redon next presents his translations of Edgar Allan Poe, tackling the most subtle and most abtruse thoughts of the poet, and interpreting a sentence such as this: 'At the horizon, the Angel of CERTAINTY, and, in the heavens, an interrogative glance', in the following way: a white eye rolls in an expanse of darkness, while an odd being emerges from icy, subterranean water, like an aged Cupid by Prud'hon, or a foetus by Corregio macerated in an alcohol bath, who looks at us, raising a finger, his mouth creased in a mysterious and childish smile.

Head on a Stem by Odilon Redon. *At the Horizon* by Odilon Redon.

Finally, alongside these creatures of insanity, we see the tranquil apparition of an Etruscan woman in a rigid, almost hieratic attitude, and, resembling both the Virgins of Primitive painters and the unsettling goddesses of Gustave Moreau, a white fairy figure sprouting like a lily from a black sky.

It would be difficult to define the surprising art of M. Redon; basically, if we except Goya, whose spectral aspect is less rambling and more real, and if we also except Gustave Moreau, of whom M. Redon is, all things considered, in his healthy parts, a rather distant pupil, we will find precursors to him only perhaps among musicians, and certainly among poets.

In effect it's a veritable transposition from one art into another. The masters of this artist are Baudelaire and especially Edgar Allan Poe, whose comforting aphorism – 'All certainty is in dreams'[4] – Redon seems to have meditated deeply on: that is the true filiation of this original spirit; with him, we like to lose our footing and float in dreams, a thousand miles from any school of art, antique or modern.

Is it really worthwhile now to go back to the Champs-Élysées? In order to find what? A pastel by M. Carteron, perhaps, a sunlit portrait that approaches an uncompromising work, but after that...nothing. It's simpler to return home and try to forget this heap of official paintings. Certainly my conclusions haven't changed, I can only repeat those I stated last year in my review of the Independents' exhibition: in my opinion, it's high time to put an end to these State-sanctioned masquerades; it's high time to remove the honorary and pecuniary assistance we hand out, from father to son, in these orgies of mediocrity, these saturnalias of stupidity.

Notes

1 Huysmans was not above bending the truth in order to advance his career or put things in a more flattering light. Of the five pieces and two short appendixes that make up *L'Art moderne*, only the first two Salons of 1879 and 1880 were previously published in full, in *Le Voltaire* and *La Réforme* respectively. A section of the 1881 Salon – twenty pages on the English illustrators – also appeared in the *Revue littéraire et artistique*, but in essence, despite Huysmans' implication, almost half the book was made up of previously unpublished material.

The Salon of 1879

1 The Académie des Beaux Arts is the central administrative body regulating the arts in France. It was formed in 1816 by the merger of other Académies devoted to specific disciplines, such as those of painting and sculpting, architecture, and music. During the 19th century the Académie des Beaux Arts had something of a stranglehold over art and artists, controlling who was awarded prizes, grants and public commissions, and deciding whose work would be shown at the annual Salon. A turning point came in 1863, the year the Salon jury refused two-thirds of the paintings presented to them, including works by Courbet, Manet and Pissarro. There was such an outcry that a 'Salon des Refusés' was organised to show the works that had been turned down. During the 1870s the group that came to be known as the Impressionists began holding their own annual exhibitions, and the power of the Académie was further weakened with the growth of independent galleries which promoted and sold the work of individual artists.

2 Artists whose work had been selected by the Salon jury would vie for

a medal which would effectively give them an official seal of approval. Gold medal winners were no longer elibigle for the competition and were therefore '*hors concours*', but the advantage of this was that their subsequent paintings were accepted at the Salon without having to go through the jury's selection process.

3 The factory at Batignolles in Paris was famous for producing decorative tapestries and embroideries of classical or 'oriental' scenes.

4 In the original, *l'art industriel* (industrial art), a term coined in the 19th century and associated with the movement to see the decorative arts, and the new techniques of art facilitated by the industrial revolution, as part of art as a whole. Later, Huysmans makes a point of praising forms of artistic work that were not at that time considered to be 'serious' art, such as illustrations for children's books, Japanese prints, advertising posters, ceramics and so on.

5 A one-year volunteer was a conscript who agreed to pay his own costs for equipment, food, and clothing, in return for a shorter-than-normal term on active military service.

6 The Palais d'Industrie, also known as the Palais de Champs-Elysées, in which the Salons were held was on the Champs-Elysées, roughly where the Grand Palais now stands.

7 Author's original footnote: "I want to explain, once and for all, the generic terms that I'm obliged to use in these articles. Despite the systematic injustice and vile limitation of regimenting people of individual talent and diverse opinions, and cramming them into the same uniform, I couldn't divide into two camps the so-called 'Impressionists' – such as MM. Pissarro, Claude Monet, Sisley, Miss Morisot, MM. Guillaumin, Gauguin and Cézanne – and the artists designated under the epithet 'Independents', which today embraces without distinction artists such as M. Degas, Miss Cassatt, MM. Raffaëlli, Caillebotte and Zandomeneghi. Firstly, by not doing so I was being necessarily incomplete; the points of comparison being lacking due to the abstention of a certain number of so-called Impressionist painters who didn't exhibit during the three year period embraced by these Salons; and secondly, because in trying to cast into one camp or the other artists like M. Renoir, who has, by turns, abandoned and resumed the Impressionist principles, or like M. Forain, who has deviated from the path set out by M. Manet and now follows the path pioneered by M. Degas, it would have meant giving oneself up to a singularly pedantic analysis and expose oneself to inevitable errors. Nevertheless, I had to separate these painters from the official Salon

NOTES

painters. So I have indiscriminately designated them by the familiar, comprehensible and well-known terms 'Impressionist', 'intransigent' or 'Independent'; this contrivance allowed me to confine myself to the small plan I'd drawn up for myself: to simply show the parallel progression in recent years of both the Independent and the official Salons, and thereby reveal the consequences, from the artistic point of view, that might have resulted."

8 Huysmans alludes here to his Dutch ancestry. He saw his genealogical connection to Dutch art as one of his credentials to be an art critic.

9 Huysmans uses the word *rouennerie* in the original, meaning a kind of woollen or cotton fabric made in Rouen which was distinctive for its designs and patterns using pink, purple or red dyes.

10 As a bibliophile, Huysmans took a great interest in the look and feel of his books, and was familiar with all the techniques and terms of bookbinding.

11 In the original Huysmans coins the neologism *lechotteries* which plays on the two senses of the verb *lécher*, one being to over-polish or overwork something, and the second being to lick. The sexual double entendre of the second meaning was doubtless intended as both the artists he names were famous for portraits of nudes.

12 The two pictures in the Panthéon, *L'Education de Sainte Geneviève* and *La Vie Pastoral de Sainte Geneviève*, were Puvis de Chavannes's first Parisian commission.

13 In the original Huysmans uses the word *Arpins*, a reference to the name of the famous wrestler, 'Arpin, the Terrible Savoyard'.

14 The painting's title is given in the catalogue as *La mort d'Orphée*.

15 The painting is now believed to be lost. One observer described it as depicting Regnault, an academic painter who died in the Franco-Prussian war of 1871, as a personification of France, bathed in blood.

16 Théodore de Banville (1823-1891), French poet. The ballad containing the lines referred to is called '*Ballade de ses regrets*', published in 1873.

17 Roll's *Inondation à Toulouse* was actually shown in 1875.

18 *La Danse* is a sculpture by French artist Jean-Baptiste Carpeaux (1827-1875). One of four sculptural groups decorating the façade of the Opera Garnier in Paris, it caused a scandal when it was unveiled.

19 In the original Huysmans coins the neologism, *blaireauteurs*, from the verb *blaireauter*, which means to rub down or scumble a painting, or to take excessive care over fine detail.

20 Huysmans uses the name 'Selene', the Greek goddess of the moon, as a generic name for these representations of female figures. I have

changed it to Diana, the Roman goddess traditionally associated with the moon, for ease of comprehension.

21 The painting measures over 4m by 3m, hence the reference to its size.

22 In the original Huysmans sets up a contrast between 'Sidonie' and 'Thérèse', two names which he'd also used in his pantomime written with Léon Hennique, *Pierrot sceptique* in 1881. Whether this was just a convenient use of names, whether he expected people to be familiar enough with his work to see the joke, or whether at the time the names Sidonie and Thérèse were associated in people's minds with a specific type of women is difficult to determine. In brief, 'Sidonie' refers to a generic representation of classical women in academic paintings, whereas 'Thérèse' refers to the generic representation of religious women or saints in academic paintings.

23 Delacroix painted two large murals in one of the chapels of Saint-Sulpice in Paris: *La Lutte de Jacob avec l'Ange* and *Héliodore chassé du Temple*.

24 I have slightly enlarged the description here to make the subject of the painting, entitled *Le repos en Egypte*, a bit clearer.

25 The title of the painting in the catalogue is *Journée d'hiver, dans la campagne belge*, so it's unclear where Huysmans got the name 'Campine' from. A painting similar to Huysmans' description is now in the Musée Royaux des Beaux Arts in Belgium. It is dated 1880 and has the title *Les sapinières de Campine*, so may be from the same series.

26 In the original Huysmans mistakenly refers to him as Danish.

27 The Exposition Universelle was held in the Champ de Mars in 1878 and celebrated France's economic recovery after the traumatic events of the Franco-Prussian war (1870-71) and the Commune (1871).

28 The celebrities depicted in the painting include the actors Ernest Coquelin, Henri Villain and Sarah Bernhardt, the writers Alphonse Allais, Félicien Champsaur and Achille Mélandri, and the caricaturists André Gill and Georges Lorin.

29 In the original *paysages composés*, a virtual synonym for historical landscapes. Huysmans advocated writing (and painting) from what you could see and experience, so he was temperamentally indisposed to imaginary landscapes that supposedly represented times past.

30 Charles Frederick Worth (1825-1895) was a British couturier, often considered to be the father of haute couture. After an apprenticeship in textiles in London, he moved to Paris at the age of twenty and worked his way up to become one of the leading couturiers of his day. His significance in this anecdote becomes clearer when Huysmans

begins to talk about the distinction between painters who tried to capture the externals of modernity, usually by a meticulous attention to luxurious clothing, who he termed 'couturiers', and those who tried to capture an essence or a feeling of everyday modern life. I have slightly expanded the reference to Worth to make the allusion clearer.

31 La Reine Blanche was a seedy dancehall in the Montmartre district. It was transformed in 1889 into La Moulin Rouge by two businessmen Joseph Olier and Charles Zidler.

32 These two paintings, which formed a pendant with each other, achieved a considerable success at the 1868 Salon. *Penelope* was acquired by the Metropolitan Museum of Art in New York, but the whereabouts of *Phryne* is now unknown. Huysmans' reference to 'late' is because Marchal committed suicide in 1877.

33 In his account of the same Salon, Émile Zola described the painting as 'a scene of jealousy between a woman in tears and a gentleman in a suit, nervously trying to remove his gloves'.

34 Huysmans' allusion here is a little opaque, but it seems to centre on Franco-Polish relations in the 19th century. Napoleon had supported and held out the possibility of a free Polish state, though this was never realised. In the same way, Bastien-Lepage seemed to hold out the hope of a painter who had liberated himself from the academic style, but who never quite wholly did so.

35 *Léda* was Béraud's first painting to be shown in the 1875 Salon.

36 Paintings at the Salon were exhibited so that they covered the whole wall, making it quite difficult to see those which were high up.

37 The Champ de Mars in Paris was the location for the Exposition Universelle of 1878.

38 *Notes sur l'Angleterre* ('Notes on England') by the French critic and historian Hippolyte Taine (1828-1893) was published in 1872. The quote can be found on p.319.

39 In the original this appears as *soldat Pitou*, the caricatural or typical French soldier.

40 In the original it's not clear which of the Verhas brothers Huysmans is referring to, but as he mentions 'paintings' and Frans had two canvases on show to Jan's one, it would seem to be the older brother. In his account of the 1881 Salon, Huysmans makes another disparaging comment about Frans Verhas' abilities as a painter.

41 The painting measured just a little over 40cm by 30cm.

42 The paintings of the Düsseldorf school were very stylised and often had allegorical overtones. These qualities were the opposite of the

NOTES

true-to-life naturalism that Huysmans was looking for in art, and he consequently found pictures in this style affected and pretentious, and the people portrayed in them overly-dramatic and exaggerated.

43 The title refers to a peace treaty signed at San-Stefano between Russia and the Ottoman Empire, ending the Russo-Turkish War, 1877–78.

44 It's not clear why Huysmans picked on Wiertz as a comparison, as he died in 1865 and didn't feature in the Salon. Baudelaire, who Huysmans considered his master, also wrote very disparagingly about him.

45 In the original *beuglants*, a slang term for a low-class music hall, derived from the verb *beugler*, to bawl.

46 Henri Murger (1822-1861) was the author of *Scènes de la vie de bohème*. In a chapter entitled 'Francine's Muff', Francine is an impoverished seamstress with a heart of gold who falls ill with consumption. Despite assistance from her bohemian artist friends and her lover Jacques, she dies in hospital.

47 It isn't quite clear which painting Huysmans is referring to. Gustave Jacquet did have a painting in the 1879 Salon in which the pose of his model was vaguely similar to Haquette's, but Jacquet also painted a number of other portraits, such as *La repose*, in which his female sitter lounged at full length.

48 In the original Huysmans uses the term 'Jablochkoff', a form of arc lighting invented by Paul Nicolaïewich Jablochkoff in 1876, a few years before Edison and Swan's invention of the electric light bulb.

49 Jeanne Samary (1857-1890), a French actress at the Comédie française. Renoir painted her portrait numerous times between 1877 and 1880.

50 Marguerite Charpentier was the wife of Georges Charpentier, Huysmans' publisher since 1879. The two had been introduced by Émile Zola. Charpentier was the publisher of many of the big names of the period – Flaubert, Goncourt, Daudet and Maupassant – and he and his wife were also collectors of Impressionist art.

51 In the original, *hors concours*. See Note 2.

52 A reference to André-Charles Boule (1642-1732), a renowned French ebenist and furniture maker of the Louis XIV period. Huysmans used the term in his novel *En ménage*, to indicate how the middle class conformed to notions of respectability at the expense of good taste.

53 Valtesse de la Bigne was the pseudonym of Émilie-Louise Delabigne (1848-1910), a well-known demi-mondaine or courtesan of the period. Her luxurious bed was the model for that of the demi-mondaine, Nana, in Émile Zola's eponymous novel of 1880. Manet had also done a portrait of her.

NOTES

54 Author's original footnote: "Following the numerous complaints that the series of these articles aroused in the world of painters, M. Laffitte, the director of *Le Voltaire*, deemed it necessary to bandage some of the wounds that had been opened. It was after the distribution of food vouchers and medals to the cripples and beggars of art that M. Pothey was commissioned to prepare the compresses." Huysmans is settling an old score here. Shortly after his attack on Carolus-Duran, Alexandre Pothey wrote an article in *Le Voltaire* lavishly praising the Salon jury for awarding the painter a medal of honour. As editor, Jules Laffitte clearly found Huysmans too controversial and the following year he chose another writer to review the Salon.

55 Evidence of carelessness in the preparation of *L'Art moderne* seems particularly noticeable here, not only with the glaring reference to the newspaper, but also in the title of the painting. In the catalogue, it is given as *Portrait de Mme la Comtesse V****, the three asterisks masking the name of the sitter, but this gets transcribed in *L'Art moderne* to *Portrait de Mme la Comtesse de Trois Étoiles*, though whether this was Huysmans' mistake or the compositor's isn't clear.

56 The information about Carolus-Duran seems to be taken from Émile Zola's account of the Salon of 1878. Zola claimed that the colours in Carolus-Duran's paintings at the Exposition Universelle seemed to have aged very badly. Huysmans more or less paraphrases Zola's point, and Zola's comment that 'Carolus-Duran's talent shines like glass, but is as fragile as glass', is echoed in Huysmans' comment about the fragility of the painter's reputation.

57 Paul Déroulède (1846-1914) was a French author of patriotic poems and dramas. For the 1878 Exposition Universelle he wrote *Vive la France*, set to music by Gounod. He later became a politician and was one of the founders of the nationalist League of Patriots.

58 Huysmans slightly misquotes Baudelaire here, as Baudelaire is speaking specifically about Horace Vernet's military painting, rather than military painting per se. If anyone were in any doubt that art criticism could be ferocious in the 19th century one just needs to read the rest of Baudelaire's criticism of Vernet: 'I hate this man whose canvases aren't paintings, but a form of agile and frequent masturbation...' Baudelaire, whose *Curiosités esthétiques* (1868) was essentially a collection of his writings on the Salon, was one of Huysmans' literary heroes.

59 In the original Huysmans uses the uncommon medical term *médullaire*, referring to bone marrow or the pith of a plant.

Notes

60 It might be easy to misconstrue this and the following paragraph as being descriptions of real ivory or stucco figurines, but Huysmans is being drily ironic here and all the ivory, stucco and unglazed porcelain portraits he describes are in fact paintings.

61 Although there are two painters called Goupil listed in the Salon catalogue, Huysmans seems to be referring to Jules-Adolphe Goupil, whose portraits often featured large swathes of fabric that dwarfed their subjects. One of his early successes was a portrait of his son dressed in clothes from the period of the Directoire, which is hinted at in the original French, *le vétilleux fripier du directoire*.

62 The nude subject was in fact Fortuny's teenage son.

63 In Greek mythology Omphale was the daughter of a river-god and the mistress of Hercules.

64 In 1879 the Société des Aquarellistes Français was established in the Galerie Durand-Ruel, Rue Laffitte, Paris. Its members included Gustave Doré, Ferdinand Heilbuth and Jehan Georges Vibert.

65 A quote adapted in a roundabout way from Goncourt's journal entry for 23 August 1862. Although the *Journal* wasn't published at the time Huysmans was writing, Goncourt quoted from it in his preface to Émile Bergerat's book *Théophile Gautier: Entretiens, Souvenirs, Correspondance* (Charpentier, 1879). Goncourt recalls Gautier telling the journalist Gustave Claudin, '*Tu aimes le progrès, les ingénieurs qui abîment les paysages avec leurs chemins de fer...*' ('You like progress, the engineers who spoil the landscapes with their railways...').

66 The picture by Jenny Haquette-Bouffé features on a list of acquisitions made by the State during the course of the 1879 Salon.

67 Émile Signol painted four frescoes on the walls of Saint-Sulpice in Paris.

68 Nana was a character who first made her appearance in Zola's 1877 novel, *L'Assommoir*. Zola would go on to tell the demi-mondaine's story more fully in the eponymously titled novel, *Nana*, of 1880. Manet's 'portrait' of Nana, which was much closer to the spirit of Zola's book, appeared in 1877.

69 Huysmans gives the figure of seventeen in the original, though the Salon catalogue states that Desboutin exhibited five etchings.

70 This reference is perhaps another hangover from the article's original newspaper appearance. The issue of *L'Illustration* featuring Renouard might have been topical when the original article appeared, but seems out of place in a review of work exhibited at the Salon.

71 Huysmans was a lifelong lover of cats, so it is probable that he is not being sarcastic here as he normally would be. Many people might

NOTES

consider the pictures cloying in their cuteness.

72 Paris Hippodrome, or the Hippodrome de l'Alma, was an immense building, much of it in iron, capable of holding 6,000 spectators. It was used for horse racing, as well as other mass events. It opened in 1877, but was forced to close in 1892 because the owner of the land refused to renew the lease.

73 In the original this read *ylang et moos-rose*, two exotic ingredients used in perfumes at the time. I have substituted names more commonly associated with perfumery to make it clearer.

74 Gustave Droz (1832-1895), a painter turned novelist who enjoyed a huge vogue following the success of his moralistic, amusingly sentimental novels. His most famous work, *Monsieur, Madame et Bébé* (1866) had gone into a hundred and sixty editions by 1882. I have expanded the reference in the text to make it more comprehensible.

75 Victor Hugo (1802-1885) was perhaps the greatest literary figure of the French Romantic period; Leconte de Lisle (1818-1894) was a poet belonging to the Parnassian movement, which was a reaction against Romanticism's political engagement and which embodied a philosophy of 'art for art's sake'; Alfred de Musset (1810-1857) was a Romantic poet, dramatist and dandy.

76 From the Salon catalogue this looks to be a work in marble by Adolphe Maubach, entitled *Le Sabot de Noël* (the sabot or clog serving the same function in France as the Christmas stocking in Britain). The catalogue describes the child as being a little girl, while in the original Huysmans refers to him as a boy.

77 Author's original footnote: "My God, an omission! I've passed over in silence those porcelain plates onto which unfortunate girls in long black aprons copy pictures by MM. Chaplin and Compte-Calix. All in all, such forgetfulness is for the best, as it would be unseemly to spoil with acid laughter the glorious pleasure that daddies, hubbies or lovers must feel in front of their darling's handiwork, hung with a white number on one of the walls of the exhibition."

EXHIBITION OF THE INDEPENDENTS IN 1880

1 In *Manette Salomon* (1867), a novel in which art and artists serve as the backdrop, by Edmond and Jules Goncourt.

2 Huysmans uses this rare term meaning dusty or powdery, often in relation to the dusty coating on a surface such as a beetle's carapace.

3 Nadar was the pseudonym of Gaspard-Félix Tournachon (1820-1910), a Parisian photographer, caricaturist and journalist. In April 1874 he

lent his studio at 35 Boulevard des Capucines for the first exhibition by the group of artists who would come to be known as Impressionists.

4 Paul Durand-Ruel (1831-1922), a Parisian art dealer who was associated first with the Barbizon school, then with the Impressionists, organizing their second exhibition in 1875, which took place in his gallery.

5 I have added the proprietary name to make it clearer why the water a washerwoman might be using would be blue.

6 Jean-Martin Charcot (1825-1893) was one of the most influential medical practitioners in 19th century France, particularly on notions of mental illness, neurosis and hysteria.

7 Dr Xavier Galezowski (1832–1907) was a Franco-Polish ophthalmologist. He opened a private opthalmic clinic in Paris in 1867 and founded the *Journal d'Opthamologie* in 1872.

8 Eugene Véron (1825-1889) was a French writer and journalist. His book *L'Esthetique*, which gave case studies that supported some of the views Huysmans puts forward, was published in 1878. The book, which sold quite widely and was translated into English, had a considerable influence on writers on aesthetics. Although it is easy now to ridicule Huysmans' statements, at the time his views were given at least some credence by what was seen as the latest scientific research in ophthalmology. Huysmans' reference to Charcot's studies is essentially a paraphrase of a paragraph in Véron's book. Recent studies have shown that some of the Impressionists did indeed suffer from problems with their eysight – Cézanne, Pissarro and Renoir from myopia, Degas from retinopathy, and Mary Cassatt and Monet from cataracts in later life, although obviously the impact this may have had on their painting remains highly debatable.

9 The poster for the exhibition held at 10 Rue de Pyramides, Paris, in April 1880 described it as the Fifth Exhibition of a Group of Independent Artists. In it, eighteen artists showed their work, ten of whom Huysmans refers to by name in his review.

10 *Le Charivari* was an illustrated magazine that included political caricatures and satirical articles; *L'Évenement* was a daily newpaper with a progressive, centre-left viewpoint.

11 Albert Delpit (1849-1893) was a prolific French novelist and playwright, mostly known for his stories of adventure and intrigue.

12 Elisabeth Rachel Félix (1821-1858) was a French actress, better known as Mademoiselle Rachel. She was a brunette and her name was used for a line of face powder specifically designed for brunettes.

13 Huysmans coins the neologism *enténèbrements*, from the verb

NOTES

enténèbrer, meaning to envelope in shadows. I have used the technical term for this play of light and shadow, chiaroscuro, which Gérôme was fascinated by and which he often employed in his paintings.

14 Vaux de Cernay is a particularly picturesque part of a national park, located south west of Versailles. It is situated in a narrow valley through which the river Vaux flows and forms several small waterfalls.

15 Adolphe Philippe d'Ennery or Dennery (1811-1899) was a prolific French playwright and novelist, the author of some two hundred dramatic works written alone or in collaboration with others.

16 The Parc Monceau is a landscaped garden in the fifth arrondissement of Paris, which originally included an artificial grotto, a Roman colonnade, a pyramid and a lily pond. It was remodelled by Baron Haussmann in 1861, who nevertheless retained some of the follies. Gobelins refers to an area in the thirteenth arrondissement, the site of the Manufacture des Gobelins, a tapestry factory that originally supplied fabrics to the royal court. By the 19th century, however, the area was one of the more run-down parts of Paris.

17 La Route de la Révolte, formerly the Route des Princes or the Route de Versailles à Saint-Denis, is the name of an ancient road originally constructed to link Versailles with Saint-Denis. Leading from the Allée Royale in the Bois de Boulogne the road passed what is now Porte Maillot and stretched out in a straight line to Saint-Denis.

18 The working class hero of Victor Hugo's novel *Les Misérables*.

19 *The Graphic* was a weekly British illustrated newspaper founded by William Luson Thomas in 1868. The paper employed numerous illustrators for its stories.

20 No. 11 Rue le Peletier was the address of Durand-Ruel's gallery in Paris.

21 Célestin Crevel was the name of a character in several of Balzac's novels, a vain, self-satisfied man 'exuding the smugness of commercial success', as the critic Sarah Maza puts it.

22 In the original, *riches et lancées, ou besogneuses et pauvres, cocottes à traînes ou vadrouilles en cheveux*. Huysmans was no stranger to prostitution and in his work one can find an array of slang words and expressions for the various forms of prostitution that made up the underbelly of 19th century social life. I have broken his list of women down into the four most common forms of prostitution: society escort, brothel worker, kept woman and streetwalker.

23 One of Forain's most famous paintings, *Le Client* or *La Maison Close*.

24 The stanza is a rough paraphrase of Paul Verlaine's poem '*Tu m'ostines!*'

25 The scent 'New Mown Hay' was one that had a certain vogue during

the 1880s and was marketed by a number of perfumers, most notably Guerlain in Paris. It contained coumarin, one of the first perfumery ingredients to be created synthetically. Huysmans was obviously taken with the perfume's name, which is in English on the original bottle, and he also referred to it in *À vau-l'eau* (1882) and *À rebours* (1884).

26 'L'Exposition des Impressionnistes', *Gazette des Amateurs*, No. 25, 15 April 1876. In actual fact Huysmans made his debut as an art critic in 1867, with a piece on contemporary landscape painting which appeared in the *Revue contemporaine*. He may have wanted to pass over this earlier, more conventional piece, in order to emphasise his modern credentials as an up-and-coming critic of the new school.

27 The French term Huysmans uses, *marcheuses*, has a slightly ambiguous meaning here. While it can mean someone who has a very minor part in a ballet i.e. a non-dancing walk-on part, it also has the connotation of streetwalker or prostitute. Dancers and actresses were commonly associated with prostitution at the time, not least because theatres and operas had a rich clientele and many of the girls who worked as dancers and actresses came from poor backgrounds.

28 Louis Edmond Duranty (1833-1880) was a French novelist and art critic who promoted realism and supported the Impressionists. He died shortly before Huysmans wrote his original article.

29 Flaubert's novel *Éducation sentimentale* (1869) was about the romantic life of a young man, Frédéric Moreau, during the 1848 revolution in Paris. It was attacked when it first appeared as being too politically radical, but is widely considered now to be one of the most influential novels of the 19th century.

30 Huysmans uses the term 'Daltonism', a condition named after John Dalton (1766-1844), the English chemist, physicist, and meteorologist who was the first to write about colour blindness in a scientific paper – both he and his brother were colour blind – and consequently his name was associated with the condition for many years.

31 Huysmans again shows himself an expert in the various forms of prostitution. I have slightly expanded the allusion in the text to make it clearer, as the original French term for this kind of prostitution, *faire le fenêtre*, doesn't really have an English counterpart.

THE OFFICIAL SALON OF 1880

1 Artists who were classed as *hors concours* didn't have to go through the jury selection process, nor did those who had won prestigious honours from other institutions. Even though there were relatively few artists

NOTES

in these categories compared to the total number of submissions, these privileged artists were allotted more space in better locations.

2 Edmond Turquet (1836-1914) was the Under Secretary of State for Public Instruction and the Fine Arts. In *Le Voltaire* (18-22 June 1880), Émile Zola gave a calmer analysis of the problem: 'This year, the opening of the Salon has made a singular stir in the artistic world... The Under Secretary of State for the fine arts, M. Turquet, assisted by his employees, is ambitious to attach his name to reform...so M. Turquet has, in his turn, modified the rules of the Salon. He has above all tackled the classification of works exhibited. Before him, they were happy enough with hanging the paintings throughout a string of rooms in alphabetical order: but M. Turquet, a man of order, has created four categories: artists who are *hors concours*, artists who are exempt from the jury examination, artists who are not exempt, and foreign artists...Well, you cannot imagine the disruption this M. Turquet's classification system has caused. No one is happy, all the painters are up in arms, the studios are in revolt.'

3 Gaston Alexandre Auguste, Marquis de Galliffet (1830-1909), a French general who had played a prominent role in the Franco-Prussian war. He had commanded a brigade during the repression of the 1871 Paris Commune, which left him a disliked and often criticised figure.

4 *La Bataille de Gründwald* is over 4m high and 9m long, and is every bit as excessive as Huysmans makes out.

5 Alfred Grévin (1827-1892), was a French sculptor and illustrator who is remembered now mainly as the costume designer for the Théatre Français. He also founded, with Arthur Meyer, the waxwork museum in Paris that bears his name.

6 Mignon is the eponymous heroine of an opéra comique by Ambroise Thomas (1811-1896), based on Goethe's novel *Wilhelm Meisters Lehrjahre*.

7 In the original *demoiselle* ('damsel'). It seems as if Huysmans is 'outing' Bastien-Lepage here. Lepage certainly had close links to established gay painters of his day, such as Pascal Dagnan-Bouveret and his long-term partner Gustave Courtois, as well as to the English painter Henry Scott Tuke, who was friends with Lepage during his three-year stay in Paris and whose work frequently featured homoerotic portraits of naked boys and sailors.

8 The subject of Henri Gervex's painting, entitled *Le souvenir de la nuit de décembre 4*, is borrowed from a poem by Victor Hugo about the death of a young girl during the course of the 1851 Coup d'État. It shows the doctor holding the limp body of the dead girl, surrounded

Notes

by her family and some of the rioters. Hugo himself is placed at the back of the scene looking out from the canvas.

9 Nicolas Bornier was a minor sculptor not particularly well known or regarded as a yardstick for masterpieces, which gives further force to Huysmans' dig at the sculptoral conceit in Puvis de Chavannes' work.

10 This seems to be an autobiographical memory from Huysmans' youth. In the 1860s a man in his seventies, known as the 'man with the rats' or 'the rat man' would perform with animals – rats, cats and guinea pigs – for the amusement of children and passersby, on the Boulevard des Invalides and near the Obervatoire. When his animals refused to perform he would chide them with the words '*Coelina, hobeissance!*' ('Coelina, obey!'), hence Huysmans' reference.

11 Huysmans echoes the point about the fading colours of Carolus-Duran's paintings made in his previous Salon. See Note 56 above.

12 The original sentence reads: *Elle appartient à la série des Théo parées par des couturiers en vogue.* This seems to be a reference to Louise Théo, a music hall singer and actress in vogue during the 1870s and 1880s. She was popularly known as 'Théo', her married name.

13 Tony Robert-Fleury had recently painted a ceiling in the Palais de Luxembourg in Paris entitled 'The Glorification of French Sculpture'.

14 Huysmans gets the title of the painting the wrong way round, referring to it as *La droit prime la force*, rather than *La force prime la droit*. I have corrected the title so that his allusion makes sense.

15 As Huysmans observes, the painting alludes to Chardin's still life, *La raie*, which is considered a masterpiece.

16 In the original this reads *Jardinière* (a female gardener) rather than *Sardinière* (a female sardine worker), though whether this was a mistake by Huysmans or by a compositor isn't clear.

17 Alfred Grévin, see Note 5 above; Albert Robida (1848-1926) was a French illustrator, caricaturist and novelist who would go on to write three futuristic novels; Crafty was the pseudonym of Victor Eugène Géruzez (1840-1906), a writer and comic illustrator who specialised in books on hunting and horses; Stop was the pseudonym of the illustrator Louis Morel-Ritz (1825-1899).

18 The painting measures over 4m by 3m. Huysmans gives the painting the title *Le bal de l'Opera*, though the catalogue has it as *Bal masqué*.

19 This painting depicts the distribution of soup to the poor, which it seems was organised by Paul Brébant (1823-1892), the owner of the Restaurant Vachette, situated at the corner of the Faubourg Montmartre and the Boulevard Poissonnière, in Paris.

NOTES

20 Despite Huysmans' dislike of the painting it was a huge success, so much so that Dagnan-Bouveret was commissioned to paint at least one other version for a client. Whether influenced by Huysmans' criticism or not, in the later version Dagnan-Bouveret reduces the amount of blood in the bowl, which is half-obscured by a chair leg.

21 An exhibition at the gallery of the illustrated journal, *La Vie moderne*, Boulevard des Italiens, in April 1880. Manet sold only two paintings.

22 Author's original footnote: "Since these lines were written, I've been given the opportunity to review almost all of Gustave Courbet's work. What disillusion! These canvases, reputed to be worthy of comparison with some of the indelible works in the Louvre, had become as incoherent as pub signs! The allegory, *The Painter's Studio*, appeared to me as a terrifying piece of nonsense imagined by an uneducated man and painted by an old labourer. And what can one say about the marble seas, the sheet-metal skies of his *Young Ladies on the Banks of the Seine*, about this jumble of naiads that is banally ordered and clumsily painted? What can one say, moreover, about those two, almost naked women entitled *The Awakening*, a picture as cold and as dead as those of François Gérard, whose disappointing memory he evokes. With Courbet we are simply back in the most exasperating old-fashioned type of painting: in my opinion, the man's talent is a perfect mystification, cooked up by critics and officially approved by M. Proust."

23 *L'Art* was a weekly journal based at 33 Avenue de l'Opera in Paris.

24 The date appears as 1879 in the original, though the Exposition Universelle at de Nittis exhibited twelve pictures, seven of which were views of London, was held in 1878.

25 Author's original footnote: "It should be remarked that the only engravers of talent we possess today don't exhibit at the Salon. M. Bracquemond has united with the Independents. M. Legros is in London, and M. James Tissot, who is perhaps the only truly modern etcher of our time, also lives in England, and justly despises the promiscuity of the rooms in the Salon."

26 Auguste Poulet-Malassis (1825-1878), a French publisher famous for printing Baudelaire's *Les Fleurs du mal*. He went bankrupt in 1862.

27 Jean-Pierre de Florian (1755-1794) was a French dramatist and writer whose pastorals and fables achieved a considerable success. Jean-Baptiste de Grécourt (1684-1743) was a French poet. Editions of his stories and poems were very popular during the 18th century.

28 Émile Boilvin (1845-1899) a French illustrator. His illustrations for *Madame Bovary* are indeed ridiculously old-fashioned.

29 Huysmans' somewhat convoluted allusion is to the novel *Manon Lescaut*, also known as *L'Histoire du chevalier des Grieux et de Manon Lescaut*, published in 1731 by the French author Abbé Prévost (1697-1763). Like *Madame Bovary*, it was controversial in its time and banned in France on publication. The novel tells the story of the Chevalier des Grieux, who is disinherited by his father when he runs away with his lover, Manon Lescaut.

30 Henri Monnier (1799-1877), a French playwright and caricaturist. He produced several albums of lithographs satirising his contemporaries. He created the character Monsieur Prudhomme, who Balzac described as the 'classic example of the middle-class Parisian'.

31 An allusion to the fact that *Madame Bovary* was put on trial for obscenity when it was first published.

THE OFFICIAL SALON OF 1881

1 In the original, *tableaux à épisodes et à tiroir*. This was an advanced form of slide projection, with one slide being a static background scene, on top of which other glass slides could be superimposed, thus creating a variety of scenes and the illusion of basic movement.

2 In the original *larme des batailles* (battle tears), presumably a sentimental song of the time. I have used *The Last Past* as a substitute.

3 After the loss of the Franco-Prussian war, Alsace and Lorraine were annexed by the German Empire. They would only return to French jurisdiction after the First World War, as part of the reparations imposed on Germany.

4 Huysmans was violently opposed to militarism or glorification of militarism. Given the feelings surrounding the annexation of Alsace and Lorraine, and the vein of anti-German feeling as a result, Huysmans' criticism of the heroic portrayal of French soldiers, and the imputation of brutality to them, would have been controversial.

5 Huysmans is being ironic here as Schopenhauer was something of a misogynist. It's unclear how many of Huysmans' readers would have got the allusion as Schopenhauer had only recently been translated into French and his work wasn't widely known at this period.

6 Huysmans' irony may have gone over the heads of some of his readers. Detaille's canvas, which is over 4m long, was painted in oil and not a chromolithograph.

7 A somewhat obscure allusion to the Dutch painter Godfried Schalken (1643-1706), who was famous for his chiaroscuro paintings in which a single flaming candle produced dramatic effects of lighting.

Notes

8 In Breugel's *The Magpie on the Gallows* a man can be seen in the act of defecating, and in *Netherlandish Proverbs* a man can be seen with his bare backside poking out of a window, as if about to defecate.

9 Scheffer was influenced by Goethe's work. He painted several Faust-themed paintings, as well as pictures featuring Mignon, a character from Goethe's influential novel, *Wilhelm Meister's Apprenticeship*.

10 Horace Lecoq de Boisbaudran (1802-1897) a painter and a teacher at the École des Beaux Art in Paris. Cazin was one of his pupils.

11 Sadi Carnot (1837-1894) was a French politician. He was subsequently president of the Republic from 1887 until his assassination in 1894.

12 In the original this reads, *M. Lepage a cessé de chatouiller l'agreste guitare de M. Breton* ('M. Lepage has ceased to tickle the rustic guitar of M. Breton'), alluding to Jules Breton, an artist known for idealised paintings of peasant life, and the guitar being a commonly used Romantic trope.

13 In the original Huysmans incorrectly spells his name Verhaz, which is how the name appeared in the Salon catalogue.

14 The description Huysmans goes on to give doesn't match the subject of Bartholomé's *Dans la serre* (*In the Conservatory*), so I have slightly altered the wording to avoid confusion. Huysmans refers to Bartholomé's picture again (which is actually a portrait of his wife) in Appendix II as it was shown a second time in 1882 under a different title, though this time it is described correctly. It is possible Huysmans got his notes mixed up as a painting by Amable Pinta, *Une jeune mère*, also in the 1881 Salon, almost exactly matches his description of a mother and her baby.

15 'Avatar' was a short story by Théophile Gautier, published in 1856. The story's plot is somewhat convoluted, but revolves around the strange physician Balthazar Charbonneau and his ability to transmigrate souls, something he learned from spending several years as an ascetic in India.

16 Author's original footnote: "Another artist has recently asserted himself in France in the painting of the fantastic: I mean M. Odilon Redon. Here, the nightmare is transported into art. Mix together a macabre milieu and somnambulant faces, with a vague kinship to those of Gustave Moreau turned to terror, and you'll perhaps get an idea of the bizarre talent of this singular artist." Huysmans is referring somewhat obliquely to an exhibition of twelve of Redon's charcoal drawings, held at the offices of *La Vie moderne* in April and May of 1881. Huysmans is indulging here in a bit of retrospective promotion – both for Redon as an artist, and for himself as an art critic – as the footnote didn't appear in the original article. Despite its implication, Huysmans didn't see the exhibition at the time, nor was he even

aware of Redon's existence. The following year, in February 1882, Charpentier showed him an album of Redon's work and Huysmans was so taken with it he wrote to the artist to ask where he could buy a picture and the two subsequently became friends.

17 Jean-Jacques Grandville (1803-1847), a French caricaturist and illustrator, whose work often featured human figures with animal heads. Paul de Kock (1793-1871), a prolific French novelist and dramatist whose work was considered vulgar and in slightly poor taste.

18 Racing a hoop with a stick was a common children's game in both England and France during the 19th century.

19 Author's original footnote: "A very bizarre connection is worth pointing out. An illustration by Rowlandson unmistakably resembles, in terms of composition and in the ordering of its subject matter, a celebrated panel by the illustrious M. Vibert, *Le Repos du Peintre*, exhibited in 1875. Rowlandson's plate bears the title, *The Comforts of Bath*, and was published on 6 January 1798, by S. W. Fores, 50 Piccadilly, corner of Sackville Street." In the 1780s and 1790s Samuel Fores (1761-1838) published a number of satirical prints.

Vibert's *Le Repos du Peintre* (left) and Rowlandson's *The Comforts of Bath* (right).

20 Edward Evans (1826-1905) was a prominent English wood engraver and colour printer. He specialised in full-colour printing and most notably collaborated with illustrators such as Walter Crane, Randolph Caldecott and Kate Greenaway.

21 Author's original footnote: "M. Crane's work is not confined just to the illustration of albums and books. In addition, he has obtained many successes as a painter in England. Unfortunately, his works have rarely crossed the Channel and it hasn't been possible for us to study them. Let's just say that he figured among the Pre-Raphaelites, which explains his preoccupation with archaeological exactitude and his care over the right detail."

NOTES

22 A reference to Thomas Vireloque, a caricature of the down-and-out drawn by the French illustrator Sulpice-Guillaume Chevalier (1804-1866), more famously known under the name Gavarni.

23 Louis-Auguste Boileau (1812-1896), a French architect who took over the design of Saint-Eugène church in the ninth arrondissement in Paris. The interior of the neo-Gothic building features iron piers and mouldings and was completed in 1855. Boileau was also the author of *Le Fer, principal élément constructif de la nouvelle architecture. Conclusions théoriques et pratiques pour servir de clôture au débat ouvert en 1855, sur l'application du métal (fer et fonte) à la construction des édifices publics* (Paris, 1871). It was through this book that Huysmans got to know Boileau in 1871, as the architect had it printed at the printing works owned by Huysmans' family at 11 Rue de Sèvres.

24 François Léonce Reynaud (1803-1880) was a French architect and engineer who supervised the construction of a number of prestigious projects. Michel Chevalier (1806-1879) was a French engineer, statesman and economist. César Daly (1811-1894) was a French architect, a precursor to Viollet-le-duc who worked on the restoration of the Sainte-Cécile d'Albi cathedral. He was appointed a member of the Commission for Arts and Religious Buildings in 1848. Eugène Viollet-le-duc (1814-1879) was one of the most celebrated French architects of his generation and was instrumental in the restoration of medieval churches and cathedrals.

25 Hector Horeau (1801-1872) was a French architect. He entered the competition to redesign Les Halles and proposed a large glass and cast iron structure for one of the great halls. However, it was Victor Baltard who eventually won the commission. Horeau also lost out in the competition to design the pavilion for the 1851 Great Exhibition in London, which was won by Joseph Paxton's Crystal Palace.

26 Henri Labrouste (1801-1875) was a French architect who adopted the use of iron construction in his buildings, most notably in the Bibliothèque Sainte-Geneviève and the reading room in the Bibliothèque nationale, both in Paris.

27 The Bibliothèque nationale moved to the Rue de Richelieu in 1868. Although much of the existing building was of stone, the renovations carried out by Labrouste (see Note 26 above) included a spacious new reading room which relied on an impressive iron infrastructure.

28 Félix Duban (1797-1870), a French architect.

29 Jakob Ignaz Hittorf (1792-1867), a German-born architect instrumental in introducing cast iron as a structural material into his buildings.

NOTES

30 Victor Baltard (1805-1874), a French architect who designed Les Halles, built between 1852 and 1872, and Saint-Augustin church.

31 Author's original footnote: "Horeau's life was like that of all the people who want to break with routine. He died, misunderstood, desperate, without being able to apply his ideas, which others have appropriated and put into practice."

32 Eugène Flachat (1802-1873), a French civil engineer who was instrumental in the early development of the railway system.

33 Félix Callet (1791-1854), a French architect who assisted Baltard with work on Les Halles.

34 Pierre François Joly was an iron manufacturer from Argenteuil and a pioneer in metallic construction.

35 Louis Adolphe Janvier (1818-1878) was a French architect who designed the markets and abattoirs at La Villette.

36 Ernest Legrand a French architect who worked with Jules de Mérindol on the cast iron and glass pavilions of the Temple market.

37 The building erected in 1865 was built on the site of an old clothes market at the Temple that dated back at least to the 17th century. The building Huysmans describes was demolished in 1901.

38 Although this sounds odd to a modern-day audience for whom brothels probably conjure up an air of poverty or exploitation, the image Huysmans was trying to convey was more like the brothel pictures of Toulouse-Lautrec.

39 Léopold Hardy (1829-1894), a French architect who is perhaps best known for designing the Palais de l'Exposition that occupied almost the entire Champ de Mars, for the Exposition Universelle in 1878.

40 See Note 70 on the Paris Hippodrome above.

41 Charles Garnier (1825-1898) was a French architect, perhaps best known for designing the opera house that took his name, the Palais Garnier. Huysmans disliked both the building and its architect.

42 The quote is taken from Charles Garnier's *À travers les arts, causeries et mélanges* (Hachette, 1869, p.76). Huysmans abridged the passage so much that the sense wasn't entirely clear. I have restored a sentence that was cut to make Garnier's hostility to the new architecture clearer.

43 Another quote taken from Garnier's *À travers les arts*, p.183.

44 This sentence is a paraphrase of a passage in Eugène Viollet-le-Duc's *Entretiens sur l'architecture*, Vol II (Morel, 1872), p.388.

45 Huysmans seems to be quoting from memory here, as the quote doesn't appear in this form in Zola's novel, *Le Ventre de Paris* (1873). I have slightly amended it in order to make the point more clearly.

NOTES

1 A reference to Emilie Bécat who introduced what came to be called an 'Epileptic' style of singing, after her debut at the Café des Ambassadeurs in 1875. The name derived from the symptoms of epileptics at the Salpêtrière, and the hysterical contracture of their hands and sudden movements of their bodies. Bécat became notorious for her risqué songs, her 'epileptic' movements and her revealing dresses, as another contemporary singer, Jean-Paulin Habans (1845-1908), recalled in his memoirs: "she seemed to have quicksilver in her veins, she would run, leap, and twist herself in suggestively naughty poses that produced the desired effect. Not to mention her come-hither eyes, her narrow waist and her exquisite calves, which a short dress showed off completely... how the public ate her up!" (Jean-Paulin Habans, *Trente ans de café-concert.*) Degas did a series of lithographs of Bécat in performance.

2 Jules Draner (1833-1926) was the pseudonym of Jules Renard, a Belgian illustrator, caricaturist and costume designer for the Belgian theatre.

3 Author's original footnote: "The art of modelling coloured wax dates from long ago; if we believe Vasari, Andréa de Ceri was already famous in the 15th century for his skill in sculpting this material."

4 A reference to a painting by Ingres of Henri IV which shows him on his knees with two of his children on his back.

5 Johann Joachim Winckelmann (1717-1768) a German art historian and archeologist who was influential in promoting a popular appreciation of classical art.

6 Paul Bins, Comte de Saint-Victor (1827-1881), known as Paul de Saint-Victor, was a French author and critic. During the last days of the Second Empire he became inspector-general of fine arts.

7 Huysmans uses a neologism *neigistes*, from *neige* meaning 'snow'.

8 In the original Huysmans uses the word *estompe*, referring to a drawing tool used by artists to smudge charcoal and crayon.

9 Huysmans uses the phrase *à chicorées et à choux* (literally 'with chicory and cabbages') in the original, which refers to the flowers decorating standard plaster frames of that period.

10 Huysmans uses the term *croûte* ('crust'), a slang expression meaning a bad painting done for money.

11 Both the Loyal and the Franconi families were closely associated with the circus, and therefore with horses. Fernando Beert opened the Cirque Fernando in Paris in 1873, which also featured horse acts.

12 Paul-Louis Courier (1772-1825) was a French political pamphleteer who was a moderate monarchist.

NOTES

APPENDIX I

1 The Salon du Grand Panorama in the Salle Valentino, Rue Saint-Honoré, housed the huge panorama of Reichshoffen, a 360-degree battle scene conceived by Charles Garnier. The seventh exhibition of the Independents was held there between 1 and 31 March 1882.

2 Huysmans clearly reads the painting in terms of his own expectations i.e. the scene represents the men who work the boats in Bougival eating and drinking with prostitutes. In fact, the scene features a group of Renoir's friends, including Gustave Caillebotte, seated lower right, the poet Jules Laforgue in the background, some well-known actresses, and Renoir's future wife, Aline Charigot, playing with a dog.

3 A reference to the sixth Impressionist exhibition of 1881 which, like the first, was held in Nadar's studio at 35 Boulevard des Capucines.

APPENDIX II

1 Charles Baudelaire, *Curiosités Esthétiques* (Michel Levy, 1868), p.167.

2 Huysmans uses the phrase *relégué dans le poulailler d'un dépotoir* (with *dépotoir* meaning 'dump' or 'junkyard'). Although *poulailler* usually means 'hen-house', it was also slang for 'the gods' or upper circle of a theatre, another allusion to the height at which some pictures were hung.

3 This was only the second time Redon had exhibited his work, the first being at the offices of *La Vie moderne* the year before in 1881. The exhibition at *Le Gaulois,* which ran between February and March 1882, contained twenty-nine charcoal drawings and prints. Huysmans' first introduction to Redon and his work came about indirectly as a result of it as his publisher Charpentier showed him an album of Redon's drawings in February 1882, shortly after the exhibition had opened.

4 Author's original footnote: "Since this exhibition at *Le Gaulois*, I've been fortunate enough to see some very beautiful drawings by M. Redon, drawings of a profound and dignified aspect, among others an ineffable *Melancholy,* in coloured pencils, a woman sitting, thoughtful, alone in space, sobbing out spleen's sorrowful laments."

5 Huysmans takes this phrase not directly from Edgar Allan Poe, but from Baudelaire's translation of Poe's stories, *Nouvelles histoires extraordinaires* (Michel Levy, 1856). The phrase doesn't appear in Poe's writings as such, but seems to be a paraphrase either of the preface to *Eureka* (1848), which he "offered…to the dreamers and those who put faith in dreams as the only realities", or of the refrain in the poem 'A Dream Within a Dream', which runs: "All that we see or seem/Is but a dream within a dream."

GLOSSARY OF ARTISTS

Note: Titles of paintings and year of exhibition at the Salon are given only for the particular year that Huysmans mentions them in his reviews. Titles are taken from the Salon catalogue and are given in French.

LOUISE ABBÉMA (1853-1927), a French painter and sculptor who first achieved notoriety in 1875 with her portrait of Sarah Bernhardt, who was also her lover at the time. 1879 Salon: *Portrait de Mademoiselle Jeanne Samary* and *Portrait de Madame ****. 1882 Salon: *Les Saisons.* **78, 263**

LAWRENCE ALMA-TADEMA (1836-1912), a Dutch-born painter of British citizenship. He would later be associated with the Pre-Raphaelite movement. 1881 Salon: *En route pour le temple de Cérès.* **191-3, 195, 197, 201, 203**

DAVID ADOLPH CONSTANT ARTZ (1837-1890), a Dutch painter associated with the Hague school, a group of artists whose work was influenced by the French realist movement. 1880 Salon: *L'orphelinat à Katwyk.* 1881 Salon: *L'hospice des vieillards, à Katwyk.* 1882 Salon: *Une chaude journée and Son trousseau de marriage.* **154, 155-6, 187, 265**

ANNIE AYRTON (c.1850-1920), an English painter, mostly of still lifes, about whom little is known. She went to Paris and studied under the French painter Charles Chaplin. 1879 Salon: *Un coin de cuisine* and *Oiseaux de mer.* 1881 Salon: *Fruits secs et accessoires* and *La desserte.* 1882 Salon: *Un thé* and *Fleurs et oranges.* **88, 191, 263**

JULES BALLAVOINE (c.1842-1914), a French painter who studied at the École des Beaux Arts. He seems to have specialised in portraits, often nude or semi-nude. 1879 Salon: *Le Tir.* **72**

Glossary

Paul-Albert Bartholomé (1848-1928), a French painter (and later sculptor) who studied at the École des Beaux Arts under Gérôme. He became a close friend of Degas who persuaded him to take up sculpture. 1879 Salon: *Portrait de Madame J.* and *À l'ombre.* 1880 Salon: *Portrait* and *Le repas des vieillards de l'asile.* 1881 Salon: *Dans la serre.* 1882 Salon: *Portrait de Madame **** and *Les dernières glanes.* **29, 78, 154-5, 188-9, 262**

Jules Bastien-Lepage (1848-1884), a French painter who studied at the École des Beaux Arts under Cabanel and later became associated with the Naturalist school. 1878 Salon: *Les foins.* 1879 Salon: *Saison d'octobre* and *Portrait de Mademoiselle Sarah Bernhardt.* 1880 Salon: *Jeanne d'Arc* and *Portrait de M. Andrieux.* 1881 Salon: *Un mendiant* and *Portrait de M. Albert Wolf.* **18, 23, 60-2, 65, 82, 83, 131, 138-40, 150, 158, 161, 182-3, 259**

Paul Baudry (1828-1886), a French academic painter who trained at the École des Beaux Arts. 1881 Salon: *Glorification de la Loi* and *Portrait de Louis de Montebello.* **191**

Georges Becker (1845-1909), a French painter, mostly of historical subjects, who trained under Gérôme. 1880 Salon: *Martyre chrétienne* and *Portrait de general Galliffet, commandant le 9ème corps d'armée.* **135**

Jan van Beers (1852-1927), a Belgian painter who turned from history painting to portraits and genre scenes after moving to Paris. 1879 Salon: *Le poète flamand Jacob van Maerlandt prédit, en mourant, à Jan Breydel et à Pieter de Coninck, la délivrance de la Patrie.* **47-8**

Jean Béraud (1848-1935), a French painter known for his pictures of Parisian society life. 1879 Salon: *Condoléances* and *Les Halles.* 1880 Salon: *Le bal public.* 1882 Salon: *L'intermède* and *Le vertige.* **60, 62-4, 155, 158, 159-60, 243, 265**

Étienne Berne-Bellecour (1838-1910), a French painter who studied at the École des Beaux Arts. He is mostly known for his paintings on military subjects. 1879 Salon: *Sur le terrain.* **85**

Sarah Bernhardt (1844-1923) was perhaps the most famous French actress of her day. She took up painting and sculpting while at the Comédie Française and exhibited at the Salon between 1875 and 1886. 1879 Salon: *Mademoiselle L. Abbéma* and *Miss H* (sculpture). **82-3, 98**

Camille Bernier (1823-1902), a French painter who was mostly known for his landscapes. He was much influenced by Corot. 1879 Salon: *L'allée abandonée.* 1880 Salon: *Le matin.* **50, 149**

Albert Bettanier (1841-1932), a painter born in Metz. When Alsace-Lorraine was ceded to Germany in 1871, he chose French nationality.

GLOSSARY

1881 Salon: *En Lorraine.* **173, 174**

PIERRE-MARIE BEYLE (1837-1902), a French painter known for his scenes of everyday life. 1879 Salon: *De la mairie à l'église* and *Une partie de dames.* **58**

CHRISTOFFEL BISSCHOP (1828-1904) a Dutch painter of genre scenes and portraits. 1880 Salon: *L'Eternel l'avait donné, l'Eternel l'a oté.* 1881 Salon: *Pièce de milieu.* **155, 156-7, 187**

JOSEPH BLANC (1846-1904), a French painter who trained at the École des Beaux Arts uner Cabanel. He specialised in scenes from ancient history and mythology. 1881 Salon: *Le triomphe de Clovis.* **180-1**

GIOVANNI BOLDINI (1842-1931), an Italian painter who lived and worked in Paris for most of his life. He specialised in genre pictures and portraits. 1879 Salon: *La Depêche.* 1881 Salon: *Portrait de Madame la comtesse de R.* **73, 185**

GERMAIN BONHEUR (1848-1882), little is known of Germain Bonheur, his work being overshadowed by that of his older, more famous half-sister, Rosa Bonheur. 1879 Salon: *La mare du clos Lavallière, aux environs de Blois.* **50**

ROSA BONHEUR (1822-1899) a French painter and sculptor who specialised in genre scenes featuring animals and animal painting. **50**

LÉON BONNAT (1833-1922), a French painter who taught at the École des Beaux Arts. 1879 Salon: *Portrait de M. Victor Hugo* and *Portrait de Miss Mary S.* 1880 Salon: *Job* and *Portrait de M. Grévy, président de la république.* 1881 Salon: *Portrait de Léon Cogniet* and *Portrait de Madame la comtesse Potocka.* **62, 77-8, 96, 105, 145, 146-7, 185, 211, 245**

FRANÇOIS BONVIN (1817-1887), a French realist painter influenced by the Dutch old masters and by Chardin. 1879 Salon: *Pendant les vacances.* 1880 Salon: *Un coin de l'église.* **88-9, 155**

NICOLAS BORNIER (1762-1829), a French sculptor. He carried out a few small municipal commissions and taught sculpture but was essentially considered a minor talent. **143**

WILLIAM BOUGUEREAU (1825-1905), a French academic painter, perhaps the most well-known of the artists who specialised in the bland desexualised idealisation of the female form. 1879 Salon: *Naissance de Venus* and *Jeunes bohémiennes.* **17, 43, 46, 98, 135**

FÉLIX BRACQUEMOND (1833-1914), a French painter, engraver and ceramicist. A founding member of the Society of Watercolourists, he was one of the first French artists to express interest in Japanese art. **122**

GLOSSARY

MARIE BRACQUEMOND (1840-1916) a French painter considered, along with Mary Cassatt and Berthe Morisot, one of the three great female Impressionists. **122**

JULES BRETON (1827-1906), a French painter of the Realist school who was renowned for his somewhat idealised paintings of peasants and of rustic life. 1879 Salon: *Portrait de Madame* *** and *Villageoise*. **62, 183**

HENRI BUREAU was a minor French watercolourist. 1879 Salon: *Croquis*. **92**

ULYSSE BUTIN (1838-1883), a French painter allied to the Naturalist school formerly a student at the École des Beaux Arts. He won medals at the 1875 and 1878 Salons. 1879 Salon: *La femme du marin, côte normande*. 1881 Salon: *Départ*. **54, 190**

ALEXANDRE CABANEL (1823-1889), a French painter of historical, classical and religious subjects in the academic style. He represented the epitome of all the things Huysmans hated about official art. 1879 Salon: *Portrait de Madame la marquise de C.T.* and *Portrait de M. Mackay*. **17, 33, 43, 59, 78, 86, 98, 132, 135, 140, 232, 233, 245**

RANDOLPH CALDECOTT (1846-1886), an English artist and illustrator. He was perhaps most famous for his illustrations for *Babes in the Wood* (1879), but he was also part of the English artistic scene of the time and was friends with Dante Gabriel Rossetti, John Everett Millais and George du Maurier. **15, 203-4, 206-10**

ADOLPHE-FÉLIX CALS (1810-1880) a French painter of the Barbizon school. He took part in the first Impressionist exhibition in 1874, as well as subsequent exhibitions in 1876 and 1881. **243**

CAROLUS-DURAN was the pseudonym of Charles Durand (1837-1917), a French academic painter who specialised in high society portraits. 1879 Salon: *Portrait de madame la comtesse V**** and *Portrait d'enfant*. 1880 Salon: *Portrait de Madame G. P.* and *Portrait de M. Louis B.* 1881 Salon: *Portrait de Madame* *** and *Un future doge*. **23, 79, 82-3, 146, 185, 262**

ALBERT CARRIER-BELLEUSE (1824-1887), a French sculptor. Rodin worked as his assistant between 1864 and 1870. 1879 Salon: *Monument funéraire élevé à la mémoire du général Don José San-Martino fondateur de l'indépendance du Pérou et du Chili* and *Portrait de M. Meunier, deputé* (sculptures). **98**

CHARLES-HONORÉ CARTERON (1850-1919), a French painter. His brother Eugène also exhibited a painting in the 1882 Salon. 1882 Salon: *Les canots de Madame Victor, à Issy.* **268**

GLOSSARY

ANTONIO CASANOVA (1847-1896), a Spanish painter and engraver known for his highly detailed and often amusing genre scenes. 1879 Salon: *Le Mariage d'un prince* and *L'indiscret*. 1880 Salon: *Le 'heros de la fête*. **89-90, 134**

MARY CASSATT (1844-1926), an American painter and printmaker. After her work was turned down by the Salon, Edgar Degas invited her to show at the annual exhibition of Independents. Her work often concentrated on private moments in a woman's life, especially scenes between a mother and child. **31, 120-1, 226-8, 244, 247, 270**

CHARLES CASTELLANI (1838-1913), a Belgian-born painter known for his panoramas. 1879 Salon: *Les marins au Bourget, 21 décembre 1870*. **85-6**

JEAN-CHARLES CAZIN (1840-1901), a French painter known mostly for his landscapes. 1880 Salon: *Ismaël and Tobie*. 1881 Salon: *Souvenir de fête* and *Poste de secours* (watercolour). **143-4, 177-8, 179, 211, 259**

CHARLES JOSHUA CHAPLIN (1825-1891), a French painter and printmaker, perhaps best known for his elegant portraits of young women. **78, 82, 122**

ÉMILE CHATROUSSE (1829-1896) a French sculptor. **224, 225**

JULES CHÉRET (1836-1932), a French painter and lithographer, was a master of poster art during the Belle Époque period. In 1881 Huysmans used Chéret to illustrate the pantomime he wrote with Léon Hennique, *Pierrot sceptique*. This was a beautifully produced book – the head of the edition was five copies printed on deluxe pink paper – and featured a distinctive cover and illustrations by Chéret. **23, 33, 170, 209**

ANTOINE CHINTREUIL (1814-1873), a French landscape painter influenced by Corot. He painted in the open air and is seen as a forerunner of the Impressionists. **258**

PAUL-JEAN CLAYS (1819-1900), a Belgian painter who specialised in marine subjects. 1879 Salon: *Le port d'Ostende* and *Calme aux environs de l'île de Schouwen, en Zélande*. **54**

CÉSAR DE COCK (1823-1904), a Belgian painter and engraver, mostly of genre scenes and landscapes. 1880 Salon: *Les bords de l'Ept* and *Les bords de l'Ept sur bois*. **148**

XAVIER DE COCK (1818-1896), a Belgian painter, mostly of genre scenes and landscapes who was influenced by the Barbizon school. 1880 Salon: *Boeufs dans une prairie marécageuse* and *Chute d'eau*. **148**

MARIE COLLART (1842-1911), a Belgian landscape artist. 1879 Salon: *Le soir* and *Avril, cerisiers en fleurs*. **48**

GLOSSARY

PIERRE-CHARLES COMTE (1823-1895) a French painter known for genre and historical scenes. He exhibited at the Salon between 1848-1887. **157**

FRANÇOIS COMPTE-CALIX (1813-1880), a French painter and illustrator known for his genre pictures. **70**

BENJAMIN CONSTANT (1845-1902), a French painter best known for his 'oriental' subjects. He was a pupil of Cabanel's. 1879 Salon: *Le soir sur les terrasses (Maroc)* and *Les favorites de l'émir.* **90**

JOSEPH THÉODORE COOSEMANS (1828-1904), a Belgian landscape painter. 1879 Salon: *Journée d'hiver, dans la campagne belge.* **49**

CHARLES CORDIER (1827-1905), a French sculptor and artist famous for his busts and sculptures which used a combination of materials, such as bronze and onyx, to produce a polychrome effect. **225**

FERNAND CORMON, the pseudonym of Ferdinand Piestre (1845-1924), a French painter. 1880 Salon: *Caïn.* **145**

JEAN-BAPTISTE COROT (1796-1875), a French painter and illustrator mostly known for his landscapes. He was one of the founders of the Barbizon school, a group of landscape artists who, in reaction against Romantism, drew their inspiration directly from nature which they tried to capture in a more realistic fashion. **101**

GUSTAVE COURBET (1819-1877), a French painter and sculptor considered to be the head of the realist school, as opposed to the academic tradition. His work often challenged conventions – such as in his more realistic treatment of peasants and workmen – and consequently provoked a scandalised response. **21, 51, 154, 231-3, 283**

THOMAS COUTURE (1815-1879), an influential French history painter, perhaps best known for his huge work, *Romans During the Decadence* (1847), which was a success at the Salon that year. He would go on to teach Manet, Fantin-Latour and Puvis de Chavannes, among many others. **33**

LÉON COUTURIER (1842-1901) a French painter who specialised in military and marine subjects. 1879 Salon: *L'école des tambours* and *Paysan de Guerchy.* **85**

HENRY CROS (1840-1907), a painter, sculptor and glassmaker. He exhibited at the Salon des Refusés in 1863, after debuting at the Salon in 1861. Two of his wax sculptures are in the Musée d'Orsay in Paris. **224**

PASCAL DAGNAN-BOUVERET (1852-1929), a French painter who studied at the École des Beaux Arts under Cabanel and Gérôme. His work

would later become associated with the Naturalist movement and he was one of the first artists to use photography as a means of achieving greater realism. 1879 Salon: *Une noce chez un photographe, Portrait de M.G.B.* and *Nana, parc Monceau* (watercolour). 1880 Salon: *Un accident.* **69-70, 92, 155, 158, 161**

KARL DAUBIGNY (1846-1886) a French landscape painter who first exhibited at the Salon in 1863. He was the pupil of his father, Charles-François Daubigny, whose talents as a painter Huysmans rated even less than his son's. 1879 Salon: *Environs de la ferme St-Siméon, Honfleur.* 1880 Salon: *La chute des feuilles* and *Bords de la Seine à Rangiport.* **50, 149, 256**

ÉDOUARD DEBAT-PONSAN (1848-1913), a French academic painter and pupil of Cabanel who first exhibited at the Salon in 1870. 1879 Salon: *La pitié de Saint Louis pour les morts.* **47**

EDGAR DEGAS (1834-1917), a French painter, engraver, sculptor and photographer, who is recognised as one of the most influential artists of the period. He organised what would become known as the Impressionist exhibitions, the first of which took place in 1874. At the time Huysmans was writing, Degas was not the universally admired artist he would later become. **9, 19, 21-3, 24, 31-2, 57, 120, 121, 122-31, 162, 166, 179, 221-4, 225, 226, 244, 247, 248, 270**

EUGÈNE DELACROIX (1798-1863), was one of the emblematic figures of 19th century French art, its foremost exponent of Romanticism. For Baudelaire Delacroix was 'the most original painter either of modern or ancient times'. **40, 46, 84, 129, 130, 140**

PAUL-LOUIS DELANCE (1848-1924), a French painter and a pupil of Gérôme and Bonnat's at the École des Beaux Arts. Huysmans describes him as a *garçon*, though they were both the same age. 1881 Salon: *Le Retour de drapeau* (third class medal). **174**

HIPPOLYTE PIERRE DELANOY (1849-1899), a painter born in Glasgow to French parents. He was mostly known for his elaborate still lifes. 1879 Salon: *Chez don Quichotte* and *Le Coran.* 1880 Salon: *La cellier de Chardin* and *Le force prime de droit.* 1881 Salon: *La table du citoyen Carnot* and *Les confitures de cerises.* **87, 152-3, 181-2**

JULES-ÉLIE DELAUNAY (1828-1891), a French painter who studied at the École des Beaux Arts and who was known for his portraits and murals, which feature in the Opera Garnier, the Hôtel de Ville and the Panthéon in Paris. 1879 Salon: *Portrait de M. Charles G.* and *Portrait de Madame D.* **80**

GLOSSARY

BERTHE DELORME, a French painter about whom very little is known. 82

GUSTAVE DEN DUYTS (1850-1897), a Belgian landscape painter. 1879 Salon: *Lever de lune.* 49

JULES DENNEULIN (1835-1904) a French painter of genre scenes, often of a vaguely comical nature. 1879 Salon: *Quatuor d'amateurs* and *L'enterrement de monsieur le maire.* 74

LOUISE A. DESBORDES (1848-1926), a French painter and singer who studied under Alfred Stevens and who later became associated with the Symbolist movement. She married the engraver Charles Jouas, who would later illustrate a number of Huysmans' books. 1879 Salon: *Fleurs, panneau décoratif* and *Souvenirs de première communion.* 1882 Salon: *L'automne* and *Les poissons.* 86, 88, 152, 263

MARCELIN DESBOUTIN (1823-1902), a French painter, engraver and writer who was associated with the Impressionists. He appears in a portrait by Manet, and in Degas' celebrated painting of the absinthe drinker, in which he is seated next to an actress and her glass of absinthe. 1879 Salon: *Portrait de M. Dailly, rôle de Mes-Bottes de l'Assommoir, Portrait de Madame B*, and five watercolours: *Mon portrait, Enfant de M. Halévy, M. Levraut, Madame Bouquer de la Grie, Le Docteur Collin.* 80-1, 93, 155, 170

BLAISE ALEXANDRE DESGOFFE (1830-1901), a French painter of still lifes. 1879 Salon: *Vase de cristal, buste d'empereur romain, médailles, socle de brome doré, table chinoise, fleurs, etc.* and *Environs du puy de Dôme.* 87, 90

ÉDOUARD DETAILLE (1848-1912), a French academic painter renowned for his military scenes and for his precision of detail. 1879 Salon: *Champigny, décembre 1870.* 84-5, 176

GUSTAVE DORÉ (1832-1883) was a French artist who is now best known for his distinctive woodcut illustrations and engravings, though he produced a number of paintings earlier in his career. 1879 Salon: *La mort d'Orphée.* 40, 195, 196

GERRIT DOU (1613-1675), a Dutch painter and a pupil of Rembrandt. He was perhaps the foremost representative of the Leyden school, which was characterised by its fine technique, high polish and use of chiaroscuro or the dramatic contrast between light and shade. 99

ÉDOUARD DUBUFE (1819-1893) a French portrait painter. In 1866 Zola criticised Dubufe as a jury member of the Salon, accusing him of bias, his judgement being compromised by his connection to academic circles. 1879 Salon: *Portrait de Madame F.* and *Portrait de Madame*

GLOSSARY

P.D. 78, 87, **143**

ERNEST DUEZ (1843-1896), a French painter of genre scenes and religious subjects. 1879 Salon: *St Cuthbert: triptyque.* 1882 Salon: *Autour de la lampe.* 47, **262, 263**

SIMON DURAND (1838-1896), a Swiss painter mostly of scenes of civilian life and of military subjects. 1879 Salon: *Une alerte, commencement d'incendie à Genève* and *Loisirs d'un forgeron.* 76

AMAURY DUVAL (1808-1885), a French painter and a pupil of Ingres. He first exhibited at the Salon in 1833 and is perhaps best known for a series of commissions under Napoleon III to decorate the churches Saint-Merry and Saint-Germain-l'Auxerrois in Paris. 37

HENRI FANTIN-LATOUR (1836-1904), a French realist painter and lithographer who is perhaps best known for his group portraits, such as *Un coin de table* (1872), which features, among others, the poets Paul Verlaine and Arthur Rimbaud, and *Un atelier aux Batignolles* (1870), which includes Claude Monet, Auguste Renoir and Émile Zola. 1879 Salon: *Portraits* (now more commonly known now as *La leçon de dessin dans l'atelier*). 1880 Salon: *Scène finale du Rheingold,* and *Portrait de Mademoiselle L. R.* 1881 Salon: *La Brodeuse, Portrait de Mademoiselle E. C.-C.* and *Tentation* (watercolour). 1882 Salon: *Portrait de Madame H.L.* and *Portrait de Madame L.M.* 23, 29, 81-2, **147-8, 185-6, 211, 240, 265**

FRANÇOIS-MARIE FIRMIN-GIRARD (1831-1921), a French painter of genre scenes, and historical and religious subjects. He was popular with the public but critics such as Zola and Huysmans found him conventional. **63, 98**

LÉON FLAHAUT (1831-1920), a French landscape painter and pupil of Corot. 1879 Salon: *Le soir.* **52**

FRANÇOIS FLAMENG (1856-1923), a French painter and illustrator who studied under Cabanel. 1879 Salon: *L'appel des Girondins, le 30 octobre 1793, prison de la Conciergerie.* 1881 Salon: *Route de Capo di Monte, à Naples* and *Les vainqueurs de la Bastille (14 juillet 1789).* 37, **177**

LÉOPOLD FLEMENG (1831-1911) a French illustrator and engraver. As well as etchings of work by the old masters, he also illustrated editions of Boccaccio, Victor Hugo and François Coppée. **167**

HIPPOLYTE FLANDRIN (1809-1864) a French painter known for his religious paintings in the neo-classical style. He studied under Ingres. 46, **179**

TONY ROBERT-FLEURY (1837-1911), a painter and art teacher best known

for his history paintings. His father, Joseph Robert-Fleury (1797-1890) was also a painter. 1880 Salon: *Le jour des morts au village* and *Les pauvres du couvent.* **151**

JEAN-LOUIS FORAIN (1852-1931), a French painter and illustrator who was closely associated with the Impressionists. He exhibited at four of the Impressionist exhibitions between 1879 and 1886. Huysmans knew Forain – who painted his portrait – and used him as an illustrator for his *Croquis parisiens* (1880). **2, 24, 92, 116-20, 162, 239-41, 247, 270**

RAOUL-ANDRÉ-JACQUES FORCADE (active c.1870-1883) a French painter from Dieppe who studied under Cabanel. 1879 Salon: *Jeanne!* and *Une part du bateau.* **73**

MARIÀ FORTUNY or MARIANO FORTUNY (1838-1874), the leading Catalan painter of his day. His work was renowned for its vibrant use of colour. Huysmans often refers to him as a yardstick for the kind of decorative showiness he disliked in painting. **73, 89, 134, 231, 259**

EUGÈNE FROMENTIN (1820-1876), a French painter influenced by Delacroix's striking composition and use of colour. Fromentin is now equally well known for his writing and his art criticism. **55-6, 71**

J. A. GARNIER. Little is known of Garnier's life or work, the illustration given in the Salon catalogue perhaps shows why his work has fallen out of favour. 1879 Salon: *La tentation* and *Jour de fête.* **40, 220**

EDUARDO LÉON GARRIDO (1856-1949), a Spanish portrait painter. 1880 Salon: *A quinze ans* and *Sous le charme d'une douce pensée.* **157**

PAUL GAUGUIN (1848-1903), a French painter who became a leading figure in the post-Impressionist movement. In 1874 he was introduced to the Impressionists and worked with Pissarro. He exhibited with the Independents in 1879, 1880, 1881, 1882 and 1886. **22, 231-2, 234-5, 236, 244, 251, 270**

WALTER GAY (1856-1937), an American painter who studied under Bonnat. During the period Huysmans was writing, Gay was still very much under the influence of Fortuny and Meissonier. 1880 Salon: *Les pigeons savants* and *Les amateurs de fleurs.* **134**

WILHELM VON GEGERFELT (1844-1920), a Swedish painter mostly of landscapes, who studied in Paris. 1879 Salon: *Coin d'un boulevard extérieur, effet d'hiver.* **49**

JEAN GEOFFROY (1853-1924), a French painter and illustrator of genre scenes and portraits. 1879 Salon: *L'abandonnée* and *Ressemblance non garantie.* **76**

JEAN-LÉON GÉRÔME (1824-1904), a French painter and sculptor in

GLOSSARY

the academic style whose work included historical painting, Greek mythology, Orientalism, and portraits. Huysmans rarely has a good word to say about Gérôme. 33, 40, 43, 50, 98, 111, 120, 132, 189

HENRI GERVEX (1852-1929), a French painter who studied under Cabanel and Fromentin. His painting *Rolla* was rejected for the 1876 Salon on the grounds of obscenity. 1879 Salon: *Portrait de Mademoiselle V.* and *Retour du bal.* 1880 Salon: *Souvenir de la nuit du 4 décembre.* 1881 Salon: *Le mariage civil* and *Portrait de M. de G.* 1882 Salon: *Bassin de La Villette.* 18, 23, 59-61, 131, 139-40, 158, 161, 166, 182-3, 265

JEAN GIGOUX (1806-1894), a French painter and illustrator. 1879 Salon: *La belle au bois dormant.* 41

CHARLES GLEYRE (1806-1874), a Swiss painter and a teacher at the École des Beaux Arts. His students included Monet, Renoir and Sisley. 157

NORBERT GOENEUTTE (1854-1894), a French painter and illustrator. Huysmans classified him among the 'fake' moderns, those whose painting had a superficial air of modernity, but which continued the outmoded practices of academic painting. 1877 Salon: *L'Appel des Balayeurs devant l'Opéra* and *Le Boulevard de Rochechouart.* 1879 Salon: *Dernier salut.* 1880 Salon: *La Soupe du Matin* and *Le Boulevard de Clichy par un temps de neige.* 60, 63, 155, 158, 160-1, 243

EVA GONZALÈS (1849-1883), a French painter closely associated with the Impressionist movement who studied under Manet. Manet helped her early in her career and also painted a portrait of her, seated at her easel painting. 1879 Salon: *Un loge aux Italiens.* 74, 75

JEANNE GONZALÈS (1852-1924), a French painter perhaps better known under her married name Jeanne Guérard-Gonzalès. She was the younger sister of the above, who taught her to paint. 1880 Salon: *Les géraniums* and *La porteuse de pain.* 154

GOSEDA YOSHIMATSU (1855-1915), a Japanese painter. He went to Paris in 1880 where he became Léon Bonnat's pupil. He was the first Japanese painter to have his work shown in the Salon. 1881 Salon: Five watercolours. 211

JULES ADOLPHE GOUPIL (1839-1883), a French painter who specialised in genre pictures. 1879 Salon: *L'amie complaisante* and *Le repos.* 88

EDWARD JOHN GREGORY (1851-1909), an English painter and a close friend of Hubert von Herkomer, with whom he had studied at South Kensington Art School. 60

FERDINAND GUELDRY (1858-1945), a French painter who specialised in sporting scenes. 1881 Salon: *Une regatta à Joinville, le depart.* 1882

GLOSSARY

Salon: *Course de skiffs, l'arrivée.* **189, 263-4**

ARMAND GUILLAUMIN (1841-1927), a French painter and lithographer allied to the Impressionist school. **230-1, 252, 270**

ANTOINE GUILLEMET (1841-1918), a French landscape painter, associated with the Barbizon school. He studied under Daubigny and Corot, and was a friend of Pissarro and Monet. In 1881 Huysmans dedicated his pantomime *Pierrot sceptique* to him. 1877 Salon: *Environs d'Artemare* and *Les falaises de Dieppe.* 1879 Salon: *Le Chaos de Villers.* 1880: Salon: *Le vieux quai de Bercy.* 1881 Salon: *Le vieux Villerville* and *La plage de Saint-Vaast-la-Hougue.* **29, 51, 149-50, 190-1**

JULES-LOUIS HAMON (1821-1874), a French painter who often used a relatively restrained palette in terms of colour. **264**

HECTOR HANOTEAU (1823-1890), a French landscape painter. He trained at the École des Beaux Arts. 1879 Salon: *La victime du réveillon.* **52**

GEORGES HAQUETTE (1854-1906), a French painter who studied at the École des Beaux Art under Cabanel. 1879 Salon: *Le manchon de Francine* and *Un intérieur au Pollet.* **75-6**

JENNY HAQUETTE-BOUFFÉ (dates unknown), a French painter, sister of the above, about whom little is known. 1879 Salon: *Un interior* (watercolour). **92**

HENRI HARPIGNIES (1819-1916), a French landscape painter of the Barbizon school. 1879 Salon: *Le pavillon de Flore, vue prise du Pont Neuf* and *Les dindons de Mme Héraut, souvenir de l'Allier.* **52**

PIERRE EDMOND HÉDOUIN (1820-1889), French painter and engraver. **170**

FERDINAND HEILBUTH (1826-1889) a German-born watercolourist who moved to Paris and became a French citizen in 1869. Van Gogh was an admirer of his work. **90**

ARMAND JEAN HEINS (1856-1938) a Belgian painter and engraver. 1881 Salon: Two watercolours. **211**

HUBERT VON HERKOMER (1849-1914) a German-born British painter. After a short period studying in Munich he moved to London and enrolled at the Royal College of Art. 1879 Salon: *Asile pour la vieillesse, en Angleterre* (also known as *Eventide*). **29, 60, 67-9, 71**

CHARLES HERMANS (1839-1924), a Belgian painter, who studied in Paris under Gleyre. 1880 Salon: *Bal masqué* and *Portrait.* **158**

LÉON HERPIN (1841-1880), a French landscape painter. He first showed at the Salon in 1868. 1879 Salon: *Paris vu du Pont Neuf, en 1878.* **52**

ALPHONSE HIRSCH (1843-1884), a French painter, sculptor and etcher. He studied under Bonnat. 1879 Salon: *Portrait de Madame W.* and *Portrait*

GLOSSARY

de Madame M. **86**

MEINDERT HOBBÉMA (1638-1709), a landscape painter of the Dutch Golden Age. He was the pupil of Ruisdael. **49**

AUGUSTE HOERTER (1836-1906), a German painter, mostly of landscapes. 1879 Salon: *Un vieux moulin, souvenir du Haut-Rhin.* **49**

HOKKEI, TOTOYA (1780-1850), a Japanese artist in the *ukiyo-e* style, who was perhaps the best known of Hokusai's students. **200**

HOKUSAI, KATSUSHIKA (1760-1849), perhaps the best known Japanese artist working in the *ukiyo-e* style. His work, usually woodblock prints, had an enormous influence on European art movements, especially in France, during the latter half of the 19th century. **200**

GUGLIELMO INNOCENTI (dates unknown), an Italian painter of genre scenes. 1879 Salon: *Le Gâteau de la mariée* and *Une Blanche pointée*. **76-7**

JOZEF ISRAËLS (1824-1911) a Dutch landscape painter and one of the leading members of the Hague school. 1881 Salon: *Plus rien* and *École de couture à Katwyk.* 1882 Salon: *Dialogue silencieux.* **156, 187, 265**

JULES JACQUEMART (1837-1880), a French illustrator, engraver and watercolourist who was particularly admired for his etchings. **167**

GUSTAVE JACQUET (1846-1909), a French painter and illustrator who studied under Bouguereau. He is known mostly for his portraits of women and his genre pictures, but he also published a number of humorous cartoons for newspapers under the signature 'Jacquet'. **76**

GUSTAVE DE JONGHE (1829-1893), a Belgian painter principally known for his sumptuous portraits of society women. 1879 Salon: *La berceuse de Chopin* and *L'indiscrète*. **60, 71-2**

BLANCHE JULIANE (dates unknown), a French watercolourist. 1879 Salon: *Souvenir du grand concile tenu à Rome en 1869* and *Rose de mai.* **92**

GUSTAVE ADOLF JUNDT (1830-1884), a painter born in Alsace who studied art in Paris. Alsace was often the subject of his work. 1881 Salon: *Retour* and *Nice surprise par la neige.* **173, 187**

JOHANNES KAREL KLINKENBERG (1852-1924), a Dutch painter known for his village scenes and landscapes. 1880 Salon: *Les quai espagnol, à Rotterdam* and *Une vue à l'Haye.* **150**

LUDWIG KNAUS (1829-1910), a German painter of genre scenes and the recognised head of the Dusseldorf school. **73**

ALFRED DE KNYFF (1819-1885), a Belgian painter who specialised in landscape. 1879 Salon: *La barrière noire.* **49**

ELISA KOCH (1833-1914), an Italian painter active in France. Her work often seems to have featured women and children. 1879 Salon: *Petit*

caprice. 73-4, **98**, **227**

PEDER SEVERIN KROYER (1851-1909), a Danish painter. During 1877-1881 he travelled through Europe, and studied under Bonnat in Paris. He was subsequently influenced by the Impressionists. 1880 Salon: *Dans un sardinière à Concarneau.* **157**

PAUL DE LA BOULAYE (1849-1926) a French painter who studied under Bonnat. He specialised in genre scenes and paintings with historical and religious subjects. 1879 Salon: *Au sermon, souvenir de la Bresse.* 74-5, 76

ALEXIS LAHAYE (1850-1914), a French painter of portraits, landscapes and scenes of everyday life, who first exhibited at the Salon in 1876. 1879 Salon: *Sous les oliviers* and *En été.* 60, 65-6

JEAN DE LA HOESE (1846-1917), was a Belgian painter of portraits, genre scenes and landscapes. 1879 Salon: *La chaise brisée.* 60, 66-7

ADOLPHE LALAUZE (1838-1906) was a prolific French etcher. He illustrated numerous books and was considered a skilful etcher with a facility for vignettes and frontispieces. 170

LOUIS LAMBERT (1825-1900), a French painter who produced a number of twee paintings of cats. 94

EMMANUEL LANSYER (1835-1893), a French landscape painter associated with the Barbizon school. 1879 Salon: *Baie de Douarnenez à marée basse* and *Pleine mer, à Granville.* 54

CHARLES LAPOSTOLET (1824-1890), a French landscape painter. He exhibited at the Salon between 1848 and 1882. 1880 Salon: *L'avant-port de Dunkerque* and *Le port de Louviers.* 150

JEAN-PAUL LAURENS (1838-1921), a French painter and sculptor whose work dealing with historical or religious subjects was in the academic style. 1880 Salon: *Le bas empire, Honorius* and *Portrait de Mlle T.* 1881 Salon: *L'interrogatoire* and *Portrait de Madame la comtesse R.* 142, 143, 178, 185, 245

JEAN LECOMTE DU NOUY (1842-1923), a French painter and sculptor who was much influenced by the work of Gérôme. He travelled extensively and the Orient featured as the subject of many of his works. It is easy to understand Huysmans' contempt for him and today many of his paintings seem staggeringly awful and unintentionally comic. 1879 Salon: *Saint Vincent de Paul.* 39-40

HORACE LECOQ DE BOISBAUDRAN (1802-1897), was a French painter and art teacher. 179

LIONEL LE COUTEUX (1847-1909) a French painter, engraver and

GLOSSARY

sculptor. 1879 Salon: *Têtes d'études* (five engravings). **93**

JULES LEFEBVRE (1836-1911), a French painter in the academic style. He was a teacher at the École des Beaux Arts. 1879 Salon: *Diane surprise*. **45-6, 232, 233**

PIERRE LEHOUX (1844-1896), a French painter in the academic style. He was a pupil of Cabanel and won a number of medals at Salons in the early 1870s. 1879 Salon: *St. Jean-Baptiste*. **38-9**

LE NAIN is the collective name given to the work of three French brothers, Antoine Le Nain (c.1599-1648), Louis Le Nain (c.1593-1648), and Mathieu Le Nain (1607–1677). They produced genre works, portraits and portrait miniatures, but as their works were often just signed 'Le Nain' and their styles were so similar, it is difficult to distinguish which brother painted what. **237-8**

LUDOVIC LEPIC (1838-1889) was a French artist and archeologist. He was a friend of Degas and was a member of the original Impressionist group, though he was later rejected by the other members as his work remained too classical in tone. 1879 Salon: *La pêche au hareng d'Écosse, par les bateaux de Berck* and *La Vierge de Grosfliers, à Berck*. **54**

HENRY LEROLLE (1848-1929), a French academic painter who received several official commissions in Paris, such as murals for the Hotel de Ville, and paintings for the Sorbonne and the Schola Cantorum. 1880 Salon: *Dans la campagne*. **150-1**

ADOLPHE ALEXANDRE LESREL (1839-1929), a French painter in the academic style who studied under Gérôme. 1878 Salon: *La France retrouvant le cadavre d'Henry Regnault* and *Marie de Médicis reçoit des présents de Henri IV*. **41**

GUSTAVE LE SÉNÉSHAL (1840-1933) a French painter who specialised in seascapes. 1879 Salon: *Marée basse à Veules-en-Caux*. **54**

HENDRICK LEYS (1815-1869), a Belgian painter and engraver, one of the principal representatives of the Belgian Romantic school who influenced painters such as James Tissot and Lawrence Alma-Tadema. **201**

MICHEL DE L'HAY (1850-1900), the pseudonym of Michel Eudes, a French painter who, along with his friend Arthur Rimbaud, was one of the so-called 'Zutistes'. 1881 Salon: *St-Vaast-la-Hougue*. **189-90**

LÉON-AUGUSTIN LHERMITTE (1844-1925), a French painter whose work often represented peasant life. 1881 Salon: *Quatuor* and *Pot de vin* (watercolour). 1882 Salon: *La paye des moissonneurs*. **210-11, 265**

MAX LIEBERMANN (1847-1904) a German painter and printmaker.

1880 Salon: *Les éplucheuses de légumes* and *Ecole de petits enfants à Amsterdam.* 1881 Salon: *Jardin d'une maison de retrait à Amsterdam* and *Vieille femme raccommodant ses bas, en Hollande.* 1882 Salon: *Cour de la maison des Orphelines* and *Echoppe de savatier hollandaise.* **156, 157, 186, 187, 265**

TIMOLÉON LOBRICHON (1831-1914), a French painter known for his genre work and especially for his paintings of children, which are of an almost nauseating sentimentality. 1879 Salon: *Portrait de Madamoiselle Juliette d'A.* and *Allant au bain.* 1880 Salon: *Devant Guignol* and *Supplice de Tantale.* **70, 98, 134, 166**

LUIGI LOIR (1845-1916), a painter, illustrator and lithographer, mostly of landscapes, born in Austria to French parents. 1879 Salon: *Un coin de Bercy, pendant l'inondation.* 1880 Salon: *La Seine, decembre 1879.* 1881 Salon: *Giboulées.* **53, 150, 190**

LOUIS AUGUSTE LOUSTAUNAU (1846-1898) a French painter of genre scenes. 1880 Salon: *Le loup dans la bergerie.* **134**

ÉDOUARD MANET (1832-1883), a French painter who was a key figure in the development of modern painting and considered one of the fathers of Impressionism. In 1863 the Salon refused his *Le Dejeuner sur l'herbe,* which was subsequently shown at the Salon des Refusés, where it caused an enormous scandal. 1879 Salon: *Dans le serre* and *En bateau.* 1880 Salon: *Portrait de M. Antonin Proust* and *Chez le Père Lathuille, en plein air.* 1881 Salon: *Portrait de M. Henri Rochefort* and *Portrait de M. Pertuiset, le chasseur de lions.* 1882 Salon: *Un Bar aux Folies-Bergère* and *Jeanne.* **10, 13, 19, 20, 22, 29, 31, 54, 57-9, 74, 81, 110, 120-1, 122, 154, 155, 162-5, 184, 185, 243, 260-1, 270**

CHARLES MARCHAL (1825-1877), a French painter who exhibited regularly at the Salon between 1852 and 1876 before his suicide in 1877. **57**

FRANÇOIS MARTIN (1861-1931), a French painter who seems to have specialised in 'oriental' scenes. 1880 Salon: *Chez un orientaliste.* 1881 Salon: *Intérieur oriental.* **152-3, 191**

JULES MASURE (1819-1910), a French landscape and seascape painter. 1879 Salon: *Matinée au cap d'Antibes* and *Coup de vent sur la côte de Granville.* **54**

JAN ALOJZY MATEJKO (1838-1893), a Polish artist known for his historical paintings. 1880 Salon: *Bataille de Grünwald (15 juillet 1410) entre l'ordre Teutoniques et les Polonaise* and *Portrait des enfants de peintre.* **136**

LOUIS MATOUT (1811-1888), a French painter who studied at the École des Beaux Arts. 1879 Salon: *Saint Louis fait enterrer et enterre lui-même*

les morts sur le champ de bataille de Sayete. 46

EUGÈNE MÉDARD (1847-1887), a French painter who specialised in military subjects. 1879 Salon: *Une retraite.* 85

ERNEST MEISSONIER (1815-1891), a French painter particularly known for his pictures of Napoleon and for his battle scenes. His paintings were renowned for their fine detail. He also famously produced a series of miniature paintings in oil. 73, 98, 108

GASTON MÉLINGUE (1840-1914), a French painter who worked in the academic style. 1879 Salon: *Edward Jenner.* 34, 35, 37

LUCIEN-ÉTIENNE MÉLINGUE (1841-1889), brother of the above, a French painter who produced works in the academic style. 1879 Salon: *Le prévôt de marchands Etienne Marcel et le dauphin Charles.* 34, 35, 37

ADOLPH MENZEL (1815-1905), a German realist painter, engraver and illustrator. One of his most famous works, *The Forge*, depicted the inside of a busy industrial foundry. 132

HUGUES MERLE (1823-1881), a French painter who first exhibited at the Salon in 1847. His work was often compared to that of Bouguereau. 1879 Salon: *Hébé après sa chute* and *Carmosine.* 46

LUC-OLIVER MERSON (1846-1920), a French academic painter. 1879 Salon: *Le Repos en Egypte* and *St Isidore, laboureur.* 46-7

HENDRIK WILLEM MESDAG (1831-1915) a Dutch marine painter. 1879 Salon: *Rentrée des pêcheurs, Scheveningue* and *Marché aux poissons, à Groningue, l'hiver.* 29, 54

FRANÇOIS DE MESGRIGNY (1836-1884), a French landscape painter who first exhibited at the Salon in 1866. His style was similar to that of the Barbizon school. 1879 Salon: *Environs de Lagny* and *Bords de la Marne.* 1880 Salon: *L'Isle-Adam* and *Bords de l'Oise.* 50, 149

GABRIËL METSU (1629–1667), a Dutch painter of historical scenes, still lifes, portraits and genre works. 32

CONSTANTIN MEUNIER (1831-1905), a Belgian painter and sculptor, who concentrated on images of industrial workers. 1881 Salon: *La Coulée de l'acier, usine de Seraing.* 190

FRANÇOIS ÉMILE MICHEL (1828-1909), a French painter and art critic who studied at Metz. 1879 Salon: *La Moselle à Liverdun, matinée d'octobre* and *Un étang.* 50

WILLEM VAN MIERIS (1662-1747), a painter from the Netherlands who specialised in portraits and genre scenes. His works usually focussed on those of a higher class, and even when dealing with subjects from the lower echelons of society he depicts them as more elegant and

refined than they would be in real life. **43, 183**

ABRAHAM MIGNON (1640-1679), a Dutch painter who specialised in excessively sumptuous still lifes of flowers and fruit. **87**

JOHN EVERETT MILLAIS (1829-1896), a British painter and illustrator, one of the founding members of the Pre-Raphaelite Brotherhood. His later works concentrated on landscape and were more realistic in style. **50, 51, 228**

FRANCIS DAVIS MILLET (1846-1912), an American painter, sculptor and writer. 1879 Salon: *Les pacificateurs, à San-Stéphano.* **74**

JEAN-FRANÇOIS MILLET (1814-1875), a French painter and one of the founders of the Barbizon school. His work is noted for its scenes of peasant and rural life, and he was himself from a farming family. **50, 61-2, 84, 230, 237, 239, 255**

ROBERT MOLS (1848-1903), a painter from Antwerp who specialised in seascapes, landscapes and still lifes. He came to Paris in 1866 and studied under Jean-François Millet. 1879 Salon: *Le Vieux Port de Marseille, en décembre* and *Le Tréport.* **52**

XAVIER-ALPHONSE MONCHABLON (1835-1907), a French history and portrait painter in the academic style. 1880 Salon: *Victor Hugo.* **144-5**

CLAUDE MONET (1840-1926), a French painter who studied under Gleyre and who first exhibited at the Salon in 1866. He exhibited at the first Impressionist exhibition in 1874 and was considered one of the leading exponents of Impressionism. 1880 Salon: *Lavacourt.* **101, 104, 132, 150, 229, 247, 255, 256-8, 270**

CHARLES MONGINOT (1825-1900), a French painter principally of still life and portraits. 1879 Salon: *Le Paon revestu* and *Groseilles.* **86**

GUSTAVE MOREAU (1826-1898), a French painter who became a major figure in Symbolist art. Huysmans' descriptions of his work in *À rebours* of 1884 had a huge impact on his reputation and on the way people saw his work. 1880 Salon: *Galatée* and *Hélène.* **9, 22, 24, 140-2, 192, 259, 268, 285**

GEORGES MOREAU DE TOURS (1848-1901), a French history painter who studied with Cabanel. 1879 Salon: *Une extatique au XVIII siècle* and *Blanche de Castille, surnommée 'l'Amour des pauvres'.* **36, 37**

BERTHE MORISOT (1841-1895), a French painter and one of the founding members of the Impressionists. Her work was both influenced by and an influence on that of Manet's, and the two had a close friendship for many years. She would later marry Manet's younger brother. Much of her work after 1878 featured portraits of her daughter, Julie, who was

GLOSSARY

born in that year. **103, 121-2, 243, 252, 270**

AIMÉ NICOLAS MOROT (1850-1913), a French painter in the academic style. He was a student of Cabanel's but found his atelier too noisy to work in and left. He subsequently married one of Gérôme's daughters. 1879 Salon: *Episode de la bataille d'eaux-sextiennes* (known today as *Les Ambonnes*). The title derives from the Latin name for Aix-en-Provence, *aquae sextiae*. **40-1**

ALPHONSE DE NEUVILLE (1835-1885), a French academic painter, mostly of military subjects. **55, 175-6**

GUISEPPE DE NITTIS (1846-1884), an Italian painter whose work crossed the borders of the Salon style and Impressionism. **165-6, 211-2**

BALTHASAR PAUL OMMEGANCK (1755–1826), a Flemish painter of landscapes and animals, he was also credited with helping to revitalise landscape painting in the Low Countries. **50**

ADRIAN VAN OSTADE (1610-1685), a Dutch genre painter of the Golden Age. **19, 32, 178**

MANUEL PANSELINOS or PANSELENOS was a Greek painter from the late 13th and early 14th centuries, one of the most important late Byzantine artists, and one of the main creators of religious iconography in Eastern Christianity. **46**

JEAN-ADOLPHE PAPIN (1800-1880), a French painter in the neo-classical style. 1879 Salon: *Le tirage au sort de la tunique du Christ.* **46**

FERNAND PELEZ (1848-1913) was a painter based in Paris. Following a period of poor sales during the 1880s and the failure of his painting at the Salon of 1896 he became a recluse and refused to exhibit his work. 1879 Salon: *Mort de l'empereur Commode* and *Avant le bain, jeune fille romaine.* **36, 37**

LÉON GERMAIN PELOUSE (1838-1891), a French landscape painter of the Barbizon school. 1879 Salon: *Le vieux puits* and *Un coin de Cernay en janvier.* **152-3**

LÉONCE PETIT (1839-1884), a French painter, illustrator and cartoonist. He exhibited at the Salon in 1869, but during the 1870s the majority of his work was as an illustrator for papers such as the *Petit Journal pour rire* and *Le Monde illustré.* **74**

LUDOVIC PIETTE-MONTFOUCAULT (1826-1878) was a French Impressionist painter and a close friend of Camille Pissarro. **105, 229, 230, 256**

AMABLE LOUIS PINTA (1829-1888), a French landscape painter. 1879 Salon: *L'automne* and *Jardin des Plantes de Paris.* **76**

VICTOR POLLET (1811-1882), a French painter and watercolourist, a pupil

GLOSSARY

241, 247, 253-4, 270

PAUL RENOUARD (1845-1924), a French painter and engraver. 93-4

ANDRÉ REVERCHON (1808-1882), a French painter of military and historical scenes. 1879 Salon: *Franc-tireur blessé à mort*. 1881 Salon: *Dernière pensée* and *Bonne maman*. 85, 171-2

RUDOLF RIBARZ (1848-1904), an Austrian landscape painter. In 1876 he moved to Paris where he became attached to Corot and the Barbizon school. 1879 Salon: *Quai du bassin de la Villette*. 90

JUSEPE DE RIBERA (1591-1652), a Spanish tenebrist painter. 100

GERMAIN THÉODORE RIBOT (1845-1893), a French painter, who was taught by his father, Théodule Augustin Ribot, and by the still life painter, Antoine Vollon. 1880 Salon: *Poissons*. 154

JEAN-DÉSIRÉ RINGEL (1849-1916), a French painter and sculptor who was born in Alsace. 1879 Salon: *Djann* and *Demi-monde* (sculptures). 1881 Salon: *Splendeur et misère* (sculpture). 98, 212, 224

ALFRED ROLL (1846-1919), a French painter whose work became increasingly Naturalist in tone after 1879, having been influenced by Gustave Courbet. 1875 Salon: *Inondation à Toulouse*. 1879 Salon: *La fête de Silène*. 1880 Salon: *Greve de mineurs*. 1882 Salon: *14 Juillet 1880*. 44-5, 136-7, 264-5

HENRI ROUART (1833-1912), a French painter and collector who was an early supporter of the Impressionists. 243

PHILIPPE ROUSSEAU (1816-1887) a French painter who specialised in still life. 1881 Salon: *Huîtres*. 191

THÉODORE ROUSSEAU (1812-1867), a French landscape artist and one of the founders of the Barbizon school. His paintings often have a brooding, melancholy air. 50

THOMAS ROWLANDSON (1756-1827) an English artist and caricaturist. 203-6, 209, 286

JACOB VAN RUISDAEL (c.1629-1682) was a Dutch painter, draughtsman and etcher, generally considered one of the pre-eminent landscape painters of the Dutch Golden Age. 50-1

JULES SAINTIN (1829-94), a French painter. 1879 Salon: *Portrait de Mademoiselle H.B.* and *Émilienne*. 76

RENÉ DE SAINT-MARCEAUX (1845-1915), a French sculptor of busts and animals. He trained at the École des Beaux Arts. 1879 Salon: *Génie gardant le secret de la tombe* (sculpture). 97-8

HUGO SALMSON (1843-1894), a Swedish painter, mostly of genre scenes and portraits. He moved to Paris in 1868 and began showing at the

Salon in 1870. 1879 Salon: *Une arrestation dans un village de Picardie* and *Dans lés champs.* **75**

JOHN SINGER SARGENT (1856-1925) was born in Italy of American parents and studied art in Paris. Renowned from an early age for his technical ability he was considered one of the leading portrait painters of his day. His portraits had a formal grandeur but avoided academic dryness and had an almost Impressionistic brushwork. 1879 Salon: *Portrait de M. Carolus-Duran* and *Dans les oliviers à Capri.* **82, 261-2**

ARY SCHEFFER (1795-1858) a French painter of Dutch extraction, considered one of the masters of Romantic painting. **179**

OTTO SCHOLDERER (1834-1902), a German painter of landscapes, portraits and still life. On his trips to Paris he came to know Fantin-Latour and Manet, and featured in Fantin-Latour's group portrait, *Un atelier aux Batignolles.* 1880 Salon: *Portrait de M.O.S.* **148**

LUCIEN-PIERRE SERGENT (1849-1904), a French painter who concentrated mainly on military subjects. He first began showing at the Salon in 1873. 1879 Salon: *Origine du pouvoir: Force; Suffrage universel; Droit divin.* **41**

ÉMILE SIGNOL (1804-1892), a French artist and member of the Académie des Beaux Arts. He specialised in history paintings in the academic style. 1879 Salon: *Psyché voyant l'Amour* (watercolour) and *Le Sacrifice d'Abel et de Caïn: Abel mort* (watercolour). **33, 92**

ALFRED SISLEY (1839-1899), a landscape painter who was born in Paris to English parents. He spent most of his working life in France, but retained his British citizenship. An early associate of the Impressionists, he exhibited at their first show in 1874. **105, 229, 247, 255-6, 270**

FRITHJOF SMITH-HALD (1946-1903), a Norwegian landscape painter. 1879 Salon: *Retour des pecheurs, le matin* and *Promenade du matin.* 49

JAN STEEN (1626-1679), a Dutch genre painter. **32, 178, 204**

GERARD TERBURG (1617-1681), an influential Dutch genre painter. **32, 178**

FRITS THAULOW (1847-1906), a Norwegian painter best known for his naturalistic landscapes. He was a follower of the Impressionists. 1879 Salon: *Vers la côte, Norvège* and *Une plage de Norvège.* **49**

OSVALDO TOFANI (1849-1915) was an Italian illustrator, engraver and painter. He is mostly known now for his illustrations in papers such as *Le Petit Journal illustré, L'Illustration, Le Rire* and *The Graphic.* **240**

AUGUSTE TOULMOUCHE (1829-1890), a French academic painter famous for his portraits of affluent society women, often in extravagant – and extravagantly painted – dresses. **72, 98, 244**

GLOSSARY

VALENTIN DE BOULOGNE (1591-1632), known as LE VALENTIN, was a French painter who worked in the tenebrist style after coming under the influence of Caravaggio. **99**

PIETER VERBRUGGEN (1615-1686), a Flemish sculptor of the Baroque period. Some of his best life-size figures are in Saint Paul's church, Antwerp. **225**

FRANS VERHAS (1827-1897), a Belgian painter. 1879 Salon: *Fleurs de printemps* and *La fête de papa.* 1881 Salon: *L'inconsolable* and *Le maraudeur.* **72, 187**

JAN VERHAS (1834-1896), a Belgian genre painter, younger brother of the above. 1879 Salon: *Portrait de Suzanne Stevens.* 1881 Salon: *Revue des écoles.* **187**

VINCENT VIDAL (1811-1887), a French painter and watercolourist best known for his portraits of fashionable Parisian women. **243**

ANTOINE VOLLON (1833-1900), a French painter best known for his still lifes. 1880 Salon: *Courges.* **51, 87, 151, 152, 154**

JAMES MCNEIL WHISTLER (1834-1903), an American painter known for his distinctive portraits. He came to Paris in 1855 where he became acquainted with Fantin-Latour, Carolus-Duran and Manet. 1882 Salon: *Portrait de Madame Henry Meux.* **253, 264**

ANTOINE WIERTZ (1806-1865), a Belgian painter whose work is often considered eccentric if not altogether deranged. **74**

EDMOND CHARLES JOSEPH YON (1836-1897), a French engraver and painter of landscapes. He first exhibited at the Salon of 1865 and won medals at the 1875 and 1879 Salons. Yon specialised in river painting and often painted on the banks of the Marne and the Seine. 1879 Salon: *Le bas de Montigny, bords de la Marne.* 1880 Salon: *Le canal de la Villette, hiver de 1879-1880* and *Isle-les-Villenoy, bords de la Marne.* **29, 53, 150, 172**

FEDERICO ZANDOMENEGHI (1841-1917) was an Italian painter who joined the Impressionist movement. He came to Paris in 1874 and after making the acquaintance of Degas and the Impressionists he took part in four of their exhibitions, in 1879, 1880, 1881 and 1886. **115-6, 242-3, 247, 270**

ABOUT THE TRANSLATOR

Brendan King is a freelance writer, reviewer and translator with a special interest in late 19th-century French fiction. His Ph.D. was on the life and work of J.-K. Huysmans.

His previous translations of Huysmans' work for Dedalus include *Là-Bas: A Journey into the Self, Parisian Sketches, Marthe, Against Nature, Stranded, The Vatard Sisters* and *Drifting*.

He also edited Robert Baldick's definitive biography *The Life of J.-K. Huysmans,* which was published in paperback by Dedalus in 2005.

OTHER TITLES BY J.-K. HUYSMANS AVAILABLE FROM DEDALUS

Marthe

The Vatard Sisters

Parisian Sketches

Drifting

Against Nature

Stranded

Là-bas: A Journey into the Self

En Route

The Cathedral

The Oblate of St Benedict

DRIFTING BY J.-K. HUYSMANS

The misfortunes of Jean Folantin, a downtrodden clerk working for the Ministry of the Interior in Paris, form the subject of J.-K. Huysmans' blackly comic novella, *Drifting* (*À vau-l'eau*). At first glance, Folantin's problems seem to be a world away from those of Jean Floressas des Esseintes, the aristocratic anti-hero of Huysmans' Decadent classic *Against Nature*, written just two years later in 1884. But the two men share more than just a first name: like des Esseintes, Folantin is in the throes of an existential crisis: alienated from a Paris undergoing rapid modernisation, the pace of social change leaves him feeling out of place, impotent, a small cog in an impersonal commercial world. Through the distorting lens of Huysmans' dark sense of humour, the dyspeptic Folantin is transformed into a modern-day Ulysses, and his tortuous quest through the streets of Haussmann's Paris to find a capable housekeeper and a decent meal reaches its conclusion in one of the most daring anti-climaxes — literally speaking – in the whole of 19th-century fiction.

This new translation by Brendan King includes, for the first time in English, a contemporary profile of Huysmans' life and work in which the author plays both interviewer and interviewee, and which was published pseudonymously for the journal *Les Hommes d'aujourd'hui* (*Men of Today*) in 1885.

£7.99 ISBN 978 1 910213 63 6 109 p B. Format

*

THE VATARD SISTERS BY J.-K. HUYSMANS

J.-K. Huysmans' second novel, *The Vatard Sisters* (1879), was a key work in his development as a writer, consolidating his reputation as one of the most extreme figures in the controversial Naturalist movement. It tells the story of two working-class sisters: Désirée, young and attractive, but idealistic and a bit of a prude; and the

worldly Céline, who is a few years older and has a more casual, more pragmatic approach to affairs of the heart. Despite their differences in temperament and moral outlook, the two sisters each have to try and negotiate their way through a brutal world that is sharply divided along class and gender lines. Their respective love affairs with men of varying degrees of integrity and social status are set against the backdrop of the gaslit bookbindery in which they work, and the cheap wineshops and bars of the quarter in which they live.

But neither Désirée's naivety, nor Céline's cynicism are a match for the relentless pressure of bourgeois convention and respectability, and in their search for love both lose out in the end. *The Vatard Sisters* exemplifies Huysmans' vibrant early style, full of neologisms, archaisms and slang, and his florid, meticulously observed descriptions of contemporary Paris provide a fascinating glimpse into the lives of ordinary working women during a tumultuous period of industrial, social and cultural change.

£9.99 ISBN 978 1 907650 53 6 272 p B. Format

*

AGAINST NATURE BY J.-K. HUYSMANS

A gainst Nature (*À rebours*) is the perfect illustration of Oscar Wilde's famous paradox that it is life that imitates art, rather than the other way round. First published in Paris in 1884 when the Naturalistic school — of which Huysmans himself was a major figure — was at its height, it delivered a body-blow to Zola's brand of literary realism, and almost single-handedly redefined the literary and artistic canon of the 19th century in the process. To a rising generation of readers, writers and artists across Europe, Huysmans' novel was the instruction manual of a movement that was to become emblematic of *fin-de-siècle* France: Decadence. The novel tells the story of its decadent aristocratic anti-hero, Jean Floressas des Esseintes, who, bored by the aesthetic and carnal pleasures the Parisian *beau monde* has to offer, decides

to sell up and move to an isolated house in the suburbs. There he constructs a world of artifice that exactly mirrors his super-subtle, perverse and painfully neurotic sensibility. The result is one of the most bizarre, intriguing and influential books of the period. Whether read as an existential fable, psychological analysis, style manual, cultural critique or social satire, the novel remains as audacious and original today as when first published.

This new translation by Brendan King includes an introduction and extensive notes. It is also the first English edition to feature a significant selection of textual variants and passages deleted from the original manuscript of *À rebours*, the only existing copy of which is now conserved at the Bibliothèque Nationale in Paris.

£8.99 ISBN 978 1 903517 65 9 315 p B. Format

*

Stranded by J.-K. Huysmans

Hounded by creditors and gripped by a deep existential gloom, Jacques Marles decides to flee Paris for the countryside, hoping to find shelter from the financial storms raging around his head, hoping to find peace. But Jacques soon discovers he cannot escape the problems of modern city life by hiding in the country. His Parisian creditors are exchanged for grasping peasants, and the soul-destroying competitiveness of bourgeois capitalism is replaced by the relentless ravages of nature. Stuck with his sick wife, Louise, in an abandoned château that seems to be rotting to pieces around them, Jacques waits for money to arrive with nothing to do but give himself up to his increasingly disturbing dreams.

J.-K. Huysmans' *Stranded* (*En rade*), published in 1887 just three years after the iconoclastic *Against Nature*, sees him again breaking new ground and pushing back the boundaries of the novel form. Stamped throughout with his characteristic black humour, *Stranded* is one of Huysmans' most innovative and most imaginative works. Jacques' waking reveries and daydreams are

balanced by a succession of dreams and nightmares that explore the seemingly irrational, often grotesque, world of unconscious desire, producing a series of images that are as unforgettable and unsettling as anything to be found in the decadent fantasies of *Against Nature*, or the satanic obsessions of *Là-bas*.

£9.99 ISBN 978 1 903517 84 0 251 p B. Format

*

Parisian Sketches by J.-K. Huysmans

First published in 1880, the same year as Edgar Degas' *The Dancing Lesson* and Edouard Manet's solo show of paintings at *La Vie Moderne* gallery, J.-K. Huysmans' *Parisian Sketches* (*Croquis parisiens*) shares with these vibrant Impressionist works a fascination with the contemporary life of Paris, an exuberant Paris in the era of the Opéra Garnier and the Folies-Bergères. Like the striking images of the early Impressionists, whom Huysmans championed when it was unfashionable to do so, *Parisian Sketches* is an all-out assault on the visual senses. Composed of a series of intense, meticulously observed impressions — of café-concerts and circus performers, of streetwalkers and hot-chestnut sellers, of run-down slums and forgotten quarters in the grimy, shiny 'City of Light' – *Parisian Sketches* recreates the Paris of the *bal masqué* and the can-can, the *brasseries à femme* and the *buveurs d'absinthe*, all captured with an imtimacy and an immediacy that confirms Huysmans as one of the masters of 19th-century French prose.

£8.99 ISBN 978 1 903517 24 6 196 p B. Format

*